THE ARTISTS IN PERSPECTIVE SERIES
H. W. Janson, general editor

The ARTISTS IN PERSPECTIVE *series presents individual illustrated volumes of interpretive essays on the most significant painters, sculptors, architects, and genres of world art.*

Each volume provides an understanding of art and artists through both esthetic and cultural evaluations.

GERT SCHIFF is Professor of Fine Arts at New York University. He has written widely on art and literature. Among his recent publications is a two-volume study of the life and works of Henry Fuseli.

PICASSO

in Perspective

Edited by

GERT SCHIFF

A SPECTRUM BOOK

Prentice-Hall, Inc., Englewood Cliffs, New Jersey

Library of Congress Cataloging in Publication Data

Main entry under title:

PICASSO IN PERSPECTIVE.

(The Artists in perspective series) (A Spectrum
Book)
Bibliography: p.
1. Picasso, Pablo, 1881–1973—Addresses, essays,
lectures. I. Schiff, Gert.
ND553.P5P477 759.4 76-40110
ISBN 0-13-675801-0
ISBN 0-13-675793-6 pbk.

1 2 3 4 5 6 7 8 9 10

PRENTICE-HALL, INTERNATIONAL, INC. (LONDON)
PRENTICE-HALL OF AUSTRALIA PTY., LTD. (SYDNEY)
PRENTICE-HALL OF CANADA, LTD. (TORONTO)
PRENTICE-HALL OF INDIA PRIVATE LIMITED (NEW DELHI)
PRENTICE-HALL OF JAPAN, INC. (TOKYO)
PRENTICE-HALL OF SOUTHEAST ASIA PTE. LTD. (SINGAPORE)
WHITEHALL BOOKS LIMITED (WELLINGTON, NEW ZEALAND)

PREFACE

Many different factors determine the form in which a book like this finally sees the light, and a lifelong passion for its subject is certainly not the least of them. What has helped me more than anything else in clarifying my ideas about Picasso were several graduate seminars about his art, taught during the last few years at New York University and Yale University, and I feel I owe a great debt of gratitude to the ever encouraging and stimulating collaboration of my students.

Those materials of my own which are included in this volume have greatly benefited from the critical reading of my friends Elliot Feingold, Werner Muensterberger, and Robert Rosenblum. Conversations with Leo Steinberg and William Rubin have also been particularly helpful. In obtaining little-known information about Max Raphael, I could always rely upon the help of his devoted followers, Professors Robert S. Cohen and Claude Schaefer, and Ilse Hirschfeld, M.D. For the translations of the texts by Fagus, Meier-Graefe, Cassou, Raynal, Einstein, Aragon, and Char, I am indebted to Mr. A. D. Simons.

Very special thanks are due to Nancy Mowll who spent many hours in libraries, tracing often obscure references, and sifting and copying piles of material. I am equally grateful to Josephine Geare who helped me in compiling the biographical data and the bibliography.

All those who gave permission for their texts to be used are gratefully acknowledged.

Finally, I would like to thank Michael Hunter and Betty Neville of Prentice-Hall for their help and encouragement in the preparation of this book.

CONTENTS

INTRODUCTION

Gert Schiff

He regards art as a product of sadness and pain—and on this we agree. He believes that sadness teaches us to meditate, that suffering lies at the root of life.

JAIME SABARTÈS

In June 1955, *Le Figaro Littéraire* published seven replies to an inquiry launched by one of its art critics on the occasion of a large Picasso retrospective at the Musée des Arts Decoratifs in Paris.[1] The question was: *How do you explain the distortions used by Picasso in depicting the female face?* In order to visualize the problem, the text was accompanied by reproductions of three paintings: the almost photographic, impeccably elegant if somewhat sweetish portrait of the artist's first wife, Olga Koklova (1918); a purely Neoclassical *Woman with Mandolin* (1925); and a most savagely distorted *Seated Woman* (1937). Here is a summary of the answers.

André Salmon, a critic and friend of Picasso's since 1904, makes a strong plea for the unity within the seeming variety of the artist's styles—"all of Picasso was already there in the Blue Period"—and for the purely pictorial character of his art. According to Salmon, even Picasso's most daring distortions are firmly rooted in the great tradition of painting by virtue of their formal perfection.

The painter André Rouveyre calls Picasso's art *parodistic* in substance, and therefore inexhaustible. But he traces its distortions back to a strange book by a forgotten critic: *La Morale des Lignes* (c. 1905) by Mécislas Goldberg. Using some of Rouveyre's own drawings as a point of departure, Goldberg developed a philosophy, or rather a physiology, of pure lines and plane surfaces, which, "in accordance with the abstract suggestions and unities whose functions they are," form strange constellations, "circle-men, and others—made in squares." [2] This was written about three years before the emergence of

[1] *Le Figaro Littéraire*, June 11 and 18, 1955.
[2] See Edward F. Fry, *Cubism* (New York and Toronto: McGraw-Hill, 1966), pp. 45–46.

Cubism, which Goldberg did not live long enough to see. By invoking his theories as the starting point, or backbone, of Picasso's deformations, Rouveyre takes a position similar to that of the artist himself, who once said: "The secret of many of my deformations—which many people do not understand—is that there is an interaction, an intereffect between the lines in a painting; one line attracts the other and at the point of maximum attraction the lines curve in towards the attracting point and form is altered." [3]

André Lhote, the official academician of Cubism, explains Picasso's deformations of the female face as an offshoot of Cubist simultaneity of points of view. He refuses to see in them more than a conjugation of front view and profile, and this to him is a purely pictorial fact.

If that is only what one would expect of Lhote, one cannot help being surprised by the statement of André Breton. One would have expected him more than anybody else to link this disturbing feature of Picasso's art to his unconscious, to barbaric ritual, or to some unexplored regions of the psychology of dreams. But no: according to Breton, the extreme variations in Picasso's interpretation of the female face neither reveal any obsessive interest on his part, nor conceal any secret intentions. He deals with woman not as a subject, but as an object, in the same way that he deals with a guitar or a lollipop: treating her as a construction in space. In transforming her image, he makes use of the most durable means of expression among all the styles of the world; but with all the mental agitation these games involve, he remains solely on the plane of plastic creation.

The Roman Catholic critic Louis Martin-Chauffier views Picasso as a complete genius, which includes the gift to mystify. But above all, he is possessed by a desperate thirst for freedom, and a consequent fear of committing himself to any routine. Therefore, he must wipe the slate clean as soon as he feels he has exhausted a particular creative possibility. After each "period," he wants to leave a desert behind him and to find himself, alone and his own master, before a new desert that he will populate with unexpected forms.

An entirely different view is that of Raymond Nacenta, author of books on the School of Paris, Gauguin, Modigliani, and Vlaminck. Hinting at Picasso's descent from a "persecuted race" (there is an ungrounded tradition that he was Jewish), Nacenta comprehends his deformations as a protest against the possibility of the atomic annihilation of all mankind, as an outcry against all the cruelties man continues to inflict upon his fellowmen.

Blaise Cendrars, the experienced traveler and the author of the

[3] Dore Ashton, *Picasso on Art, A Selection of Views* (New York: Viking, 1972), p. 24. Hereafter cited as Ashton.

Prose du Transsibérien, stands out by explaining Picasso's treatment of the female face psychologically. He understands it to be the result of an oedipal revolt against his father, the academic artist, and of other painful experiences: "I have always known Picasso unhappy with women, from his first one to his last one. . . . *C'est le peintre des malaimés.*" One might note that Cendrars is thus the only respondent who bases his explanation on the fact, implied in the question itself, that Picasso reserved his most savage modes of distortion for his treatment of women. His depiction of men, children, or animals, if stylistically analogous, is always less severe. But we may leave the matter at this point; the reader will find more speculations about this aspect of Picasso's art elsewhere in this volume.[4]

The remarkable thing about the inquiry is this. Seven individuals —painters, poets, and critics, all closely familiar with Picasso's work and some also with the man himself—are questioned about the most disturbing feature of his art. There is still nothing more shocking to the greater part of the public than the way in which Picasso distorts, disfigures, maims, and then restructures not only the female face, but the whole fabric of the female body, especially in his paintings from the late '20s until the end of World War II. If in his Cubist still lifes he transforms common objects beyond recognizability, those who are still mistaking art for realistic representation can at least be placated if they are told that what the painter portrays is not the objects themselves, but some abstract essence of their relationships. Similarly, the total elimination of visible reality in the painting of Kandinsky, Malevitch, or Mondrian can be made palatable by reference to certain philosophic ideas. But if in paintings that suggest the most palpable presence of their figural subjects, eyes are placed awry, noses changed into muzzles, cranes hollowed, whole sections of the face split apart; if the human figure undergoes all sorts of theriomorphic transformations until it resembles some low class of invertebrates—the reaction is different. Fear of dismemberment can cause repulsion as well as any religious concern with the integrity of God's own image. Enraged humanism as well as any dispassionately searching spirit demands an explanation. And yet, only two of the experts who were questioned about these unprecedented practices of Picasso's explained them with reference to the artist's personality, or to some broader human concerns. A third hinted at parody (of what?), and a fourth at occasional mystification, but even these two, along with the remaining three, insisted that Picasso's distortions were cerebral procedures, solutions of purely artistic problems. And the artist himself endorsed this view.

[4] See especially Leo Steinberg, "Who Knows the Meaning of Ugliness?", pp. 137–39 in this volume.

If this seems paradoxical, the paradox is exceeded by a much greater one. Despite the disturbing and, to some, repellent character of much of his art, Picasso has won universal acclaim. The more he assaulted the nerves of his viewers, the more his art became sacrosanct—sheltered, as it were, behind masses of noncommittal, aestheticist writing, just as its maker was sheltered behind the high walls around his princely estates, behind his wealth and his international reputation.

There is much more in Picasso's life and art, and in the history of its reception, that could be called paradoxical. He is by universal agreement the most representative artist of the century, and yet his most striking artistic explorations after Cubism—his reinvention of human anatomy, his experiments with multiple simultaneous vision, his irrational mythopoeic fantasies, his reinterpretations of works of art of the past—have been shared by no other artists. He has been widely imitated—but only on the most superficial level. He never had pupils. If, in a general way, he has affected the most varied branches of the visual arts—from book illustration to advertisement, from stage design to pottery—none of his innermost artistic concerns have been taken up and further developed by others. They were too personal. At the very latest, from the mid '30s on, his goals were different from those of his fellow artists. Throughout his later life, new artistic trends followed one another with the same turbulence as when he swam midstream; but none of them were related to his pursuits. He became a Communist, but refused to conform with the Communists' demand for an "art for the people." He was proud to add to the prestige of the party, and yet he found among Marxists his most violent critics. After the defeat of the Spanish Republic he swore to never again set foot in his home country, but toward the end of his life he honored Spain with ever more lavish artistic donations. Throughout his life, Picasso was revered and loved by poets, artists, and women; yet he has been described as the loneliest of all men.[5] He is said to have been extremely well read, even erudite; and yet this is rarely apparent in his reported sayings. He was profoundly serious about his art, but all he would say about it were witticisms, brilliant paradoxes, statements that occasionally seemed designed merely to put his listeners on a wrong track. Given Picasso's very old age and his isolation from the mainstreams of art and life, one would expect his last works to have become ever more hermetic, serious, and severe; instead they are quite often characterized by lightheartedness, irony, good humor, even ribaldry. Despite his age and isolation—Picasso's last works are by no means completely out of tune with the spirit of the period in which he died: "His very anti-heroicism (his work had become increasingly

[5] See Jean Cassou, "The Solitudes of Picasso," pp. 32–34 in this volume.

mundane since 1945), his unconcerned sexual frankness (liberated by Freud), his conviction that the sensations of youth are the most precious and should be prolonged, even his struggle against age are the predominant values of this past decade." [6]

The last great public manifestations of Picasso's creative compulsion were two exhibitions in Avignon, in 1970 and 1973. They covered his activity from January 1969 until his death; altogether, 400 paintings and about 50 drawings were shown, merely a selection from the incredible output of this nonagenarian. The works included in the first exhibition have been published in full color in a magnificent volume by Rafael Alberti;[7] for the second one, we must rely upon a catalogue with only twenty colorplates.[8] The principal difficulty in viewing these exhibitions was the richness of the material. Both times, the subjects were more or less the same: seventeenth-century cavaliers in splendid array; toreadors; painters with their models; men with cupids or genii of youth; couples embracing; families; heads of old fishermen, painters, or prophets; nudes; women's heads with birds; dwarfs, the progeny of Velázquez's jesters; and very rarely, still lifes and landscapes. More than ever did Picasso's word apply to these works: "My paintings are pages of a diary which I didn't have the time to edit." They were all painted hastily, some hardly more than diagrammatic notations of unexecuted compositions; others were unresolved experiments; a few even showed signs of formal disintegration. But all were strident in their colors and explosive in their forms. They were hung much too close to each other, so that their fields of energy overlapped. Even the wonderfully bleak walls of the Grand Chapel in the Palace of the Popes were not neutral enough a background for the continuous *furioso* of these paintings. Dazzling and dizzying, they left many spectators bewildered. Each time I attended, I found the masses of visitors in a state of agitation the likes of which one rarely encounters in contemporary art exhibitions. The bombardment of their visual nerves created in some a state of panic that expressed itself in angry criticism. Only with the distance of months, or years, can one estimate Picasso's achievement in his last works. Leafing through the reproductions, one finds oneself still haunted by the hypnotic stare of hundreds of eyes; struck by the discordant clash of a purple and an orange; shocked by a particularly trenchant

[6] Jean Sutherland Boggs, "The Last Thirty Years," in Sir Roland Penrose and Dr. John Golding, eds., *Picasso 1881–1973* (London: Paul Elek, 1973), pp. 239 ff. Hereafter cited as Boggs.

[7] Rafael Alberti, *A Year of Picasso, Paintings: 1969*, trans. Anthony Kerrigan (New York: Harry N. Abrams, 1971).

[8] *Exposition Picasso 1970–1972, 201 peintures.* Du 23 mai au 23 septembre 1973, Palais des Papes, Avignon. The essay by René Char "Picasso under the Etesian Winds" (p. 168 in this volume) is the preface to this catalogue.

disruption of the organic cohesion of face or body; then again disarmed by the idol-like nobility of a profile. One tries to order one's responses, and one realizes that there is a progression, even a sharp contrast between the works of 1969–70 and those of the following years. The former—this baroque pageant, these priapic revelries— were a last, violent outcry of the thirst and lust for life; the latter, its revocation. Some of the weather-beaten heads in the 1973 exhibition —fishermen, painters, or prophets[9]—wore expressions of weariness, of doubt and resignation; many were stamped with the sheer horror of existence. Tender feelings cropped up amid the still violent uproar of forms, especially in small pictures, mostly blue, of women and children kissed by little birds. One unforgettable oilsketch shows Picasso himself, age-old but having become a child again. Shy, as if he were bidding forgiveness for the continuance of his creative urge, and hesitant, like one who for the first time is performing a particularly high and demanding office, he raises his hand to put his first/last touches of paint on an invisible canvas.[10] Since I wrote these lines in 1973, 119 of the latest paintings have been stolen from the walls of the Papal Chapel in the course of one of the most sensational art robberies of the century. One would like to imagine behind this robbery some nabob in a remote country and, thus in fantasy, interpret it as the first manifestation of a truly loving appreciation of these pictures. But alas! The usual insurance blackmail seems a much likelier explanation. However, even if the 119 paintings were to be found within the next few months in a lonesome country barn and returned, one may still hope that such an occurrence would shake the public out of their present neglect of this, Picasso's great pictorial testament.

The difficulty in coming to terms with an exhibition of Picasso's paintings—or with any given period of his work, let alone with the whole of his *oeuvre*—lies, as I have said, in its richness, in terms of both quantity and inventiveness. It has been reported that a team of cataloguers will be kept busy for at least three years merely listing the mass of unpublished works left by the artist. It is true that with his fame increasing steadily, and with a growing industry exploiting his exertions in minor arts such as pottery, his works are being published ever more rapidly and lavishly. Hence, his output of the last twenty years is perhaps more accessible in excellent reproductions and more fully documented than much of his earlier work. Nevertheless, the latest works are still very little explored; they are also generally less liked. If the paintings are criticized for their loudness, their hasty execution, and their ensuing harsh forms, the much more numerous drawings and graphic works often fail to arouse enthusiasm for quite

[9] See Fig. 39 in this volume.
[10] See Fig. 40 in this volume.

different reasons. They are characterized by a wealth of narrative invention, quite often by a classicizing attitude, almost always by an unabashed emotionalism—qualities contrary to the prevalent aesthetics of the '60s and '70s. However, it has been the rule throughout Picasso's long career that he was always ahead of even his sympathetic critics by just one "period." This should caution us in dealing with his latest works. It has happened quite often that some of his most fervent partisans, bewildered by an unexpected turn in his development, found it necessary to call him to order with reference to the style that he had just outgrown, thus defending him against himself. Examples of this may be found in various parts of this book.[11]

In selecting the following texts, I have tried to reconcile two different aims: on one hand, to cover some of the principal aspects of Picasso's art, and on the other, to document the critical reception of his work from 1901 until 1973 in various countries and in different ideological camps. The main topics are, in sequence: beginnings, Blue, and Rose Periods; *Les Demoiselles d'Avignon*; Cubism; the Neoclassical Period; Biomorphism and Surrealism; Picasso as a creator of myths; *Guernica*; Picasso and the Marxists; Picasso psychoanalyzed; the "ugly" paintings; the *Human Comedy* drawings, or Picasso's art as autobiography; and the variations and other works of the last years. Due to the limitations of this small selection, four major fields of Picasso's activity are hardly touched upon: his sculpture, his ceramics, his book illustrations, and his work for the stage, all subjects of major, well-documented monographs.[12] In general, I have given preference not to well-known standard works on Picasso, but rather to little-known articles in periodicals, many of which are long defunct. Although one of my objectives is to document the American response to Picasso from the earliest to the most recent testimonies, I have included several foreign contributors whose essays in this volume have never been translated into English and, thus, remain virtually unknown in this country. The texts vary from purely ephemeral voices and obvious misinterpretations to solid research that has either stood the test of time or represents the state of our most recent knowledge. In few cases, conflicting opinions appear side by side—sometimes in order to denote a historical error and its correction, sometimes in order to show that one and the same work or body of works may bear different but equally valid interpretations.

[11] See especially Waldemar George, "Picasso and the Present Crisis of Artistic Conscience," p. 68 in this volume.

[12] Daniel-Henry Kahnweiler, *The Sculpture of Picasso*, trans. A. D. B. Sylvester (London: Rodney Phillips, 1949); Roland Penrose, *The Sculpture of Picasso* (New York: The Museum of Modern Art, 1967); Douglas Cooper, *Picasso Theatre* (New York: Harry N. Abrams, 1968); Daniel-Henry Kahnweiler, *Picasso: Keramik. Ceramic. Céramiques.* (Hanover: Schmidt-Küster, 1957); Abraham Horodisch, *Picasso as a Book Artist*, trans. I. Grafe (Cleveland: World Pub. Co., 1962).

The outcome of my study was what I assume will be the outcome of reading this book: the conclusion that the evaluation of Picasso's achievement is still in its beginning, much research needs to be done, deep-rooted conceptions about his art need to be reconsidered. In a word, he remains as mercurial and elusive now as during his lifetime.

Take his beginnings. In 1970, to honor the memory of his great friend Jaime Sabartès, Picasso gave to the city of Barcelona all the works of his youth since the age of nine, treasures that until then had been hidden in his family's house. This gives us a unique opportunity to study the birth of his genius. Yet his relations with the very active artistic and political "counter-culture" of Barcelona—an ambience where anarchism and aestheticism could cohabit not only in one and the same group, but even in one and the same individual—need much more study, and much more of the autobiographical elements in Picasso's early works must be brought to light[13] before it can be determined whether the Blue Period (see Fig. 3) was really "a sentimental idealization of poverty as a Franciscan virtue." [14]

The influence of African and Oceanic art on the works immediately preceding Cubism is a much debated question, especially since Pierre Daix, backed with the authority of Picasso himself, attempted to disclaim it altogether until 1910, and to explain the "Negroid" features in *Les Demoiselles d'Avignon* (Fig. 6) entirely on the basis of the immanent dynamism of Picasso's formal development.[15] However, this is clearly contradicted by the historical and visual evidence advanced by Edward Fry[16] and especially John Golding;[17] Robert Goldwater's analysis, which explains the appeal African sculpture had for Picasso— the "relative permanence of the states of feeling which it renders"—is still the most valid answer to this question.[18] In other respects, the *Demoiselles d'Avignon* still contains many unresolved problems. Research on this picture, which André Salmon in 1912 called "white equations on a blackboard . . ." "the first appearance of painting as algebra," [19] has too long been dominated by questions concerning its

[13] As in Theodore Reff, "Themes of Love and Death in Picasso's Early Work," in Penrose and Golding, eds., *op. cit.*, pp. 11–17.

[14] Max Raphael, "Picasso in the Light of a Marxist Sociology of Art," pp. 106–16 in this volume.

[15] Pierre Daix, "Il n'y a pas 'd'art negre' dans les *Demoiselles d'Avignon*," *Gazette des Beaux-Arts* (Paris), series 6, vol. 76 (October 1970), 247–70. See p. 46 in this volume.

[16] "A Note on the Discovery of African Sculpture," in Edward F. Fry, *op. cit.*, pp. 47–48.

[17] John Golding, "*Les Demoiselles d'Avignon*," *The Burlington Magazine*, C 145 (May 1958), 155–63; and *Cubism. A History and Analysis 1907–1914* (New York and London: Harper & Row, Icon Editions, 1968), pp. 47–62.

[18] See Robert Goldwater, "Intellectual Primitivism," pp. 35–45 in this volume.

[19] André Salmon, *La jeune peinture française* (Paris: Société des Trente, 1912), p. 43.

sources and its style. Only recently has the question of its content been attacked, and its stylistic discrepancies begun to be understood as an expression of those intertwined motives of moral conflict and sexual tension that constitute its meaning.[20]

The scholarly investigation of Cubism (Figs. 7–9) is still at its midpoint. The recognition "that it has been falsely interpreted as an intuition of the changing concept of the physical world as a result of Quantum physics and should be seen instead as a summing up of the Newtonian approach to the universe" [21] is only gradually gaining ground. Too long has a true understanding of the style been impeded by the writings of Picasso's own friends such as Salmon, Raynal, and Reverdy, who instead of starting with what was actually to be seen on the Cubist canvases, sought to define the nature of the new style by referring to philosophic concepts.[22] The article in this volume by Maurice Raynal—who, as late as 1921, attempts with a great deal of intellectual effort to prove that Cubism was something diametrically opposed to Impressionism, that Picasso sought to endue the objects "with the essence of their eternal form"—represents this tendency.[23] How refreshing in contrast is Marius De Zayas's introduction to the first American Picasso exhibition in 1911.[24] His warning that one should not "look for the factors that entered into the composition of the final result" anticipates Picasso's own admission that all the forms in an Analytical Cubist painting could not be rationalized; hence, his definition of its pictorial reality through the metaphor of a perfume.[25] Our understanding of the pictorial structure of Picasso's Cubist paintings has been greatly advanced by the writings of Robert Rosenblum[26] and, more recently, William Rubin.[27] What is still lacking

[20] See in particular Leo Steinberg, "The Philosophical Brothel," *Art News*, 71, no. 5 (September 1972), 20–29, and 71, no. 6 (October 1972), 38–47.

[21] Boggs, p. 239.

[22] See Leo Steinberg, "What about Cubism?", p. 63 in this volume.

[23] See Maurice Raynal, "Picasso and Impressionism," p. 56 in this volume.

[24] See Marius De Zayas, "Pablo Picasso," p. 47 in this volume. Cp. also the contribution by Andrew Dasburg, p. 61 in this volume.

[25] Picasso told William Rubin: "At the time, everyone talked about how much reality there was in Cubism. But they didn't really understand. It's not a reality you can take in your hand. It's more like a perfume—in front of you, behind you, to the sides. The scent is everywhere, but you don't quite know where it comes from." Rubin adds that this definition "seems particularly appropriate to some of the spectral forms of the pictures from the winter of 1911–12. Picasso would not have used such an image for the more tactile Cubism of 1908–10." William Rubin, *Picasso in the Collection of The Museum of Modern Art* (New York: The Museum of Modern Art, 1972), p. 72 and p. 206, n. 3.

[26] Robert Rosenblum, *Cubism and Twentieth-Century Art*, rev. ed. (New York: Harry N. Abrams, 1966).

[27] See n. 25.

is a detailed comparison and differentiation of the styles of Picasso and Braque during the years of their closest collaboration.

Today, attention is focused on the iconography of Cubism. We begin to realize that the allegedly "neutral" subject matter of Cubist still lifes—the glasses, bottles, mandolins, numbers, and fragments of script—are vehicles of sometimes highly personal symbolism. It was Rosenblum who detected a wealth of references in those newspaper clippings, calling cards, cigarette-paper packets, advertisements, and bottle labels that Picasso and the other Cubists pasted onto their canvases.[28] In his famous article on Picasso's collages, Apollinaire offers similar clues, extracted from his personal intimacy with Picasso and from his own poetic intuition.[29] Those small fragments of everyday reality—the pieces of cardboard, wallpaper, oilcloth, and tin that the Cubists included in their compositions seem to have inexhaustible implications. To Aragon these prefabricated elements seemed at one point to herald the end of painting and its replacement by manufactured objects.[30] Of Picasso's two most penetrating Marxist critics, John Berger hailed this "débris" as the overthrow of the "whole bourgeois concept of art as something precious, valuable and to be prized like jewelry";[31] and Max Raphael condemned this inclusion of "real" things as a naive misunderstanding of materialism.[32] But this confuses the issues. As part of the painting, these fragments from everyday life are principally equivalent to the forms produced by paint or crayon; hence, they may be seen as "valeurs," except that they are imbued with a particularly strong suggestion of reality. The whole ideological confusion concerning Picasso's collages and assemblages explodes in the angry sentences of Wyndham Lewis's outburst of 1914.[33]

Among the few writings about Picasso's Neoclassical Period, I found that Waldemar George's early appraisal of the *"baigneuses, déesses* and *symboles de fleuves,"* which Picasso painted between 1919 and 1924 (Fig. 10), deserved to be saved from oblivion[34] because of his vivid report of the incomprehension with which these works were received by Picasso's doctrinaire, abstractionist followers, his intuition

[28] Robert Rosenblum, "Picasso and the Typography of Cubism," pp. 49–75 in Penrose and Golding, eds., *op. cit.*

[29] Guillaume Apollinaire, "Picasso and the 'papiers collés,'" pp. 50–52 in this volume.

[30] Louis Aragon, "La peinture au défi" (introduction to an exhibition of collages at the Galerie Goemans) (Paris: Corti, 1930).

[31] John Berger, *The Success and Failure of Picasso* (Baltimore: Penguin, 1966), p. 57. Hereafter cited as Berger.

[32] Max Raphael, "Picasso in the Light of a Marxist Sociology of Art," p. 106 in this volume.

[33] Wyndham Lewis, "Relativism and Picasso's Latest Work," p. 53 in this volume.

[34] See n. 11.

of the deeper unity underlying Picasso's various styles, and his recognition of the creative potential of the Neoclassical idiom. Shortly after this article was written, George's insight was verified by the unparalleled linear grace and ideal beauty of the etchings known as the *Suite Vollard.*

Carl Einstein's analysis of Picasso's paintings from Dinard reveals this critic's divinatory gift.[35] Reading this text in 1974 and beyond, one must take into account that these pictures were among Picasso's most radical departures from the canon of the human form, and from all accepted canons of beauty and "good sense"; to connect them immediately with "the earliest of languages, that of collective symbols," and to recognize in them the archetypal images of "the stake, the skull, the house and the womb," was a bold and imaginative interpretation indeed. Einstein's sentence, "He demonstrates that Mankind and the world are daily invented by Man himself," appears to me the best definition of the human importance of Picasso's art that has ever been proposed.

In the late '20s, partly as a result of the emotional pressure caused by his marital problems, Picasso became, in the words of René Char, "a sinker of wells in the interior of the human body from which he drew its uncertainties and its pulsations." [36] "The image of female sexuality as a monstrous threat" and as a vegetative blessing has been brilliantly described by Rosenblum in his study, "Picasso and the Anatomy of Eroticism." [37] What psychoanalysis can contribute to the understanding of these erotic works may be seen in the article by Frederick Wight, "Picasso and the Unconscious." [38] These same works can be even more fully evaluated in light of modern research on the Body Image, that is, "the individual's subjective experiences with his body and the manner in which he organized these experiences." [39] The image we hold of our own body varies a great deal, especially under conditions such as pain, fear, sexual excitement, sexual union, dance, intoxication, sleep, pregnancy, and so forth. It would be very rewarding to determine whether some of the deformations in Picasso's depictions of figures in such states could be related to changes in the body image that have been ascertained scientifically. Much that seems arbitrary in Picasso's form might thus reveal its biological validity.

At the end of his article, Rosenblum compares the "constantly

[35] Carl Einstein, "The Dinard Period," p. 71 in this volume.

[36] René Char, "Picasso under the Etesian Winds," p. 168 in this volume.

[37] P. 75 in this volume.

[38] P. 130 in this volume.

[39] Sidney E. Cleveland and Seymour Fisher, *Body Image and Personality*, 2nd rev. ed. (New York: Dover, 1968), p. x. The validity of this approach has been brought to my attention by one of my students, Mr. Charles Katz.

fluid evocations of human and biological archetypes" in Picasso's *Girl before a Mirror* (Fig. 18) with the literary technique of James Joyce's *Finnegans Wake*. We can enlarge upon this, for Joyce's book contains a scene in which every detail parallels this, one of Picasso's greatest paintings, and Rosenblum's analysis of it. One of the characters in *Finnegans Wake* is Issy, a nymphet. She has been described as "a perfect triumph of female imbecility . . . the embodiment of young female sexuality . . . at once below and above civilization . . . the bewildering tempting diversity that leads man to his fall." [40] Toward the end of the book we find her engaged in an amorous mono-dialogue with her "sister-reflection" in the mirror. "Could I but pass my hands some, my hands through, thine hair," she addresses her mirror image; compare the gesture Picasso's girl describes with her right hand! Rosenblum explains the difference in the shapes of the girl and her reflection in terms of the contrast between virginity and consummation; he finds that "the anatomies of both the girl and the mirror image that she embraces and contemplates evoke their male counteparts." Correspondingly, Issy imagines her future in love, marriage, and wedlock, and her mirror-reflection transforms itself into her imagined lover—"May I introduce! This is my futuous, lips and looks lovelast." So far does the amorous identification go that the passage closes with the question: "Is she having an act in apparition with herself?" [41]

The multiple identities of Joycean heroes and the plurality of action in his novels, which unfolds on several levels simultaneously, have been compared, also by Rosenblum, with Picasso's Cubist *simultané*.[42] There are more similarities between the artistic personalities of Picasso and Joyce. Both were exiles who carried their home countries about themselves constantly, wherever they went. Both shared a profound respect for basic facts of life such as love, death, and children and family, and a delight in simple pleasures, even vulgar entertainment. Both comprehended life as thoroughly sexualized. Both were deeply interested in myths, and thought of myth as a living force that permeates life as it shapes our understanding of it. Both enjoyed all forms of masquerade or travesty, and on the artistic plane, both skillfully assimilated the most varied styles, past and present, or parodied them. Metamorphosis was an integral part of the artistic techniques of both. Joyce as well as Picasso started always from something familiar and simple, and distilled the most fantastic formal structures from the most common experiences. Both were great humorists, but their humor was rooted in deeply melancholy dispositions.

[40] Adaline Glasheen, *A Census of Finnegans Wake* (London: Faber & Faber, 1956), p. 61.

[41] James Joyce, *Finnegans Wake* (London: Faber & Faber, 1939), pp. 527–28.

[42] Robert Rosenblum, *Cubism and Twentieth-Century Art*, pp. 57, 62, 101.

 "Picasso and the Anatomy of Eroticism" touches upon the artist's relation to Surrealism, which in the present volume is further documented by the contributions of Bell and Soby. It is clearly and, I think, on the whole accurately defined in the various writings on Picasso by André Breton. In *Surrealism and Painting* (1928) he "claim[ed] him unhesitatingly as one of us," even if he deferentially added: "I shall always oppose the absurdly restrictive sense that any label ([footnote:] Even the 'surrealist' label) would inevitably impose on the activity of this man. . . .)" In his beautiful essay "Picasso in his Element" (1933) Breton writes profusely about Picasso's feeling for the magic and mystery of common things. In an assessment of the significance of Picasso's art that is remarkably similar to Einstein's, Breton says: "It seems to me that the most important aspect of his work is its unique ability to suggest the power man has within himself to bring his influence to bear on the world in order to refashion it in his own image. . . ." But in a statement made in 1961, Breton limits Picasso's truly Surrealist production to "part of his output during 1923 and 1924, a number of works he produced from 1928 to 1930, the metallic constructions of 1933, the semi-automatic poems of 1935 and, more recently, his 1943 play *Desire Caught by the Tail*." Breton says that at various points in his career Picasso "moved voluntarily in the direction of Surrealism"; but his "indefectible allegiance to the external world (of the object) and [his] blindness to the oneiric and imaginative level" kept him forever separated from the Surrealists.[43] This analysis is perceptive. Picasso stressed many times that his point of departure was always from something seen and real, and that he did not believe in the possibility of unconscious creation. This is also corroborated by Clive Bell's analysis of Picasso's "Surrealist" poetry.[44] On the other hand, it was precisely because Picasso's distortions of the female face had their roots in visual experience that Breton refused to see in them anything other than formal exercises.
 Picasso once said: "If all the ways I have been along were marked on a map and joined up with a line, it might represent a minotaur."[45] (Fig. 19) This monster, often quite sensitive in Picasso's interpretation, haunted the artist's mythopoeic fantasy. In the etchings of the *Suite Vollard*, we see him banqueting with women in a sculptor's studio, then ritualistically put to death by a youth in an arena. He is the hero of the enigmatic *Minotauromachy* (Fig. 23), of which this volume includes several interpretations. Both Melville and Ries[46] (and also

[43] André Breton, *Surrealism and Painting*, trans. Simon Watson Taylor (New York and London: Harper & Row, Icon Editions, 1972), pp. 7, 105, 117. For a detailed analysis of Picasso's Surrealist phase, see William S. Rubin, *Dada and Surrealist Art* (New York: Harry N. Abrams, 1968), pp. 279–301, 309.

[44] P. 86 in this volume.

[45] Ashton, p. 159.

[46] Robert Melville, "Picasso in the Light of Chirico—Mutations of the Bullfight," p. 90

Blunt[47]) consider him the incarnation of evil, and the female toreador the victim of his cruelty. Yet in regard to the meaning of his works, Picasso used to say: "Rien n'est exclu—Nothing is excluded." [48] This gives me the license to propose an entirely different reading of the strange scene. All interpretations seem to agree that a corrida-like fight, in which the minotaur was victorious and the girl was defeated, has preceded the situation portrayed. Much attention has been paid to the gesture of the monster. Leiris says he "stretches his arm out as if to thrust aside an obstacle, or, perhaps, to tear the veil from some ineffable mystery."[49] Blunt thinks he shields himself from the taper that symbolizes the light of truth; hence, he understands the meaning of the scene as "the checking of violence and evil by truth and innocence." But could not the gesture be meant rather to assuage hurt feelings, to dispel fear? And does not the fact that the victor and the defeated arrive together suggest that the minotaur really does not bear any harmful intentions? He has defeated his challenger, but now he proves the supreme mercy of the strong by guiding her home to her people.

But it may be wiser to abstain from such literal or allegorical interpretations of Picasso's works. How pernicious a narrowly rational approach can be to the evaluation of one of his masterpieces is shown by the one piece I included just *because* of its total inadequacy and its untenable point of view, Vernon Clark's paper on *Guernica* (Fig. 22). This writer surprises us, first, by this incredible assumption: "The artist has apparently set a limit upon his feelings and upon the intensity of his expression beyond which he has arbitrarily forbidden himself to go [!]" In speaking further in regard to *Guernica* (and, by implication, any figural work of Picasso's), of a "controlled range of sensations," and of "muted and controlled emotion," Mr. Clark is unique indeed. He feels that *Guernica*, this flaming indictment of war and destruction, fails to live up to its subject because of its coolness (the "neutral" grays) and because of the mistake of using "such archaic symbols as classical profiles, swords, oil lamps, etc. to express the social struggle as we know it today." [50]

Now, the one page in which Herbert Read asserts this painting to

in this volume; Martin Ries, "Picasso and the Myth of the Minotaur," p. 96 in this volume.

[47] Anthony Blunt, *Picasso's Guernica* (New York and Toronto: Oxford University Press, 1969), pp. 24–25.

[48] Quoted by Leo Steinberg, *Other Criteria, Confrontations with Twentieth-Century Art* (New York: Oxford University Press, 1972), p. 148.

[49] Michel Leiris, "Picasso and the *Human Comedy*, or The Avatars of Fat-Foot," p. 140 in this volume.

[50] Vernon Clark, "The *Guernica* Mural—Picasso and Social Protest," p. 97 in this volume.

be the most comprehensive symbol of the age suffices to dismiss this kind of criticism.[51] However, the objection that Picasso "alludes to the remote and the romantic" instead of expressing "the social struggle as we know it today" occurs also in the writings of the more sophisticated Marxist critics. In his thought-provoking and intense study "The Success and Failure of Picasso," John Berger contrasts *Guernica* with a painting by Siqueiros in which "we see the materials which make modern wars possible."[52] Berger also suggests that if Picasso had "visited India, Indonesia, China, Mexico or West Africa, . . . he would have found his work [and] become the artist of the emerging world. . . ."[53] There is much to be learned from Berger's evaluation of Picasso's Cubist period, and from his insistence upon Picasso's "preoccupation with physical sensations so strong and deep that they destroy all objectivity and reassemble reality as a complement to pain or pleasure."[54] But all Berger's speculations on Picasso the "infant prodigy" and on the allegedly fatal influence of his early virtuosity on his development as a man and as an artist read like ill-applied psychoanalysis. Furthermore, Berger is totally incapable of seeing anything positive in Picasso's work after 1944, and his ultimate conclusion—that because of his uprootedness, Picasso had run out of subjects and no longer knew what to paint—is contradicted, if by nothing else, by that incredible outpouring of iconographic invention, the *Suite 347*, created three years after the publication of Berger's book.[55] And if Berger faults Picasso for too rarely painting subjects of immediate social and political importance, he simply does not meet the artist on his own grounds. Picasso said in 1932: "As far as I am concerned, I'll continue to be aesthetic, or, if you prefer, purely cerebral. I'll continue making art without preoccupying myself with the question of its influence, or if it 'humanizes' our life, as you put it. If it contains a truth, my work will be useful without my express wish. If it doesn't hold a truth, so much the worse. I will have lost my time. But I will never make art with the preconceived idea of serving the interests of the political, religious or military art of a country. I will never fit in with the followers of the prophets of Nietzsche's superman."[56] This remained the rule with Picasso, paintings such as *Guernica*, *The Charnel House*, and *Massacre in Korea* excepted.

[51] Herbert Read, "Picasso's *Guernica*," pp. 104–5 in this volume.

[52] Berger, p. 167 and pl. 97.

[53] Berger, pp. 178–79.

[54] Berger, p. 104.

[55] See Gert Schiff, "Picasso's *Suite 347*, or Painting as an Act of Love," p. 163 in this volume. Cp. also Leo Steinberg, "A Working Equation or—Picasso in the Homestretch," *Print Collector's Newsletter*, 3 (February–March 1973), pp. 102–5.

[56] Ashton, p. 148.

Needless to say, this does not mean that he was cynically detached from political or humanitarian issues. Picasso's moral attitude during the Spanish Civil War, the German occupation of France, and the uprising in Hungary is too well known to be repeated here; and he continued until his death to be concerned with the problems of the oppressed, regardless of their country—witness his efforts on behalf of the Greek freedom fighter Beloyannis.[57]

Berger dedicated his book, among others, "to the memory of Max Raphael, a forgotten but great critic." The reader who wishes to learn about Raphael is referred to Herbert Read's well-documented essay on the life and works of this extraordinary scholar which forms the introduction to Raphael's posthumously published book *The Demands of Art*.[58] Raphael met Picasso in 1911 and kept in touch with him until 1913, the year when he published his first book, *Von Monet zu Picasso*, which contains an excellent analysis of Picasso's Cubism. When, around 1930, Raphael founded his theory of art on Marxism, Picasso became to him the prototype of the "bourgeois artist." He analyzed him as such in his book *Proudhon, Marx, Picasso: trois études sur la sociologie de l'art*, from which some excerpts are included in this volume. Even if one accepts neither Raphael's position nor his increasingly negative judgment of Picasso's art, one cannot help admiring the conclusiveness and high seriousness of his deductions. Profound insights—for instance, the one concerning the influence of primitive art on Picasso and on Western art in general—occur in many places, and the whole is permeated, it seems to me, by a suppressed love and admiration for Picasso's art. It should also be noted that only one year before the publication of this book, Raphael wrote a vivid account of his personal acquaintance with the artist,[59] at the end of which he called him "the strongest artistic potence of our time." He also rose immediately to Picasso's defense when C. G. Jung denounced Picasso and his art as "schizophrenic." [60]

However, since Raphael views Picasso as the exponent of the disintegrating bourgeoisie, he considers him a torn personality and consequently finds "splits," or lack of integration, everywhere in his art. He remarks about the 1923 painting *Three Women on the Beach* (Fig. 24) "that the figures are not connected in space through some

[57] Ashton, p. 150.

[58] Max Raphael, *The Demands of Art*, with an Appendix, "Toward an Empirical Theory of Art," trans. Norbert Guterman (Princeton, N.J.: published for the Bollingen Foundation by Princeton University Press, 1968). This book contains a hostile but serious discussion of *Guernica*: "Discord between Form and Content."

[59] Max Raphael, "Erinnerungen um Picasso," *Davoser Zeitung*, 3 (September 3, 1932).

[60] Max Raphael, "C. G. Jung vergreift sich an Picasso," *Information* (Zurich), 6 (December 1932).

overall plane." But this is demonstrably wrong. The running figure is foreshortened in accordance with the distance she is about to traverse: partial diminution in relation to depth. The reclining figure has a disproportionately large left foot: partial aggrandizement in relation to width. The standing figure has a disproportionately long leg: partial aggrandizement in relation to height. And the whole painting is a joke.

Once more it is Herbert Read who, writing in 1934 and calling himself a socialist, dismisses in a few words all criticism of Picasso's art that is based on doctrinaire Marxist ideology.[61]

A series of 180 drawings that Picasso made in the winter of 1953–54 has been called the *Human Comedy*, the title Michel Leiris gave to his moving interpretive essay on these works (Figs. 27–31).[62] Leiris, like Penrose[63] and other writers, interprets these drawings as what they are, the objectification of a shattering personal experience, the end of Picasso's liaison with Françoise Gilot. Aragon instead used all his eloquence in an attempt to convince the public that these drawings, the most poignant of all the many representations of ill-assorted couples, had no autobiographic content at all, that Picasso was perfectly happy, and that the whole series was nothing else than a satire against abstract art.[64] Berger, who becomes increasingly vitriolic in the last pages of his book terms the situation between the old painters and their beautiful young models "obscene," and concludes that what Picasso expresses here "is the despair of the idealized 'noble savage' who, alone, abstracted from history and insulated from any social reality, is forced back and back until finally he is left with all his imagination unaccounted for by the pure nature which he must worship." [65] What is surprising is that both the gallant Aragon and the aggressive Berger, two writers of a materialistic persuasion, thus seem to presuppose that the man of genius should be exempted from the laws of nature, from the vicissitudes of old age and the ravages of passion.

A large and very conspicuous section of Picasso's later work comprises the variations, or paraphrases, of great works of art of the past. Ever since the anxiety, excitement, and, finally, euphoria of the

[61] See Herbert Read, *Picasso and the Marxists*, p. 127 in this volume.

[62] See n. 49.

[63] Roland Penrose, *Picasso: His Life and Work*, 2nd ed. (New York: Schocken, 1962), pp. 344–46. Hereafter cited as Penrose.

[64] Louis Aragon, *La Verve de Picasso*, a series of articles published in *Les Lettres Françaises*, November 18–December 16, 1954. The excerpts on p. 151 of this volume do not include Aragon's polemic against the autobiographical interpretation of these drawings, but only his descriptive analysis.

[65] Berger, p. 202.

liberation of Paris in August 1944 induced him to paint a highly personal version of Poussin's *Triumph of Pan*, Picasso maintained his dialogue with those masters he revered. In 1949 he paraphrased in four lithographs Lucas Cranach's *David and Bathsheba*. Early in 1950, he transposed two works as different as Courbet's *Demoiselles des bords de la Seine* and El Greco's *Portrait of a Painter* into a highly complex idiom of his own. Between December 1954 and February 1955 he painted fifteen variations on Delacroix's *Algerian Women*. These were followed by forty-four variations on Velázquez's *Las Meninas* (Figs. 37–38), done in a state of the highest creative tension between early August and the end of 1957. Manet's *Déjeuner sur l'Herbe* caught Picasso's imagination in August 1959, and did not cease to haunt him until 1962; the outcome was about 150 drawings and 27 paintings, plus a few occasional paraphrases of Manet's *Old Musician*. During the winter of 1962–63 several large canvases based on David's *Sabines* were painted.[66] Almost inevitably, Ingres followed, next to Cézanne perhaps the most decisive influence on Picasso throughout his career. A few pencil drawings (January 1968) paraphrased his *Turkish Bath*;[67] these were developed further in some of the finest etchings of the *Suite 347*—the same suite that climaxed in a series of twenty variations on another painting by Ingres, *Raphael and La Fornarina* (Fig. 36).[68] Picasso's last graphic works, the 165 etchings done between 1970 and 1973, also include variations—or at least compositions that are based upon one of Degas's rare monotypes of scenes in a brothel, owned by Picasso himself. These are only the most notable examples of his creative appropriation of works by older masters. One might also mention some transformations of Rembrandt's *Bathsheba*, done in 1960.[69] Minor "borrowings" may even have occurred much earlier. Picasso, who confessedly liked all painting, and always looked at the paintings—good or bad—in barbershops, furniture stores, or provincial hotels,[70] could transform even a sentimental and insignificant model, such as Léon Bonnat's *First Steps*, into a characteristic work of his own.[71]

[66] For this whole body of works see Klaus Gallwitz, *Picasso at 90, The Later Work* (New York: G.D. Putnam's Sons, 1971), Chapter "The Absorption of the Old Masters," pp. 113–150; hereafter cited as Gallwitz. Cp. also Boggs, pp. 197, 198, 214–31.

[67] René Char and Charles Feld, *Picasso, Dessins 27.3.66–15.3.68* (Paris: Editions Cercle d'Art, 1969), pls. 344–57, 367–71.

[68] *Picasso 347* (New York: Random House, Maecenas Press, 1971), nos. 289, 290, 296–315.

[69] Gallwitz, pl. 150; cp. also Boggs, pl. 378.

[70] Ashton, p. 55.

[71] Berger, pl. 84.

No doubt, these variations were of vital importance to Picasso and must be of equal significance to anyone concerned with his art. Artists of all ages have made creative use of the works of their predecessors, but in entirely different ways. They have copied them for the purpose of study, or borrowed from them individual motifs or even whole compositional patterns. Van Gogh's copies of works by Rembrandt, Doré, or Millet are similar to Picasso's variations insofar as they are deliberate transpositions of the original's into the copyist's personal style. On the other hand, Roy Lichtenstein's reinterpretations of paintings by Picasso, Mondrian, or Monet (the *Rouen Cathedral* series!) are not variations like Picasso's, for, leaving the linear and planar compositions of his models unchanged, he only replaces their free brushwork by a quasi-mechanical style of reproduction. In fact, no one except Picasso ever used another artist's work as a musician uses another composer's theme, submitting it to a *series* of transformations. And no composer has dissected, distorted, and restructured the foreign material to such an extent and with such an obsessive fury as Picasso did with his models. His variations are perhaps the most bewildering among all his innovations.

As one would expect, Picasso never really explained the reasons for this absorbing concern of his later years. Once he declared himself jokingly a collector who created his collection by painting other people's pictures that he admired.[72] While working on the *Algerian Women*, he said to Kahnweiler: "I wonder what Delacroix would say if he saw these paintings." Assured that he would probably understand, Picasso continued: "Yes, I think so. I'll tell him: You, you thought of Rubens and you made Delacroix. And I, thinking of you, I'm making something else." [73]

In searching for an explanation, most writers refer to the well-known incident in 1946 when Picasso took some of his paintings to the Louvre and inspected them, side by side, with the works of David, Goya, Velázquez, and Zurbaran, in order to determine whether they stood the test.[74] Hence, it is generally assumed that in recreating the work of an earlier master his objective was to "test his powers." And his choice of the "themes" for his variations is usually explained by their adaptability to specific pictorial problems of his own: that is, the treatment of space and the attitudes of the figures in the older work could serve as a starting point for the further elaboration of some of his own spatial and compositional techniques. It has also been observed that Picasso usually chooses works whose subjects had a kinship to his own iconographic themes. Thus, Michel Leiris linked

[72] Gallwitz, p. 114.
[73] Ashton, p. 168.
[74] Penrose, p. 350.

Picasso's three great series of variations to his favorite subject of all, *The Painter and his Model: "Les Femmes d'Alger* (which can, after all, be considered as a group of models posing for Orientalist painters), *Le Déjeuner sur l'Herbe* (an artist's spree away from the studio) and *Las Meninas* (Velázquez in the midst of his royal models)." [75]

The first comprehensive analysis of one of these series is Douglas Cooper's essay on *Les Déjeuners*. Retracing the creative process through all its stages, Cooper shows how the subject was gradually transformed from a country outing into a *Baignade*, a nocturnal excursion, and a classicist idyl: "Manet's *Déjeuner sur l'Herbe* provided Picasso with an opportunity to recapitulate, on a grand scale, some of his recurrent themes . . . the artist and his model, bathers on the beach, the female monster, man's naturally peaceful inclinations, and his delight in simple pleasures, the fallibility of human reason, and the deceptive nature of what passes for reality. Secondly, Picasso saw in the *Déjeuners* a means to enhance the connotation of certain figures he has created [as, for example, a girl bending forward while washing herself] by bringing them together to create the various episodes of this pictorial transformation scene. Thirdly, . . . Picasso found an outlet through the ensemble of the *Déjeuners* to take up not so much the individual challenge of Manet as that of the whole French School from Poussin till today." [76]

Leo Steinberg used his analysis of the variations on *The Algerian Women* as a starting point for his study "Picasso at Large." [77] He concluded that in this series Picasso succeeded, above all, in solving a problem that had haunted him since 1907: to combine, in one single consistent shape, both front and rear views of a figure (here a sleeping nude) or to "try to symbolize or insinuate corporeality through an intelligible coincidence of front and back." This is an observation of far-reaching consequences, revealing as it does the logic inherent in many of Picasso's most baffling post-Cubist deformations of the human face and figure.

However, both Cooper and Steinberg tend to analyze these two cycles of variations almost always with reference to Picasso's own work, and hardly ever with reference to the works that are paraphrased. Such a procedure, despite its illuminating results, leaves us in doubt. Are we really to believe that *The Algerian Women, Les Demoiselles des bords de la Seine*, El Greco's *Painter*, and David's *Sabines, Las Meninas*, and *Le Déjeuner sur l'Herbe* were no more than

[75] Michel Leiris, *"The Artist and His Model,"* in Penrose and Golding, eds., *op. cit.*, p. 256.

[76] Douglas Cooper, *Picasso*, Les Déjeuners (New York: Harry N. Abrams, 1963), p. 34.

[77] Leo Steinberg, *"The Algerian Women* and Picasso at Large," in *Other Criteria* (see n. 48). The excerpts on pp. 63 and 137 in this volume are from this essay.

stimulants or catalysts for Picasso? And can we come to a true understanding of the variations as a whole without taking into account the interaction between theme and variation? Should we not in every instance try to define the expressive character of the transformation and its meaning? The aesthetic pleasure that we derive from listening to a series of musical variations consists to a great extent just in our recognition of the continual presence of the theme, even in its most radical permutations. Or, to return to the visual arts, when the greatest apologist of eclecticism, Sir Joshua Reynolds, painted English noblemen in the attitude of the Apollo Belvedere, or Dido on the funeral pyre in the attitude of Giulio Romano's Psyche asleep, did he not presuppose that the sophisticated viewer would recognize the borrowing and appreciate the ingenious use made of such disparate models?

The inference seems inevitable: Picasso, with his keen understanding of the nature of all styles, must have equally presupposed that an ideal viewer would base his apperception of his variations upon comparison with their "themes." He who so often juxtaposed representational and abstract styles in one and the same picture must have wanted us to experience the extreme distance between style and mood in the works of Delacroix, Velázquez, and Manet, and his own re-creations of these works.

But as soon as we accept this view, new questions arise. What are we to do with the "irreverent," caricatural, and parodistic aspects of the variations? In some of Picasso's *Algerian Women*, Delacroix's langorous Orientals are transformed into mere diagrams; in others, into funny comic-strip characters. In the *Las Meninas* cycle,[78] the sweet little infanta and her delicate companions are subjected to the most rigorous trial of distortion; they emerge with their eyes, mouths, and nostrils displaced and their faces crossed by heavy lines that have no relation to anatomical structure; or he treats them in the manner of children's drawings. And the chamber in the Royal Palace in Madrid resembles a mirror-cabinet in a Chinese fair, as seen in a psychedelic dream (Fig. 38). The nude in Manet's *Déjeuner* becomes in some of Picasso's variations a mere lump of flesh, with squabby excrescences supporting a tiny, dislocated head; her interlocutor is transformed into a professorial ghost.

What was Picasso doing? Was he rebelling against the burden of the past, against a conception of beauty and an idealistic aesthetic that although valid no more, were still being perpetuated? But he continued to create, until the end of his life, works in a truly classical spirit; he once admitted that, basically, he had always loved classical beauty.[79] Was he driven toward re-creating the art of the past because

[78] Picasso, *Variations on Velázquez' Painting* The Maids of Honor *and other Recent Works*, with a personal reflection by Jaime Sabartès (New York: Harry N. Abrams, 1959).

[79] Ashton, p. 74.

the present did not provide him with significant subject matter? [80] Except in his early twenties, Picasso was never a "chronicler of his times." His subject matter was timeless, hence inexhaustible. Was he questioning art itself, or at least that over-reverent attitude that makes a sacrament of art? Perhaps a little of the latter; but certainly not the former, which is clearly contradicted by his own lifelong struggle with the most arcane, and for the most part entirely self-created, problems of painting. While at work at the *Las Meninas* series, Picasso was often close to despair. Did he treat the particular work that he paraphrased "as an object that has been integrated into the real world, something that must not be allowed to fossilize but must be helped, so to speak, to fulfill its natural evolution by being given a new lease of life"? [81] Just because of his fraternal feelings toward the old masters, he must have known that they could well do without him. Finally, was he perhaps affirming "the historical exhaustion and vitiation of the means and appliances of art"? [82]

This last is the view adopted by John Anderson in his study of the variations on *Las Meninas*.[83] Anderson feels that "Far more than the Delacroix or Manet cycles, the Velázquez relies upon its source being recognized as promoter and surety for the cycle." Hence, he seeks a reason for Picasso's interest in this particular painting, and tries to establish a connection between its character and the spirit of Picasso's transformation. "The original *Las Meninas* in its historical context borders on subversion": on the political and human level, by its exposure of eroded etiquette, and on the artistic level, by its ambiguous play with the laws of perspective. Hence, its attractiveness to the equally subversive and disenchanted genius of Picasso, who parodies it by translating it "into the artificial mock-reality of the doll's house." For Anderson, the waywardness and absurdity of Picasso's distortions of *Las Meninas* constitute "an untransfigured expression of suffering." [84] Even further, he implies that the last pictures, deprived of any supporting reality, no longer parody Velázquez, but only themselves. Anderson is right in calling the series a parody. He is also right in emphasizing the transposition of the human and historical situation into sheer phantasmagoria. But he is too insensitive to the intrinsic artistic values of these paintings (which still await adequate evaluation): to their formal inventiveness; to their all-pervading,

[80] Cooper, *op. cit.*, p. 32.

[81] Michel Leiris, "Picasso and the *Human Comedy*," p. 140 in this volume.

[82] Thomas Mann, *Doctor Faustus, The Life of the German Composer Adrian Leverkühn as told by a Friend*, trans. H. T. Lowe-Porter (New York: Knopf, 1970), p. 135; quoted by J. Anderson, see following note.

[83] John Anderson, "Faustus–Velázquez/Picasso," p. 158 in this volume.

[84] This is also a quote from *Doctor Faustus*, p. 240.

sometimes grotesque, sometimes gentle humor; to their fairytale-like magic and mystery. He also appears to be too ensnared in the pessimistic aspects of Thomas Mann's philosophy of culture, from which he derives his concept of parody as a "gesture of despair." Indeed, in the very quote from *Doctor Faustus* with which he begins his essay, Anderson overlooks Mann's own concession that, at least in the hands of genius, parody can also become a means of revitalizing art.

Perhaps we ought to realize that in Picasso's variations much serious comment on art and life is achieved through parody. A striking example is his series of variations on David's *Sabines*. Picasso transforms the original scene, one of pacification through the intervention of women, into a holocaust, with episodes of massacre, rape, and the Murder of the Innocents. In the first version, the smooth, Neoclassical style of David is replaced by an anti-idealistic, coarse, and savagely funny figural idiom. The canvas is filled with convulsions of apparently boneless, tumescent humanoids, or humanized molluscs; their assailants are hideously deformed giants. Looking at this picture, one is reminded of a strange conversation between Picasso and the Italian painter Renato Guttuso, which took place two years after the picture was painted. They talked about the Crucifixion, and about martyrdom and execution. Guttuso said: "There are no paintings in which the painters are not on the side of the martyrs." Picasso answered: "There aren't any—but it could be done." [85] However, in continuing his exploration of David's *Sabines*, Picasso derived from this work one of his most powerful and moving statements for life and against death and destruction.[86] The figures are monumentalized and reduced to four. In the upper half of the picture two men are assailing each other with the same stupid and reckless fury displayed in one of Goya's "Black Paintings" from the Quinta del Sordo, in which two men, both sunk knee-deep in a morass, are battering each other's heads with clubs. Underneath, a crying child rises from the dead body of its mother. The expressive language is similar to that of *The Charnel House* and *Guernica*.

Picasso's use of parody again brings to mind his spiritual kinship with James Joyce. The Irish writer, too, was a master of parody. More often than not, he used his mythical models in the same way in which Picasso used David's *Sabines*: by turning their plot and its emotional content into their contrary. In *Ulysses*, the parallels with Homer are often a measure of what Joyce's characters do *not* do:[87] the *non*-hero returns to an *un*-faithful Penelope and is *rejected* by his (spiritual) son.

[85] Ashton, p. 35.
[86] Gallwitz, pls. 247–48.
[87] Hugh Kenner, *Dublin's Joyce* (Gloucester, Massachusetts: P. Smith, 1969), p. 182.

Like Picasso, Joyce measured his achievement against the greatest works of the past. He also maintained a spiritual dialogue with those poets he revered most, above all with Shakespeare. Just as Picasso was wondering what Delacroix would say about his *Algerian Women*, Joyce once asked a friend: "What would Shakespeare say about my Work in Progress [*Finnegans Wake*]?" [88] There can be no doubt that "Great Shapesphere" was the ultimate authority to Joyce. And yet he treated him with a great deal of irreverence in his writings. In *Ulysses*, the ghost of Shakespeare presents himself in a mirror to the visitors of a brothel, stammering inane gibberish. In *Finnegans Wake*, which is loaded with quotations from Shakespeare, Joyce refers to him as *Shakhisbeard*, *Shikespower*, and other ludicrous transformations of his name. Are these just silly plays with words, or slightly tasteless puns? It could seem so, but only to those who are unfamiliar with the literary technique of *Finnegans Wake*. In this book, the puns are used to create epiphanies. "Shakhisbeard" links the greatest of the Elizabethans to the mythical Bards, thus confirming the continuity of the poetic tradition, or telescoping history into the timeless, eternal present. "Shikespower" endows the prince of poets with the power of the Sheik—the tribal ruler—and attests at the same time his "chic"— his urbane manners—which ensured his power in the treacherous world of the court.

Does not Picasso treat Velázquez similarly in the first picture of his *Las Meninas* cycle (Fig. 37)? The towering figure of the painter has been described by Penrose as endowed with the authority of an inquisitor;[89] by Berger as a father: "It may be that as an old man Picasso here returns as a prodigal to give back the palette and brushes he had acquired too easily at the age of fourteen [from the hands of his father who swore that he would never paint again because his son had out-mastered him]. Perhaps," Berger continues, "this last large painting of Picasso's is a comprehensive admission of failure." [90] But if we look at the figure, we see that it has none of the forbidding qualities implied by such interpretations. Its enormous size is expression enough of reverence, even awe; yet this very exaggeration contains an element of irony. Velázquez's face is composed of two profiles confronting each other, one thoughtful and tender, the other mischievously cheerful. His body is treated in a quasi-Cubistic manner; almost all its parts, even the Cross of Santiago, are slightly out of joint. So unafraid was Picasso of the authority, or competition, of Velázquez that he gave him

[88] Carola Giedion-Welcker, "Begegnungen mit James Joyce," in *Stationen zu einem Zeitbild*, Schriften und Reden, ed. Reinhold Hohl (Cologne: Verlag M. DuMont Schauberg, 1973), p. 50.

[89] Penrose, p. 373.

[90] Berger, p. 185.

two palettes instead of one, and never cared to wipe out the *pentimento*. This evocation of brotherly genius betrays the same spirit of affectionate mockery, of ironic homage that we found in Joyce's play with the name of Shakespeare. Could it be that here we grasp the deepest meaning of that element of parody that has so often been ascribed to Picasso's variations? To clothe one's most heartfelt reverence in irony seems an eminently twentieth-century trait. With mockery and affection Picasso has recreated the past as a living present. This alone among his many achievements secures his place among the immortals.

THE SPANISH INVASION: PICASSO

Félicien Fagus

. . . Picasso is a painter, wholly and beautifully a painter. His intuitive knowledge of the substance of things is proof enough of this. Like all pure painters he loves color for its own sake and each substance has its own special color. Moreover, each subject casts its spell over him, and to him everything is a subject: the way flowers thrust furiously from their vase towards the light, the vase itself, the table on which the vase stands, and the luminous air that dances around them; or the multicolored swarming crowds against the green of a racecourse; or the sun-drenched sand of a bull-ring; the nudity of female bodies—it does not matter whose—or the way their shapes, though concealed, are divined through yielding, colorful fabrics . . . and lucky finds: three little girls dancing, one of them with a skirt of sensible green contrasted against white underclothing that has the stiff boyish white seen only in little girls' heavily starched slips; the yellow and white of a woman's hat, etc. And just as in a subject everything is a subject to him, so he regards everything as suitable for translation, even slang or Gongorism—that other slang—even his neighbor's lexicon. It is easy to distinguish a number of probable influences apart from the traditional Pissarro, Toulouse-Lautrec, Degas, Forain, Rops, perhaps others. . . . Each influence is transitory, escaping as soon as captured. It is clear that his sense of urgency has not yet allowed him leisure to form a personal style. His personality resides in that very urgency, that youthful, spontaneous impetuosity (they say that he is not yet twenty and that he covers as many as three canvases a day). His danger resides in that same impetuosity, which might well tempt him into facile virtuosity and even more facile success. The prolific and the fecund are two different things, as distinct as violence and energy. And that would be a great pity, given such brilliant virility.

Félicien Fagus, "L'invasion espagnole: Picasso," *Revue Blanche* (Paris), 25:464–65 (1901). Reprinted in *Cahiers d'Art*, 7:96 (1932).

AN ENERGETIC PROVINCIAL

Julius Meier-Graefe

Picasso is typical of those energetic provincials we know so well from Balzac's novels, who pick some part of Paris, as extensive as possible—best of all the entire city—as their hunting ground. He is an extraordinarily forceful example of the breed, healthy, irritable, bursting with qualities of the highest value. Rosso, known to us from three-dimensional Impressionism, had similar features, but he was weighed down by a consistency that was positively unwieldy. And besides, he lived too soon. His ideas, weak in perspective, were too easy to see through and reduced sculpture too rapidly to the absurd. Picasso knew what Paris needed.

One of his first phases was an attachment to the traditions left behind by Toulouse-Lautrec after his premature death. This helped him to get rid of his Spanish accent. Lautrec had discovered the face of *fin-de-siècle* Man, a type leeched out by the vibrations of the boulevards, something of the sort of the curly-headed boys of the Quattrocento devoid of any inhibiting stylization. The concept was not confined to arabesques and decorative color. The loose, shorthand-like structure embraced a powerful dose of modern psychology. Parisian wit, Parisian grace and good taste, and all Paris's good spirits came together at random, and an inkling of new forms resulted. The ladies of the Moulin Rouge became poster-style heroines with a convincing pathos. A wink of the eye became a fresco—a gipsy caravan fresco. It derived its convictions from its guileless undemanding frivolity. This natural modesty matched the circumstance that the medium was no longer painting and that these garrulous forms were best expressed in print on paper. Indeed, they preconditioned these unceremonious

From the chapter "Matisse und Picasso" in Julius Meier-Graefe, *Entwicklungs-geschichte der modernen Kunst*, 2nd ed., III, trans. A. D. Simons (Munich: R. Piper Verlag, 1915), pp. 628–30. Reprinted by permission of the publisher.

materials. Their *ésprit* was too unbridled for painting, which revealed too many of the lacunae of its topicality. The lithographer found the ideal substitute. Quite incidentally, he drew independent conclusions from an unmistakable trend of modern art. The experience assembled by the admired Japanese was applied in the most European of ways.

This Parisian, whose pert improvisations concealed aristocratic manners, led Picasso to discover opportunities he could make use of. . . . The motifs were suitable for exploitation on a quite different scale, and certainly not by means of lithography. It was possible to expand them, to clothe their brittle structure, and to render their diction more profound. Outlines, sketched by Lautrec by means of dots, were consolidated to form decorative lines. The lacunae of the oil paintings were eliminated, and with them Lautrec's lively *ésprit*. The shorthand changed into a lower gear; the fun became solemn. Stately airs sang of another Paris. Now was the time to dream. Another denaturalization. Away, as far as possible, from processes of those such as Matisse. *He* was interested in forms, but Picasso sought gestures. Greco and Gaugin were a help. A heavily literary accent flavored the mixture, christened the "blue period" in the coterie of the Café Closerie-des-Lilas; it was a degenerate offshoot of Novalis's blue flower [Fig. 3]. After all, it was Gauguin who was determinative for the blue period, both the form and the spirit of that Europe-weary refugee, and even more so his romanticism. Loosely speaking, we have a continuation of the Tahiti style. To any extent Gauguin may be equated with a primitive (and he was fond of relating himself to no less than Cimabue and was forced to accept an acid comment from van Gogh as to his allegedly primitive tendencies), so Picasso, at this period, may be ranked as a "Quattrocentist." Gauguin was deprived of the last residues of his spontaneity. An over-bred dandyism flees from Nature to a remote hothouse, on to a hothouse stage of seductive paraphernalia. Here, phantom-like pantomimes take place. Pale tones whisper. The human figures—more diagrammatic than human—are taciturn. The rough importunacy of the action fails to move them. Orchids without warning. A blue Closerie-des-Lilas, from whose open windows a warm wind of cigarette-smoke and musk is wafted, harbors sufferers of a rare asceticism, proletarians whose soft nakedness is covered by a melting of pearls, thin youths full of humility and sin, pierrots of unearthly sentiment [Fig. 4]. Murger's Bohème comes into being as an assembly of individual figures of dantesque dignity. A poet, his head mantled with a crown of laurels, truncated pipe between lips, is seen in faded fresco tones. The segment selected brings him into relief. Indian miniatures, Persian potsherds, garments, the Florentines at the period of the great Medicis, mixed the colors. The texture, which draws the attention of one such as Bonnard as he passes by; the play of the hands while the eye compresses on reception psychic emotions of

indescribable tenderness. Vuillard and Roussel become crude. Confronted with such images, one is tempted to take tea like the sacrament and hardly dares allow one's weight to bear upon the chair beneath one. Thoughts as fine as spun glass and just as inexpressible are the accompaniment to this tea-time scene. It would be wonderful to be able to sigh through the hair. . . .

The like had never been seen before in French art. There might have been more chance of finding it in the land of Wilde and Beardsley, where there are no such fruits as are apt to endow abstinence with merit. Puvis was a good-hearted herdsman, and Maurice Denis lapsed too quickly into the banal for his impression to endure. It remained for Picasso to make French painting the gift of Pre-Raphaelism. For indeed, all that distinguished this fanatic from Rossetti and Burne-Jones was a more cautious selection of objects. The impenetrability of his eclecticism added to the attraction.

PICASSO IS A DEVIL

Gelett Burgess

And now for Picasso, of whom, here and there, one has heard so much. Picasso will not exhibit his paintings. He is too proud, too scornful of the opinions of the *canaille*. But he sells his work, nevertheless. That's the astonishing thing about all of them. Who buys? God knows! Germans, I suppose.

It is the most picturesque spot in Paris, where the wide Rue de Ravignan drops down the hill of Montmartre, breaks into a cascade of stairs and spreads out into a small open space with trees. Picasso comes rolling out of a café, wiping his mouth, clad in a blue American sweater, a cap on his head, a smile on his face.

Picasso is a devil. I use the term in the most complimentary sense, for he's young, fresh, olive-skinned, black eyes and black hair, a Spanish type, with an exuberant, superfluous ounce of blood in him. I thought of a Yale sophomore who had been out stealing signs, and was on the point of expulsion. When, to this, I add that he is the only one of the crowd with a sense of humor, you will surely fall in love with him at first sight, as I did.

But his studio! If you turn your eyes away from the incredible jumble of junk and dust—from the bottles, rags, paints, palettes, sketches, clothes and food, from the pile of ashes in front of the stove, from the chairs and tables and couches littered with a pell-mell of rubbish and valuables—they alight upon pictures that raise your hair. Picasso is colossal in his audacity. Picasso is the doubly distilled ultimate. His canvases fairly reek with the insolence of youth; they outrage nature, tradition, decency. They are abominable. You ask him if he uses models, and he turns to you a dancing eye. "Where would I get them?" grins Picasso, as he winks at his ultramarine ogresses.

From Gelett Burgess, "The Wild Men of Paris," *Architectural Record*, New York, May 1910, pp. 407–8. "Picasso Is a Devil" is the editor's title. Reprinted by permission of *Architectural Record*.

The terrible pictures loom through the chaos. Monstrous, mono-lithic women, creatures like Alaskan totem poles, hacked out of solid, brutal colors, frightful, appalling! [Fig. 6] How little Picasso, with his sense of humor, with his youth and deviltry, seems to glory in his crimes! How he lights up like a torch when he speaks of his work!

I doubt if Picasso ever finishes his paintings. The nightmares are too barbarous to last; to carry out such profanities would be impossible. So we gaze at his pyramidal women, his sub-African caricatures, figures with eyes askew, with contorted legs, and—things unmentionably worse, and patch together whatever idea we may. . . .

Then Picasso, too, talks of values and volumes, of the subjective and of the sentiment of emotion and instinct. *Et pat-à-tie et-pat-à-ta*, as the French say. But he's too fascinating as a man to make one want to take him only as an artist. Is he mad, or the rarest of *blagueurs?* Let others consider his murderous canvases in earnest—I want only to see Picasso grin! Where has he found his ogrillions? Not even in the waters under the earth. . . . Picasso gets drunk on vermillion and cadmium. Absinthe can't tear hard enough to rouse such phantasmagoria! Only the very joy of life could revel in such brutalities.

PICASSO'S SOLITUDES

Jean Cassou

The title of Gongora's last—and uncompleted—work is *Les Solitudes.* And the deepest meaning that can be accorded this strange title is that of a universe stripped by the poet of all that is alien to his art and evacuated of living and animate beings save for the symbols admitted to his elect companionship. This aesthetic evacuation and desolation adopted by the greatest poet of bygone Spain is also that of modern Spain's greatest painter and last bearer of the Baroque heritage, Pablo Picasso. Of all the people one meets no one gives a more striking impression of solitude, in spite of his extraordinary celebrity. The name Picasso does of course arouse echoes, enthusiastic or otherwise, throughout the universe. He leaves nobody indifferent; every individual responds to him. Yet in spite of this, Picasso seems to me the loneliest man on earth. He is never seen with a member of his family. His friends always seem to have sought his friendship purely to have it said that they joined with him in some strange adventure of the spirit—in other words, they have never been his friends except as part of the legend. Even those who survived that epoch of conjuration and alchemy and have carved out their own careers seem to take on a shadowy appearance when they are thought of in connection with that period. Having traversed that haunted zone, touched by the fires of a glory of mythical immediacy, they have become reincarnated and have continued to bask in glory, but glory of a more natural and less glowing nature. By contrast, Picasso has remained in his own sphere, the sphere of phantoms. He has remained aloof upon the pellucid heights.

 Nobody has ever been able to create solitude as he does. His

"Picasso's Solitudes" by Jean Cassou. From *Renaissance de l'art français*, vol. 21, January 1939, pp. 21–22, 49. Translated by A. D. Simons. Reprinted by permission of the author.

studio engulfs him, alone with the atmosphere of Spain. If he sets up in an apartment in the heart of Paris, even the most ordinary window, fireplace, fire irons, or the cold lines of the flooring blocks of the dwelling-house seem to take on strange forms resembling whatever chance fetishes his fingers may be creating at that moment. If he moves to the attic of a house on the Left Bank, all he has to do is to deposit a mat and an old-fashioned sofa and at once there is infinite space, a landscape of fierce disorder and abandon; the desert has moved in.

But the most astounding of Picasso's solitudes is that which inhabits his work itself, arrived at by the continual destruction, no sooner than they have been created, of the characters who might have inhabited it and thus become his companions. They are creatures to whom he could have become accustomed; but he rejected their friendship. And that is the respect in which his solitudes are comparable to those of the poet Gongora—"alma heroica," as a contemporary called him. Picasso's spiritual progress derives from the same heroism: it has the same shrug of the shoulder, at once stoical and contemptuous, which waves aside all that cannot and may not be other than ephemeral. And indeed, the *subject* of the poems cannot be other than ephemeral, they cannot endure in the life and thoughts of the poet, for it is the mere stuff of which is woven the substance of common men, weak enough to need such unending company. But for the poet, all he need retain for himself is the motion by which he steps out of his skin.

Picasso has been reproached for his constant transformations. It has been claimed that they are evidence of his lack of unity, his absence of personality, his want of genius, and his absolute nullity. But only those who have never savored the bitter delights of deep and indifferent solitude can fail to understand that it is precisely these successive transformations which reveal Picasso's unity, personality, genius, and reality in solitary essence.

People sometimes use the expression "universe" when speaking of some artist or another, meaning his accustomed atmosphere, the connoted landscape he carries constantly about with him and in which he can rediscover himself and immerse himself for regeneration. But Picasso has no "universe" at all, or if he has it is a vast solitude whose vegetation appears mushroom-like, to die at once. Never is there a retrograde movement, never any interference among these encapsulated, absolutely heterogeneous species. No nostalgia haunts Picasso, no memory of these moons he has thus briefly inhabited and whose habitability steadily decreases.

For Picasso, as though wishing to avoid the need to shed tears for the shapes he has successively conjured up and destroyed, seems to create them in forms ever stranger and more hostile. They must never

be allowed to seduce him. Never must they be able to place him under their spell and so intrude upon his solitude. They cannot be allowed to endure, and when there seems a danger that they might become durable by reason of some recognizable or emotive aspect, or that they might grip the mind by some slight enhanced legibility of character, or move the heart by an increased tenderness, an indescribable revulsion takes place and with a movement of anger Picasso turns away and distracts our attention.

Thus it was during the periods of his youth, when Picasso affected a kind of naturalism and had not yet discovered the intellectual combinations which erect an initial barrier between his inventions and the possible. Take his pictures of races, circuses, or women of the Toulouse-Lautrec period, or to use the more usual name, *Fin-de-siècle* period, in which we are reunited with manners dear to us, an acrid atmosphere breathed in common by spirits unlike, though of the same period. Take those very Catalan figures of the blue period, whose style of decoration, nudity, and emotion are perfectly classifiable and identifiable [Fig. 3]. Or again, those families of acrobats from the pink period [Fig. 4]. Undoubtedly, the whole *oeuvre* of Picasso's youth, as yet undisturbed by intellectual speculation, exerts a very direct fascination over us, and it might well be thought that this is where the artist has his "universe," a universe of simple forms, where stylization occupies a place alongside a sense of humanity and where a deeply gripping emotion of pity holds sway. It would be easy to imagine that this would have sufficed to satisfy both the artist and his public for the rest of his career. With those heart-rending motherhood scenes, those long, emaciated ephebes, those tragic vagabonds, the artist has his opportunity to enter into us. All of this might seem both possible and durable.

But it was Picasso's destiny to break with the possible and the durable and to sweep them away before the mighty wind of solitude—"toujours recommencée," like the poet's ocean. So it was inevitable that there would be an element of the intolerable in the emotions communicated to us by his earliest companions; it was inevitable that the pity they inspire in us should be adulterated with poison and an indefinable sense of atrocity and monstrosity; and that this would herald the instability, the disasters, and the scandals that marked the subsequent periods through which this unusual artist was to pass, spurning the search for a formula and contact with the laws of the universe and the ways of the heart in the manner of other artists and never ceasing to rupture every contact, retaining for himself the harshness of a breathless and splendid solitude.

INTELLECTUAL PRIMITIVISM

Robert Goldwater

THE DIRECT INFLUENCE
OF PRIMITIVE SCULPTURE

The influences of primitive art upon modern painting so far examined have not been direct formal borrowings. Gauguin employed subject matter from the South Seas, and adapted individual figures from Indian art; and in Germany artists drew inspiration from the primitive, and painted "primitive" or naïve scenes. With the exception of a very few of Gauguin's sculptures there was no study of the form and composition of aboriginal sculpture, and none of the artists we have discussed tried to reproduce its aesthetic effects. The closest approach to such an attitude was the relation of the *Blaue Reiter* group—notably Marc and Campendonk—to the folk art of their native Bavaria, although even here their appreciation was largely determined by a romantic notion of the value of popular art, unaffected by the particular form the art might take. The approach of the artists whom we have thus far considered has, in other words, been dictated by a bias toward the idea of the primitive as such which predisposed them to value primitive works of art as the symbolic products of primitive peoples. The strength of this indirect approach and the extent of its domination are well indicated by the fact that it has been possible to begin our discussion of each group with quotations from the artists themselves concerning the appreciation and value of the primitive and their ideas about it.

With the artists whom we will consider in this section such an

From Robert Goldwater, *Primitivism in Modern Art*, rev. ed. (New York: Random House, Inc., Vintage Books, 1967), pp. 143–63. Copyright 1938 and renewed 1966 by Robert Goldwater. Reprinted by permission of Random House, Inc. and Mrs. Robert Goldwater.

analysis is not possible, because there is no writing with which to deal.[1] This lack reflects attitudes different from those of the men already discussed. It means that the contact with primitive art is now directly through the objects themselves, whose individual effects of form and expression are studied apart from any general ideas about the primitive outside of its manifestations in art. Their intention, indeed, was to limit themselves even within this field, and to consider only the formal aspects of primitive work, disregarding not only its particular iconographical significance, of which they were entirely ignorant, but also the more general emotional expression and the effect induced by the form and composition of the objects that they knew. This intention was not, as we shall see, completely carried out, and there was a more definite emotional connection with African art than the generalized "poetic suggestion" which was all that Guillaume Apollinaire (thinking in the same sort of terms as had Vlaminck), as much as ten years later, could discover in the "fetishist sculpture of the Negroes."[2]

There have been conflicting accounts of when and where Picasso first encountered African sculpture. He himself, after an ironic affirmation of total ignorance, said that he first came across it in 1907 on a chance visit to the Trocadéro, and only after he had finished the *Demoiselles d'Avignon* [Fig. 6]. Vlaminck wrote that both Matisse and Picasso first saw African art in Derain's studio. However, Matisse told André Warnod that he was in the habit of buying African sculpture in a shop in the rue de Rennes, and that shortly after they met in the fall of 1906 he showed Picasso a just-acquired piece, the first Picasso had ever seen. Since Gertrude Stein, at whose apartment this occurred, confirms the account, it can be accepted as accurate. It is possible that the Trocadéro visit did take place in the spring of 1907 while Picasso was working on the *Demoiselles*, and that only then did Picasso feel the impact of African art.[3]

The range of Picasso's acquaintance with the various African styles is still a moot question.[4] His paintings are evidence that he knew

[1] During those years both Picasso and Braque were averse to saying anything about their art. Picasso's first statements were not made until after 1930. *Cf. Cahiers d'art*, VII, X; and "Letter on Art." *The Arts*, Feb., 1930, No. 2, pp. 3–5.

[2] Guillaume Apollinaire, *Catalogue: Première Exposition de l'art nègre et d'art Océanien* (Paris: Galérie Devambez, 1919), p. 7. Reprinted from *Premier Album de sculptures nègres* (Paris, Paul Guillaume, April, 1917). Apollinaire almost takes pleasure in the fact that "rien ne vient éclairer le mystère de leur anonymat . . ."

[3] *Cf. Action*, No. 3, April, 1920, where Picasso replied simply *"L'Art nègre? Connais pas"*; C. Zervos, *Pablo Picasso* (Paris, Cahiers d'Art, 1942), Vol. 2, Part 1, p. 10; André Warnod, "Matisse est de retour," *Arts*, No. 26 (July 27, 1945), p. 1; Gertrude Stein, *The Autobiography of Alice B. Toklas* (New York: Harcourt, Brace, 1933), p. 68; and Gertrude Stein, *Picasso* (Paris: Floury, 1938), p. 22.

[4] Picasso himself (July 1936) furnished only the most vague indications on the subject.

the wooden sculpture and masks of the Ivory Coast and the metal-covered grave figures of the Gabun. His few sculptures in wood of 1907, although clearly under some primitivizing inspiration, give no evidence of specific stylistic sources. Though there are references in later writings by his close associate Apollinaire, none too accurate in their geographic allusions, to the sculpture of the Congo, the discernible reminiscence in Picasso's art is much less conclusive evidence.[5] It is unlikely that he knew the work of the Cameroon grasslands, the sculptural tradition which in certain respects was the closest of any in Africa to the formal effects that Picasso was striving for.[6] Picasso early began a collection of African art—with the exception of Matisse the only artist of this time to do so on any considerable scale. Gómez de la Serna notes that there were African and Oceanic "idols" in Picasso's atelier in the Bateau Lavoir. Fernande Olivier recalls that his studio in the Boulevard de Clichy (where he lived from 1909 to 1912) was filled with *bois nègres* which he had begun to collect several years before: "Picasso was mad about them, and statues, masks, fetishes of all the African regions piled up in his studio. The hunt for African works became a real pleasure for him." There are photographs of his studio, and also of Braque's atelier, showing African masks hanging on the walls.[7] It is not without significance that at the same time he was hanging the paintings of the Douanier Rousseau, paintings which certainly have no formal relationship to African art and whose emotional relationship, which we will presently examine, it is now difficult for us, with a greater knowledge of primitive sculpture, to see.[8]

André Salmon (*Burlington Magazine*, CCII, April 1920), pp. 164–171, says Picasso collected Negro masks as early as 1906.

[5] In an article in *Le Temps*, Oct. 14, 1913, quoted by Guillaume Janneau, *L'Art cubiste: théories et réalisations* (Paris: Charles Moreau, 1929), p. 12, Apollinaire refers to "les imagiers de la Guinée et du Congo," apparently using Guinea to refer to the whole West Coast region. Janneau remarks on the "amused condescension" with which he still treats primitive sculpture. Both Daniel Kahnweiler and Charles Ratton assured me that it was the sculpture of the Ivory Coast with which Picasso was familiar. Braque did own a "Congolese" mask as early as 1905. *Cf.* Paris, Galerie Knoedler, *Les Soirées de Paris*, 1958.

[6] This was due to the fact that Cameroon was a German colony. . . . For similarities *cf. Seated Figure* in the Chadourne Coll.; *Mask*, Tzara Coll.; *Mask*, Leipzig Museum (Museum of Modern Art), *Corpus of African Sculpture*, Nos. 257, 273, 275); others might be adduced.

[7] Quoted in John Golding, *Cubism* (New York, 1959), p. 58. Also Fernande Olivier, *Picasso et ses amis* (Paris, 1933), p. 169. For the photos *cf.* Roland Penrose, *Portrait of Picasso* (New York, 1957), Illustrations 76, 84. The "first Negro mask bought by Picasso" seems to be an Ogowe River mask with crest. Picasso still has an extensive collection.

[8] Maurice Raynal, *Picasso* (German ed.: Munich: Delphin-Verlag, 1921), p. 53; he mentions, in his description of Picasso's atelier, Rousseau's *Portrait of Yadwrigha*.

It is clear that some time during the spring of 1907, at the latest, Picasso became aware of African sculpture. The pictures of the period bear this out. The *Demoiselles d'Avignon*, or at least its two right-hand figures, even more so the studies connected with it and a group of related paintings of 1907, all attest to his familiarity with at least two African styles: Ivory Coast (especially Dan) masks, and copper-covered guardian figures of the Bakota tribe of the Gabun.[9]

In a way, however, Picasso had already been prepared for the shock of African sculpture and its stylizations. In the spring of 1906 the Louvre put on exhibition a group of late Iberian reliefs from Osuna; and, as James Johnson Sweeney has pointed out, it is from at least one of them that the facial features of the three left-hand figures in the *Demoiselles* are adapted.[10] The lozenge-shaped eye, with its heavily circumscribed lids and large dark pupil is especially characteristic, as well as the emphasis on the flat plane of the long straight nose. This "Iberian" influence appears first in the *Portrait of Gertrude Stein*, which Picasso partially repainted in the autumn of 1906 after returning from Gosul. It is the source of the simplified eyes—curiously blank in their expression—and it explains, in the 1906 *Self-Portrait* with a palette the similar modeling and effect of the eyes, which at the same time seem perfectly appropriate to the rendering of Picasso's own large round eyes. The left-hand figure of the *Two Nudes* (1906) also has these same features, as well as an arrangement of the hair which repeats the ovoid forms; and the *Woman in Yellow*, painted in 1907 when Picasso already knew African sculpture, continues the "Iberian" style, though now perhaps fused (as Alfred Barr has noted) with the stylizations inspired by Africa. Thus the short-lived "Iberian" style leads into the "Negro" paintings, both because its general archaic character and hard, clearly defined forms opened the way to the primitive, and because it employed ovoid shapes akin to the African.

A comparison of the *Dancer* (1907), the painting most similar to its primitive prototype, points up Picasso's complicated and subtle relationship to African art. The parallels are evident: the arms of the figure have been brought up behind the head to surround the face in the manner of the schematic headdress of the Bakota image; the bent right leg, with foot pushing against the left calf, approximates the angularly formed extremities (which may not stand for legs); and the roughened surface of the metal is paralleled by the deliberately coarse

[9] For general discussions of this period *cf.* Alfred H. Barr, Jr., *Picasso: Fifty Years of His Art* (New York: The Museum of Modern Art, 1946), pp. 53–65; and Golding, *op. cit.*, pp. 47–62.

[10] J. J. Sweeney, "Picasso and Iberian Sculpture," *The Art Bulletin*, XXIII (1941), no. 3, pp. 191–198.

and uneven modeling of eye and nose.[11] But the differences are at least as significant. The Bakota sculpture, despite its strong curves and indented silhouette, or perhaps because of its symmetry and frontality, is static, hieratic, impersonal. Picasso's figure is all movement and violence. Its intensity is of an entirely different order, because instead of being self-contained, it immediately and directly engages the spectator. The pose itself, with its lifted arm and bent leg, is not new nor is it invented to match the African rhythms. Parts of it go back to 1905; it was used, complete, but in a much more naturalistic and quiet way in the *Nude Boy* of 1907; it is found in the two center figures of the *Demoiselles* and it will be employed again. It is significant that under the impulse of primitive sculpture it here becomes angular and linear, the modeling reduced to flat planes, and the whole agitated and brutal.

The striated surface of the metal-covered Bakota image similarly influences two portrait heads painted about the same time, although probably before the *Dancer*. These two paintings are also built out of its same ovoid forms, repeated in the silhouette of the face, the eyes, the forehead and the simplified ear—all of which suggest Ivory Coast influence.[12] But they also have the strong *quart de Brie* nose whose origins go back to the "Iberian" faces. This nose is not to be found in either the Dan, the Baulé, or the Bakota style, and though a concave nose silhouette is characteristic of Fang heads (also from Gabun), it is flat and small. Its jutting prominence seems to be entirely a function of Picasso's concern with new methods of transcribing the three-dimensional relation of parts that leads toward cubism, and which was also partially responsible for his interest in the primitive.

All these characteristics of style are present in a study for the upper right figure of the *Demoiselles d'Avignon*, a study whose bold rendering of eyes and nose-shadow are again an adaptation from the African. In the painting itself the direct connection is less evident. It is, nevertheless, clear that both the seated and the standing nudes on the right are of a different style from the three figures on the left, and that the difference is due to the intervention of African art. Picasso has acknowledged that they were painted later in 1907 than the others, though he would not say just when. Although there is no precedent for the twisted features of the seated figure, the stylizations are those that appear in the other early works of this period.[13] It is also possible that

[11] Alfred H. Barr, Jr., *Cubism and Abstract Art* (New York: The Museum of Modern Art, 1936), p. 30, makes the comparison.

[12] The male head is certainly a self-portrait; Picasso wore his hair brushed in this way.

[13] Janneau's reference (*op. cit.*, pp. 12, 13) to "Melanesian fetishes" is borne out by a photograph of Picasso in his studio, taken 1908 or 1909, that shows two New Caledonian figures on the wall behind him. *Cf.* Gelett Burgess, "The Wild Men of Paris," *Architectural Record*, XXVII (May, 1910), pp. 401–414.

the eyes of the other figures were reworked at the same time, since the way they have been filled seems closer to the "Negro" than to the "Iberian" stylizations.

Quite apart from the question of sources, the distinction between the two sides of this important painting is above all in their different intensities. The later figures have an angularity, an absence of even those remnants of grace that still linger in the earlier ones, and a heavy, darker modeling. They thus embody a new emphasis on the barbaric, which becomes even more pronounced in the slightly later *Dancer*, with its still darker earth colors.[14] It is important to recognize this new emotional tone, because it suggests that although Picasso's intention was toward the recognition and utilization of the formal solutions he perceived in African art, a romantic feeling for the savagery of the primitive also played an important role in the attraction it had for him. To be sure, that feeling was in part conveyed through the forms. Picasso said later that he liked African art because it was *raisonnable*, and he certainly found in it a parallel to his tendency at this time to summarize and epitomize the essential characteristics of form from memory, to work more with the "idea" than with detailed observation.[15] Nevertheless, it was hardly pure form alone that inspired him, but also his own concept of the primitive, which read into its simplified and geometric, rhythmically static composition, an inner nervousness and violence.

Perhaps another way of recognizing this is to note that Picasso's Negro paintings have a self-consciousness entirely foreign to almost all primitive art. A comparison between Picasso's *Nude* (1907) and a Senufo wooden figure brings this out. The sculpture is a relatively unsubtle and angular figure, without either the more modulated carving usual in the refined Baulé style, of which Picasso must also have seen a good many examples, or the smoother, sensitive curves of the Fang heads. There are certain similarities of rhythm in the two works. Yet the deliberate expressiveness of the painting, its assertion of posture and individuality, a tenseness in the figure, and a vibration in the background, give it a personally insistent impact that would be an incongruity in the sculpture. The conceptual basis of African sculpture (as opposed to its basis in observation) has often been exaggerated; its simplifications, where they exist, may have other causes, and its unselfconsciousness may be due to aesthetic premises inseparable from its functional role.[16] But whatever "reasonableness" Picasso saw in its compositions, in his own work he obviously employed it to very

[14] Barr, *Picasso: Fifty Years of His Art*, p. 60, refers to this as the "barbaric phase."

[15] *Cf.* Golding, *op. cit.*, p. 59.

[16] This emphasis is probably still the lingering influence of the point of view of the cubist period.

different ends. These works, however rational they set out to be, are imbued with the strong emotionalism that characterizes Picasso's art generally. This is certainly true of the *Nude with Drapery* (1907), which is probably the last of the series of works of this year related to the surface markings of the metal-covered Bakota guardian images; it is as agitated as the *Dancer*, but its unit of design is smaller, and its pose, again with raised arm and bent leg, more sentimental than fierce.[17]

A more generalized African inspiration is present in a series of related works that begin late in 1907 and continue in 1908. Both the *Woman with a White Towel* (1907) and *Friendship* (1908) employ a shape of head, ovoid but broad, and a hollowing out of cheeks on either side of the nose and set back from the mouth that are related to the Dan masks of the Ivory Coast and Liberia.[18] Not only the contours, but the schematization of the face into a few related areas and the strong emphasis on the concavity of the profile all relate to the way these masks interpret the salient features of African physiognomy. The limbs in *Friendship* (1908) are reduced to a few simple, flattened planes, the sections of arms in *The Farm Woman* (1908) are indented at the joints, and the hands and feet in these paintings are both large and merely blocked out so that they play a role as contrapuntal plastic elements. All these characteristics, which may be found again in the *Nude in the Forest* (1908), had their source in similar features of African art. But increasingly in these pictures Picasso seems to be summarizing his analysis of Negro sculpture, and employing his conclusions in a more and more personalized fashion. The blank eyes do away with the sense of the individual figure which, however stylized, had previously obtained, and abstract geometrical principles now also seem to come into play. Indeed the head and bust of the half-length *Farm Woman* (1908) almost seem conceived as a demonstration of Cézanne's famous sentence, written to Emile Bernard in 1904 and published by him late in 1907: "You must see in nature the cylinder, the sphere, the cone." [19] Only in its special application to the

[17] Golding, *op. cit.*, p. 61. Braque's *Grand Nu* (1908), with a similar pose and summary treatment of hands and feet, reflects African influence through Picasso's adaptations.

[18] But similar stylizations also appear in the more refined Baulé style.

[19] *Mercure de France*, Oct. 16, 1907. As Golding points out (*op. cit.*, pp. 139–140), a similar convergence was attained for a moment by Derain as early as 1906, in his *Bathers* and perhaps in his *Last Supper*, where some of the heads have the same simplified blocklike geometric character. However, the *Head*, then in the collection of Derain's friend Frank Haviland (and now in the collection of Jay Leff, Uniontown, Pa.), is not—as Golding assumes—at all typical of French Congo sculpture. *Cf. African Sculpture from the Collection of Jay C. Leff* (New York: The Museum of Primitive Art, 1964), pl. 1. Its blank, hollowed-out features, which are really absences, are entirely exceptional. It follows that Derain's blocked-out heads

human face, the particular province in which it had been the least applied by Cézanne (and by Braque)—and which must have been suggested by Picasso's study of African heads—is the influence of primitive art still in evidence. In other respects it, and a number of other heads of 1908, show the growing tendencies which are to lead toward analytic cubism.[20]

Since these relatively few paintings of 1906 to 1908 most nearly approximate direct, formal borrowings from primitive art, it is of some importance to analyze their relation to the primitive, and so to understand the reasons for the admiration given to it. How can we account for Picasso's simultaneous appreciation of African sculpture and of the painting of Henri Rousseau? In its striving for academic realism and its actual result of flat patterns of color Rousseau's art is at the opposite pole from a sculpture which, if not always more basically conceived in three dimensions than any that Europe had produced, certainly has had that character attributed to it. Since this contrast in formal qualities is obvious, we must look for the connecting link rather in the psychological attitude of the two arts, or more accurately, in these attitudes as they were conceived by Picasso. In comparison with the works of Picasso up to 1906, we are struck by the psychological directness of the paintings of the following three years. With certain exceptions (such as the two figures of *Friendship*), which, precisely, are revivals of an earlier tone, the romantic sentimentality of that previous period is gone. The bent heads, the contemplative or idyllic atmosphere of the Blue and Rose periods, are replaced by vertical heads in three-quarter view and eyes that, even when they are empty of pupil, assert an existence to the world in general rather than to the particular spectator. Even in the *Demoiselles d'Avignon* (closest to the work of that time) the figures have no relation to each other.

One of the characteristics of African sculpture, which is coupled with its formally static qualities, whose partially technical origin we need not analyze here, is the relative permanence of the states of feeling which it renders. This is true, for obvious reasons, above all of those statues which are intended as dwelling places for the souls of the dead and which, because of the required resemblance to the owner, are a kind of living death-mask; but even the dance masks, though in use only for short periods of time, are the objectivizing of a state of feeling which is conceived as having an independent, enduring existence.[21] This relative permanence is also true, in spite of formal

stem more from the idea of the simplicity of African art than from any of its actual formal characteristics.

[20] Barr, *Picasso*, p. 62 ff.

[21] The spirits which take up residence in the masks at least for the time of their use represent for the most part single states of feeling. *Cf.* Maes, *Aniota-Kifwebe*

differences which do not need to be emphasized, of the work of Rousseau and the other "Sunday painters." In their case, it is due partly to a lack of technical ability which, in the exaggeration of realistic detail and in its making rigid all the forms that it renders, gives its scenes to the sophisticated eye a symbolic permanence that is not the conscious intention of the painter. This effect would not, however, be possible without an intensity of feeling about the object or the emotion to be portrayed and without a belief in the psychological importance and aesthetic efficacy of his art that makes careful and minute delineation worth-while and that is akin to the feeling of the primitive artist. The projection of Rousseau's dreams upon canvas (and his belief in the reality of their independent existence) is similar to the objectivizing of certain spirits in primitive masks. In both, moreover, there is the unself-conscious acceptance of an artistic tradition (directly opposed to an academic acceptance), which permits concentration on the desired expression. It is true in this sense alone to say, as Guillaume Apollinaire did of Rousseau, that "One finds no mannerism, no calculated procedure, no system"; and in this sense, in spite of the contrast of its technical achievement with Rousseau's, it is also true of African sculpture.[22]

Picasso's appreciation of this supposed "naïveté" is precisely what makes possible his juxtaposition of these two arts, and the directness and assertive qualities that we have noticed in the work of this period are due to its emulation. But the overdramatic qualities of Picasso's rendering, which we have also remarked, are due to his conscious attempt to assimilate what was thought to be an altogether unself-conscious attitude on the part of the primitive artist who simply follows tradition, but is really a preoccupation with other things which does away with a subjective artistic personality. Because this cannot be achieved by the modern artist, Picasso's figures, like Picasso himself, must continue to assert themselves to the world. In view of this attitude it is not surprising that the "Negroizing" of these paintings should take the form of emulating and exaggerating such features as blunt fingers, conical noses, blank or staring eyes, and open mouths—simplifications which serve the double purpose of strengthening the plastic design and of generalizing and typifying the psychological presence of the figures. These features undoubtedly embody a tendency toward a certain conception of the primitive, and even a deliberate overprimitivizing to achieve the desired result; but

(Antwerp: Editions De Sikkel, 1924), *passim;* R. H. Lowie, *Primitive Religion* (London: Routledge, 1925), *passim.*

[22] Guillaume Apollinaire, *Méditations esthétiques* (Paris: Figuière, 1913), p. 56. The "charming child" attitude taken toward Rousseau is shown by the often-mentioned dinner given for him in 1908 by the members of this group.

neither separately nor together do they constitute any comprehensive assimilation of the style of African sculpture, nor were they so intended. It is in the stimulation of an attributed concept, not in pure form, that the relation of primitive art to cubism is to be found.

A more purely formal influence from African sculpture may well have played an important role a few years later—at the height of the cubist period. But if it did, the process, though less emotional and more intellectual, was just as subjective and teleological, with the artists once more finding only what they were looking for. Kahnweiler has made a strong point of a connection between the work of Picasso and Braque in 1912 and 1913 (paintings and constructions), and a type of Wobé (N'gere) mask from the Ivory Coast, an example of which Picasso owned at this time.[23] In these masks (which vary greatly in their degrees of naturalism), there is a stylization of the features; they are made to stand out horizontally from a single vertical background plane which represents the face without suggesting any receding modeling of the skull. The forehead, whether bulging or horizontal, is given a prominent shelflike overhang, and in extreme instances the other features are indicated by more or less abstract geometrical shapes, so that the eyes may be cubic, cylindrical, or clam-shaped, and the nose and mouth simple, separate rectangles, one vertical, the other horizontal. On occasion additional cylinders are placed in the cheeks below the eyes. All these features are given extreme prominence, being made to project as rigid, discrete forms from the recessed plane of the face. If one is accustomed to the traditional European emphasis on the space-filling convexities of the whole head, pierced by the concavities of eyes and mouth, it seems that the African artist has made concave what in reality is convex, thus reversing natural appearance. If this is so, we are being asked to fill in what is not there and—by imagining the connecting surface at the upper level of the projecting forehead, nose, eyes, and mouth—to supply that rounded, volumetric mass that the sculptor has deliberately omitted. Kahnweiler, who was an intimate of the artists at the time, proposes that this is indeed the way in which Picasso and Braque saw the Wobé mask, and that it was this vision of "transparency" which led to the transparent planes of cubism.[24] He suggests that the proof may be found in the reliefs of the time, where, for example, the sunken hole of a guitar (a negative shape) is expressed by a projecting cylinder (a positive shape), just as in the Wobé mask the eye, in fact a recessed

[23] Daniel Kahnweiler, *The Sculptures of Picasso* (London: Rodney Phillips, 1949), Preface.

[24] Daniel Kahnweiler, "Negro Art and Cubism," *Horizon*, December, 1948, pp. 412–420. Kahnweiler denies any earlier influence of African art on Picasso, while claiming for cubism all the subsequent evolution of transparent sculpture.

form, is expressed by a cylinder or cube in very high relief. This discovery freed painting from naturalism, allowing it to create "invented signs, freed sculpture from the mass, and led it to transparency."

If Picasso did, indeed, look at his Wobé mask in this way, he was viewing it in the light of his own aesthetic problems. Wobé masks are certainly highly stylized representations, more concerned with effective dramatic expression than with naturalism. But in their emphasis upon large features, projecting from a background plane, they are only extreme instances of a manner of representation widespread in African masks and figures, which, however stylized, does not reverse mass and void. Overhanging forehead, large and sometimes bulging eyes, conical nose, advancing mouth, do stand out from the flat or even concave plane of the cheeks—in essentially the way they do in Mediterranean archaic sculpture; but these are all expressive exaggerations of the observed forms of Negroid physiognomy. If the lips project, so do they in the archaic smile; if the eye projects as sphere or cylinder, it is because—in addition to the carving necessity of giving it its shape—it expresses the magical penetrating glance of the spirit symbolized by the mask or temporarily housed in it. The idea of transparency, then, is not a fundamental quality of African art (if it is in fact a characteristic at all), taken over and incorporated into cubism by Braque and Picasso. It is rather a subjective interpretation, read into Wobé masks as they were analyzed by artists engaged in the creation of an evolving series of works of art and seen through the selective lens of their own necessities. This is everywhere the relation of the modern "primitivizing" artist to primitive art.[25]

[25] In the same number of *Action* (No. 3, April, 1920, p. 24) in which Picasso denied acquaintance with Negro art, Juan Gris replied: "Negro sculptures provide a striking proof of the possibilities of an *anti-idealistic* art. Inspired by a religious spirit, they offer a varied and precise representation of great principles and universal ideas. How can one deny the name of art to a creative process which produces individualistic representations of universal ideas, each time in a different way. It is the reverse of Greek art, which started from the individual and *attempted to suggest an ideal type*." The deductive method, which Gris here attributes to African sculpture, is precisely that upon which his own later work was based—in theory, if not always in practice. He started with geometrical principles; from their precise concatenation the concrete forms and the composition of a given picture took shape. *Cf.* Daniel Kahnweiler, *Juan Gris. His Life and Work.* Trans. by Douglas Cooper (New York: Curt Valentin, 1947).

THERE IS NO AFRICAN ART
IN THE *DEMOISELLES D'AVIGNON*

Pierre Daix

Despite Picasso's repeated denials, it is now generally believed that the corrections to the faces of the right hand side figures in the *Demoiselles d'Avignon* were made in summer 1907 under the influence of African art. If the facts put forward in support of this assumption are systematically examined, they obviously only prove that painters Picasso knew, such as Matisse or Derain, were already familiar with African art in 1907. As for any signs that Picasso imitated this art in his work at that time, they must be taken either as errors in interpretation or chance resemblances. The author here contributes an unpublished declaration by Picasso on the subject. If, on the other hand, we situate the above-mentioned corrections in the line of Picasso's research after his stay in Gosol, they fit in with a change in conception of pictorial space which was to alter figuration and reopen to Picasso the medium of color. His reflections on African art came much later, after 1910, and were an interpretation, not an imitation.

This is the English summary of the article by Pierre Daix, "Il n'y a pas 'd'art nègre' dans 'Les Demoiselles d'Avignon'," *Gazette des Beaux-Arts* (Paris), series 6, vol. 76, October 1970, pp. 247–70. The summary appears on p. 270. Reprinted by permission of the author.

PABLO PICASSO

Marius De Zayas

Art has not died in Spain, or not at least among Spaniards. What is beginning to die is the old tradition, or rather the intransigent traditionalism. And the best proof of it is the notable number of Spanish painters living in Paris, who prosper there, gaining enviable fame, and who at the end will figure among the French glories, instead of adding illustrious names to the already extensive Spanish catalogue.

I intend to make these artists known to the American world, describing the work of each one of them, not as I see, feel, and understand it, but as each one of them has conceived it.

I want to tell at present of Pablo Picasso, from Malaga, who finds himself in the first rank among the innovators, a man who knows what he wants, and wants what he knows, who has broken with all school prejudices, has opened for himself a wide path, and has already acquired that notoriety which is the first step towards glory.

I do not know if he is known in Spain, and if he is, whether they appreciate his efforts and study his works. What I know is that he is a Parisian personality, which constitutes a glorious achievement.

I have studied Picasso, both the artist and his work, which was not difficult, for he is a sincere and spontaneous man, who makes no mystery of his ideals nor the method he employs to realize them.

Picasso tries to produce with his work an impression, not with the subject but the manner in which he expresses it. He receives a direct impression from external nature, he analyzes, develops, and translates it, and afterwards executes it in his own particular style, with the intention that the picture should be the pictorial equivalent of the emotion produced by nature. In presenting his work he wants

Marius De Zayas, *Pablo Picasso.* 1911. This is the second half of a pamphlet distributed at the Photo-Secession Gallery, New York, at the time of the first American Picasso exhibition. It was reprinted in *Camera Work* 35, pp. 65–67, 1911.

the spectator to look for the emotion or idea generated from the spectacle and not the spectacle itself [Figs. 7–8].

From this to the psychology of form there is but one step, and the artist has given it resolutely and deliberately. Instead of the physical manifestation he seeks in form the psychic one, and on account of his peculiar temperament, his physical manifestations inspire him with geometrical sensations.

When he paints he does not limit himself to taking from an object only those planes which the eye perceives, but deals with all those which, according to him, constitute the individuality of form; and with his peculiar fantasy he develops and transforms them. And this suggests to him new impressions, which he manifests with new forms, because from the idea of the representation of a being, a new being is born, perhaps different from the first one, and this becomes the represented being.

Each one of his paintings is the coefficient of the impressions that form has performed in his spirit, and in these paintings the public must see the realization of an artistic ideal, and must judge them by the abstract sensation they produce, without trying to look for the factors that entered into the composition of the final result. As it is not his purpose to perpetuate on the canvas an aspect of external nature, by which to produce an artistic impression, but to represent with the brush the impression he has directly received from nature, synthesized by his fantasy, he does not put on the canvas the remembrance of a past sensation, but describes a present sensation.

Picasso has a different conception of perspective from that in use by the traditionalists. According to his way of thinking and painting, form must be represented in its intrinsic value, and not in relation to other objects. He does not think it right to paint a child in size far larger than that of a man, just because the child is in the foreground and one wants to indicate that the man is some distance away from it. The painting of distance, to which the academic school subordinates everything, seems to him an element which might be of great importance in a topographical plan or in a geographical map, but false and useless in a work of art.

In his paintings perspective does not exist: in them there are nothing but harmonies suggested by form, and registers which succeed themselves, to compose a general harmony which fills the rectangle that constitutes the picture.

Following the same philosophical system in dealing with light, as the one he follows in regard to form, to him color does not exist, but only the effects of light. This produces in matter certain vibrations, which produce in the individual certain impressions. From this it results that Picasso's painting presents to us the evolution by which light and form have operated in developing themselves in his brain to

produce the idea, and his composition is nothing but the synthetic expression of his emotions.

Those who have studied Egyptian art without Greco-Roman prejudices know that the sons of the Nile and the desert sought in their works the realization of an ideal conceived by meditation before the mysterious river and by ecstasy before the imposing solitude, and that is why they transformed matter into form and gave to substance the reflection of that which exists only in essence. Something of this sort happens in Picasso's work, which is the artistic representation of a psychology of form in which he tries to represent in essence what seems to exist only in substance.

And, likewise, just as when we contemplate part of a Gothic cathedral we feel an abstract sensation, produced by an ensemble of geometrical figures, whose significance we do not perceive and whose real form we do not understand immediately, so the paintings of Picasso have the tendency to produce a similar effect; they compel the spectator to forget the beings and objects which are the base of the picture, and whose representation is the highest state to which his fantasy has been able to carry them through a geometrical evolution.

According to his judgment, all the races as represented in their artistic exponents have tried to represent form through a fantastic aspect, modifying it to adapt it to the idea they wanted to express.

And at the bottom, all of them have pursued the same artistic ideal, with a tendency similar to his own technique.

PICASSO AND THE *PAPIERS COLLÉS*

Guillaume Apollinaire

Several exhibits are currently establishing the fame of this painter, one of those who have exerted the greatest influence on the artistic consciousness of our time.

He has questioned the universe severely. He has grown accustomed to the immense light of unfathomable spaces. At times, he has not hesitated to entrust real objects to the light—a two-penny song, a real postage stamp, a piece of newspaper [Fig. 9], a piece of oilcloth imprinted with chair caning. The art of the painter could not add any pictorial element to the truth of these objects.

Surprise laughs wildly in the purity of the light, and numbers and block letters insistently appear as pictorial elements—new in art but long imbued with humanity.

It is impossible to foresee all the possibilities, all the tendencies of an art so profound and painstaking.

The object, either real or in *trompe-l'oeil*, will doubtless be called upon to play an increasingly important role. It constitutes the internal frame of the painting, marking the limits of its depth just as the frame marks its exterior limits.

Picasso represents volumes by imitating planes, and in doing so, he enumerates the various elements that compose an object so completely and so acutely that these elements take on the appearance of the object, not because of the effort of the viewers who necessarily perceive their simultaneity, but because of their very arrangement on the canvas.

Guillaume Apollinaire, "Picasso et les papiers collés." First published in *Montjoie* (Paris), March 14, 1913. From *Apollinaire on Art, Essays and Reviews 1902–1918*, ed. Leroy C. Breunig, trans. Susan Suleiman (New York, The Viking Press, 1972). Copyright © 1960 by Librairie Gallimard, English translation copyright © 1972 by The Viking Press, Inc. Reprinted by permission of The Viking Press, New York, and Thames and Hudson Ltd., London.

Does this art have more depth than height? It does not dispense with the observation of nature, and its effect on us is as intimate as that of nature itself.

Picasso conceived the project of dying when he looked at the face of his best friend and saw his circumflex eyebrows galloping in anxiety. Another of his friends led him one day to the borders of a mystical country whose inhabitants were at once so simple and so grotesque that they could easily be re-created.

And besides, anatomy, for example, really no longer existed in art; it had to be reinvented, and everyone had to perform his own assassination with the methodical skill of a great surgeon.

The great revolution in the arts that he produced almost single-handedly is that the world is as he newly represents it.

An immense flame.

He is a new man, and the world is as he newly represents it. He has enumerated its elements, its details, with a brutality that knows, on occasion, how to be gracious. He is a newborn child who orders the universe for his personal use, and also in order to facilitate his relationships with his fellow creatures. His enumeration has the grandeur of an epic, and with the coming of order, the drama will burst forth. It is possible to contest a system, an idea, a date, a resemblance, but I do not see how it is possible to contest the simple action of an enumerator. People might say that from a plastic point of view we could have done without all this truth, but once the truth appeared, it became essential. And then there are the scenes in the countryside: a forest grotto with people doing somersaults, a ride on muleback on the edge of a precipice, and the arrival in a village where everything smells of hot oil and sour wine. There is also the stroll toward a cemetery, with a stop to buy a porcelain wreath (a wreath of immortelles) inimitably inscribed with the words "Undying Sorrow." I have also heard of clay candelabras that had to be pressed on a canvas to make them look as if they came out of it. Crystal baubles, and the famous return from Le Havre. The guitars, the mandolins.

I personally am not afraid of Art, and I harbor no prejudices about the materials painters use.

Mosaicists paint with pieces of marble or colored wood. Mention has been made of an Italian painter who painted with fecal matter; at the time of the French Revolution, someone who painted with blood. They can paint with whatever they wish—pipes, postage stamps, postcards or playing cards, candelabras, pieces of oilcloth, starched collars.

For me, it is enough to see the work, one must be able to see the work. It is the amount of work accomplished by the artist that determines the value of a work of art.

Subtle contrasts, parallel lines, a worker's craftsmanship, some-

times the object itself, sometimes an indication of it, sometimes an enumeration that becomes individualized, always less softness than coarseness. One does not choose what is modern, one accepts it—the way one accepts the latest fashions, without arguing about them.

Painting . . . An astonishing art, and one whose depth is limitless.

RELATIVISM
AND PICASSO'S LATEST WORK

Wyndham Lewis

(Small structures in cardboard, wood, zinc, glass string, etc., tacked, sown or stuck together is what Picasso has last shown as his.)

1. Picasso has become a miniature naturalistic sculptor of the vast natures—morte of modern life.

Picasso has come out of the canvas and has commenced to build up his shadows against reality.

Reality is the Waterloo, Will o' the wisp, or siren of artistic genius.

"Reality" is to the Artist what "Truth" is to the philosopher.

(The Artists OBJECTIVE is Reality, as the Philosopher's is Truth.)

The "Real Thing" is always Nothing. REALITY is the nearest conscious and safe place to "Reality." Once an Artist gets caught in that machinery, he is soon cut in half—literally so.

2. The moment an image steps from the convention of the canvas into life, its destiny is different.

The statue has been, for the most part, a stone-man.

An athletic and compact statue survives. (African, Egyptian Art, etc., where faces are flattened, limbs carved in the mass of the body for safety as well as sacredness.)

You can believe that a little patch of paint two inches high on a piece of canvas is a mountain. It is difficult to do so with a two inch clay or stone model of one.

3. These little models of Picasso's reproduce the surface and

Wyndham Lewis, "Relativism and Picasso's Latest Work," from Walter Michel and C. J. Fox, *Wyndham Lewis on Art* (New York: Funk & Wagnalls Publishing Co., Inc., 1969). Copyright © 1969 by Mrs. Anne Wyndham Lewis, © 1969 by Walter Michel and C. J. Fox. Reprinted by permission of Funk & Wagnalls Publishing Co., Inc. and Thames and Hudson Ltd. It originally appeared in *Blast* (London) I, 139–40, June 20, 1914.

texture of objects. So directly so, that, should a portion of human form occur, he would hardly be content until he could include in his work a plot of human flesh.

But it is essentially NATURES-MORTES, the enamel of a kettle, wall-paper, a canary's cage, handle of mandolin or telephone.

4. These wayward little objects have a splendid air, starting up in pure creation, with their invariable and lofty detachment from any utilitarian end or purpose.

But they do not seem to possess the necessary physical stamina to survive.

You feel the glue will come unstuck and that you would only have to blow with your mouth to shatter them.

They imitate like children the large, unconscious, serious machines and contrivancies of modern life.

So near them do they come, that they appear even a sort of new little parasite bred on machinery.

Finally, they lack the one purpose, or even necessity, of a work of Art: namely Life.

5. In the experiments of modern art we come face to face with the question of the raison d'être of Art more acutely than often before, and the answer comes more clearly and unexpectedly.

Most of Picasso's latest work (on canvas as well) is a sort of machinery. Yet these machines neither propel nor make any known thing: they are machines without a purpose.

If you conceive them as carried out on a grand scale, as some elaborate work of engineering, the paradox becomes more striking.

These machines would, in that case, before the perplexed and enraged questions of men, have only one answer and justification.

If they could suggest or convince that they were MACHINES OF LIFE, a sort of LIVING plastic geometry, then their existence would be justified.

6. To say WHY any particular man is alive is a difficult business: and we cannot obviously ask more of a picture than of a man.

A picture either IS or it IS NOT.

A work of art could not start from such a purpose as the manufacture of nibs or nails.

These mysterious machines of modern art are what they are TO BE ALIVE.

Many of Picasso's works answer this requirement.

But many, notably the latest small sculpture he has shown, attach themselves too coldly to OTHER machines of daily use and inferior significance.

Or, he practically MAKES little nature-mortes, a kettle, plate, and piece of wall-paper, for example.

He no longer so much interprets, as definitely MAKES, nature (and "DEAD" nature at that).

A kettle is never as fine as a man.

This is a challenge to the kettles.

PICASSO AND IMPRESSIONISM

Maurice Raynal

The major movements in art never find their discoveries exploited by the generation immediately following the artists who created them. There will often be a lapse of several decades before innovations in the domain of feeling will bear fruit and exert a salutary influence consequent upon the actions or reactions they may give rise to, opening up new directions to the inspiration they have generated.

The Impressionists savored the sciences literally rather than "in the spirit." This predilection legitimately resulted in an exclusive taste for "phenomena." The apparent was the sole creed and their senses were its ministers. And it follows from that that the only rule of their artistic conduct was the desire for experience, while the detailed examination of objects imparted to them an image of a world seemingly undergoing perpetual transformation.

Now Picasso, together with his generation, realized that experience was incapable of sufficing alone and that it was indeed no more than a taking note of facts—frequently governed by chance. Undoubtedly, Picasso does not reject the influences of chance *in toto*, but he never risks everything on a single card, since he is convinced that to do so would lead to a simple display of technique and from there to an inevitable elimination of all emotion. In contrast to the Impressionists, Picasso deals in facts and creates objects. Now we know perfectly well that the existence of objects known to us through experience is always distinct from their own true nature. Their existence can never be determined by an understanding of their structure. That is why that Impressionist convention consisting of regarding the "moving hand of time" as a reflection of eternity seems to some people rather fragile. A more reliable deduction from Picasso's *oeuvre* is that only the extrinsic

Maurice Raynal, "Picasso et l'impressionisme." From *Amour de l'Art* (Paris), 2:213–16, 1921. Reprinted by permission of M. Raymond Raynal. Translated by A. D. Simons.

circumstances which accompany objects reveal their true nature and indeed constitute their effective genesis. In addition, our own generation has adopted a new convention, the creed of the "scientific spirit," meaning that the experiences of the Impressionists merely provide definitions of objects or simple diagrams, while it is axiomatic that the events creating an object or causing it to disappear are those which take place *within it* or *about it* and are incapable of exerting any influence on the common definition.

The flavor of Impressionist experience was forced by its very nature to depend upon inductive reasoning. Now as I see it, Picasso's *oeuvre* demonstrates that those artists who claimed to have made inductive reasoning one of the bases of art did not bear in mind that the associations attaching to images are always so personal that experience can scarcely marshal a sufficient number to enable laws to be deduced. Sensitivity is a source of phenomena which are incomparable as well as being immeasurable. Moreover, the associations attaching to images which are susceptible of being adapted to the framework of established laws cannot themselves do more than lead to results already known, doing so by reason of their repetition.

And so inductive reasoning in art can only provide repetitions of data postulated by reason and has no right to impose its methods on creative sensitivity. Induction always involves knowing rather than feeling, and indeed knowing in the sense of ratiocination as in the applied sciences. Induction means seeking to convince the intellect through the intermediary of the senses, not the direct persuasion of feeling. And finally, induction is merely the perpetual demonstration of principles which it has been necessary to assume as axiomatic once and for all.

By adopting inductive reasoning as the logical base for their art, the Impressionists and their successors tended to increase rather than resolve the difficulties presented by art to their delicate sensuality. They did indeed strive to unravel them, but since sensuality is a pupil of the School of Chance, it was pure coincidence whenever they happened to be successful in doing so. Far be it from me to believe that Cubism has succeeded in disentangling a problem more insoluble than the most mysterious arcana ever were, but it is undoubtedly true that if any given question is displaced slightly it is always possible to derive some advantage, since it is seen in a new light. So instead of inferring one phenomenon from another, Picasso considers the universe as a source of separate facts, each one with its own individual life. The experimental methods of the Impressionists should have demanded of knowledge that it make them absolute masters of Nature; but all it did was to make them its devoted, not to say obsequious, servants. In contrast, when regarding the precise facts proffered by Nature, Picasso disregards those elements of the universe

which are eminently transitory and concentrates on that which *is* and that which *persists*, or in other words on the form and the line of objects. If eternity is indeed a succession of moments, we can approach slightly closer to truth by recording that which is stable and permanent rather than by sketching the interludes and interregna and apparent fluctuations of Nature, and that is why Picasso does not see objects purely as motifs of experience; he does not merely seek to detach their ephemeral form; in the last analysis, he simply seeks to endue them with the essence of their eternal form.

One seems to sense that Picasso's endeavors are not in the direction of purely intellectual toil set in motion by a given visual stimulus or by some comparison aroused by memories. His efforts will become tied to unique impulses provided by his creative imagination. That is the object of the form of thought-expression which seems to have been proffered by Picasso, and more especially of its deductive aspects. The Impressionists' individualism tended to delineate those outlines of the world which conformed to their necessarily circumscribed personalities. Now the intuitive and simultaneous cognizance of an object is, in contrast, at the origin of Picasso's concepts. In contradistinction to the Impressionists, Picasso does not seek to arrive at the object by way of its elements; he starts from the object-image conceived definitively by his imagination. In contradistinction to the inductive hesitations of Impressionism, Picasso seizes from the very outset upon certainty, a certainty whose immediacy is at all times imperative. For Picasso, the most legitimate reason for painting does not reside in the representation of objects which do or do not exist in Nature, but in the various aspects of the images his imagination has created. And the reason for this is that to allow his *oeuvre* to be dominated by the valuations of objective elements taken from the universe would be a derivation from the academic method, and because the exclusive consideration of subjective elements issuing from the artist himself is the pivot of the Impressionist method. It will thus be seen that in Picasso these two sequences of elements do not at any time cancel one another out, but are instead intimately intertwined and even mutually interpenetrant in so complete a manner that the senses are aware of them in spite of the fact that the intellect can never distinguish clearly between them.

Thus Picasso's Cubist work is nothing but pure imagination. It can be seen that instead of interpreting Nature with the complicity of those delightful sensual weaknesses we have—to the decrement of our imagination—and instead of overturning certain values in the hope that by so doing an opportunity to achieve an entirely empirical equilibrium will be found, Picasso assigns art a destiny which is perhaps less material and capable of serving than suited to arousing pure emotion, detached from all interest, in the viewer's sensibilities.

When I state that I find this view of Nature moving I do not intend this thought to be adulterated by any reasoned comparison whatsoever. A Picasso canvas moves us without our knowing why and without our having to go to meet it. I do not want to know whether he has studied what he presents us in Nature or indeed observed it at all. All that interests our feelings are the skill and imagination with which he has combined design and color on his canvas. A Picasso work presents our gaze with objects of a kind far removed from all that is living. It is an unprecedented event, if I may use the phrase. When a picture of a woman, a landscape, or an object moves us, it is never because of any comparison. The sentiment aroused is spontaneous and is matched to our own emotional disposition and to the subject, with no intellectual speculation of any kind intervening. Thus Picasso opposes a kind of superior realism to the visual realism of the Impressionists—a realism which mainly consists in concretizing abstract definitions. Picasso says to the Impressionists, "I no longer experience any need to know your opinion about any natural spectacle; I have my own, which I regard as better, and I shall keep it to myself because I know that this is one of the little vanities possessed by every human being." Now if we relate him to the requirements of contemporary sensitivity, Picasso is right. We do not demand of a painter to tell us anything beyond that which is indispensable, but when the Impressionists seem to be saying to us, "I am going to tell you what I have seen," we are tempted to reply, "I am not asking you to tell me what you have seen; just show me *something*, and something which is clearly a human creation. No landscape, however excellently interpreted; no still life, however faithfully reproduced; no nudes, with whatever detachment they may have been observed—I know where to find all these things and do not need anyone to take me by the hand and show them to me. Instead, you will do better to show me an object suffused with the imagination of him who created it and in which I shall rediscover the constituent elements which, in a landscape, a human body, or a piece of architecture, cause me to be moved, and in which I shall rediscover, as I do in the stamp of Nature who made the real landscape, the *true* still life or the *true* nude." And finally, with Picasso, I seek a work, a work created by the human beings who invented God, not paraphrases or variations on objects which have already provided us with sensations experienced by everyone and none the less fail to move us any more.

The Impressionist reaction to the tenacious errors of the Academic was followed by the Cubist reaction. There is no point in seeking to establish on which side truth lies. We shall not find out. I shall merely leave it to the reader to penetrate more deeply into a question I have been able to do no more than touch superficially. But the thing of prime importance is that we must not be surprised by the

divergences separating Picasso's *oeuvre* from that of the Impression-
ists. It is not our fault that we have not been able to find a less clumsy
way of pursuing truth than that of contradiction, since contradiction is
perhaps the most soberly *logical* element in human reasoning.

CUBISM—ITS RISE AND INFLUENCE

Andrew Dasburg

In its inception Cubism was unconsciously a geometric definition of a state of feeling induced by Picasso's preoccupation with the tactile sensations of mass and movement in the work of Paul Cézanne. A basic synthesis which for him became a plastic equivalent for three-dimensional forms.

Cézanne realized his art by the way of nature. Picasso, through the contemplation of Cézanne's achievement, found a method that created a new school. In one of his letters, Cézanne writes: "I see the planes criss-crossing and overlapping and the lines sometimes seem to fall"—a sentence vividly descriptive of the early work of the Cubists and bearing within it the germ of Cubism.

Cézanne, who remains today the inspiration and source of energy for "modern" art, opened up, not only through what he had accomplished but even through his own feeling of failure, new possibilities of expression that ultimately led to an abstract art—an art existing within its own material means, independent of the illusion of objective reality—such as the latest phase of Cubism, a phase so different from the first that the term Cubism hardly embraces it.

Though Picasso created Cubism in its fullest sense, there is already a legend as to the origin of the term. Apollinaire attributes it to a derisive remark made by Matisse in front of one of Derain's pictures. L. Madgyes gives it as having been said before a Braque. I have it that when Matisse's *Serf* was first shown in Paris someone remarked: "It is cubical in aspect"—the characteristic that distinguishes Cubism from all other phases of modern painting.

. . . Cubism can be separated into three developments—movement, spatiality and pure form.

Excerpted from Andrew Dasburg, "Cubism—Its Rise and Influence," in *The Arts* (New York), IV, 280, 282, November 1928. Reprinted by permission of the author.

Cubism is a geometry of rhythm and an architecture of matter. Two considerations are fundamental to the understanding of rhythm. One is the force of gravity, the other, the upward impulse in living things. All matter shows the effect of one or both of these conditions, and they are two important factors in the invisible moulding of all forms. The so-called static nature of inanimate things is controlled by one; the organic materializes under the influence of both. Movement as opposed to the static effect of gravity on inanimate things—as, for example, the formation and action of the human figure—implies a displacement from the center of gravity and a sequence of adjustments against resistance to a state of equilibrium. This adaptation is a constant sensory experience of man. He, in all his movements, instinctively seeks an attitude of poise and ease. Rhythm is the effect of the harmonious accomplishment of this action. And when the essence of this is achieved in a work of art, without expenditure of energy on our part, we receive a sense of freedom from the physical difficulties of a resisting world. These forces in the mechanism of growth are the underlying principles upon which a feeling for rhythm and rhythmic composition is founded.

The instinctive experience of our natures is then the truest guide for the proportioning and directing of form into significant symbols of rhythm. In this principle Picasso found a plan that served to coordinate the form element of planes. Not content with the bilateral displacements resulting through movement, he added yet greater and more vivid interest through asymmetrical surprises in the breaking up of his objects. This gave a complex and astonishing combination of dynamic and static elements. Here began the dissolution of the objective image until it ultimately became incorporated into the space surrounding it. A transformation obtained through the extension of planes through planes, forming an architectonic unit in which the remaining fragments of the dissolved objects were held together only by the law of association. Even though the sculptural aspect of things was destroyed and transformed into purely spatial sensations, the technique for bringing about illusional depth was still employed. . . .

Picasso with a fecundity of invention finally achieved the method in which the means he employs become the motive for his composition. In this last phase of Cubism, so remote from the original conception, the emphasis is upon the material reality of the means involved, color existing for color, and all the other elements used accentuating their own reality through the fundamental aesthetic law of contrast [Fig. 9]. An aesthetic achievement which in its finest examples penetrates into a high region, having a quality akin to great Buddhistic art—one of ultimate poise wherein the conflict of elemental forces is transcended.

WHAT ABOUT CUBISM?

Leo Steinberg

"Cubist simultaneity of point of view" is a phrase so familiar, and in one sense so well-founded, that it seems to cover whatever else in that line there was to invent. If Cubism had done it all in the teens of the century, why fuss about Picasso still doing it forty years later?

Cubism had not done it all. Its simultaneities—such as a bottle in elevation poised against the plan of a tabletop—are of a special order . . . Their purpose is not the integration of forms but, on the contrary, the fragmentation of solid structures for insertion in a relief-like space where no hint of reverse aspects survives.

The effect of Cubism on the imaging of familiar bodies was to unsolder their structure and scatter their parts. Cubism was still a transformation of remembered solids into a two-dimensional system. Its inheritance was the *theatrum mundi* spaced out with objects. Whereas two World Wars later, the flat Cubist space is taken for granted. It is where its creator has been at home for a generation. And the task he now sets his art is to renew the stereometry of the body without regressing to pre-Cubist illusionism, to restore sensuous presence to objects conceived and mantained in the flatlands of post-Cubist space. Simultaneity of aspects aiming at consolidation becomes a new structural mode.

Meanwhile, the notion that Cubism was a release from fixed viewpoint, intended to analyze objects from all sides at once, has blinded us to the goals and inventions of Picasso's post-Cubist years. Wherever in the nineteen thirties, or forties, or fifties, Picasso achieves an unheard-of visualization of simultaneity, the resutt is checked off as

Leo Steinberg, "The Algerian Women and Picasso at Large," Part II in *Other Criteria: Confrontations with Twentieth-Century Art* (New York: Oxford University Press, 1972), pp. 154–60 (slightly revised by the author). Copyright © 1972 by Oxford University Press, Inc. Reprinted by permission of the author and the publisher.

a "characteristic Cubist device," implying, sometimes unintentionally, that the old genius is living off his early investment.

The visual evidence is overwhelmingly negative. Cubism never sought to confirm the structure of depicted objects, and claims of this sort made for "Analytical" Cubism by its first champions were plainly wrong. But as Meyer Schapiro remarked in his essay on Fromentin, "to perceive the aims of the art of one's own time and to judge them rightly is so unusual as to constitute an act of genius." [1] We do not fault people for lacking genius. And to observe in retrospect that the early champions of Cubism were misguided is no disparagement. Their defense of the new painting was not dispassionate but a historic bid for special status—as when Raphael, in the *School of Athens*, placed the exponents of what was then modern painting among the arts of precise measurement and at the furthest remove from the arts of inspiration.

The earliest supporters of Cubism—their writings are assembled in a luminous little book by Edward Fry[2]—searched for terms that would ennoble and justify the new art. Their achievement was to have respected it even though it resembled nothing that then looked respectable in the halls of good art. Hence the militancy of their criticism; hence their persistent attempts to refer the pictorial transformations of Cubism to such redoubtable values as objectivity, realism, science, analysis, and so forth.

"The art that must give the structure of things, . . . their structure, substructure and superstructure . . ." wrote Léon Werth of Picasso's new works in 1910.

In "the clever mixing of the successive and the simultaneous," wrote the Cubist painter Jean Metzinger in 1910, ". . . Picasso confesses himself a realist."

"What is Cubism?" asks Roger Allard. "First and foremost the conscious determination to re-establish in painting the knowledge of mass, volume and weight."

"The Cubists are . . . going to give back to painting its true aim, which is to reproduce, with asperity and with respect, objects as they are. . . ."—Jacques Rivière, 1912.

And Picasso's friend, the poet André Salmon: "Painting, from now on, was becoming a science, and not one of the less austere."

The new painting was said to have freed the representation of objects from the limitations inherent both in the single instant and in the spectator's subjectively fixed point of view. An object appearing in a Cubist painting is "a synthesis situated in the passage of time" (Roger Allard, 1910). And again: "[The Cubists] ° move round the

[1] Meyer Schapiro, Introduction to Eugène Fromentin, *The Old Masters of Belgium and Holland*, New York, 1963, p. xxxix (first published, *Partisan Review*, 1949).

[2] Edward Fry, *Cubism*, New York, 1966. Hereafter cited as Fry.

° "[Steinberg's brackets—ED.]"

object, in order to give, under the control of intelligence, a concrete representation of it, made up of several successive aspects" (Metzinger, 1911).[3]

The whole Cubist enterprise was thus raised to the status of "scientific analysis." And "scientific" it seemed to the degree that it allegedly replaced the anthropocentric fixed-point perspective of academic art by a mode of representation independent of where someone happened to stand. The transcendence of human reference was after all the keynote of the progress of science. "The characteristic of the entire development of theoretical physics to date," said Max Planck in 1908, "is a unification of its system, achieved through a certain emancipation from anthropomorphic elements, especially from the specific sense impressions." [4] It was a noble impulse to want to see the new art marching in step with so emancipated a science.

But what need to repeat those early pleas half a century later? Indeed, given the visual evidence and the further course taken by Cubist painting, the early hypothesis about the analytical objectivity of Cubism was gradually dropped. It no longer appears in the writing of thoughtful observers.[5]

But familiar ideas about difficult things tend to hang on; they are economical, and sharing them becomes a kind of companionship. Thus we still hear pronouncements that Cubism was "a movement among painters toward the sculptor's three-dimensional problems"; or that its concern was "the solid tangible reality of things." [6] The Cubist painter

[3] The above quotes are from Fry, pp. 57, 60, 70, 78, 82, 62, and 66.

[4] Lecture delivered at Leyden University, December 9, 1908, on "Die Einheit des physikalischen Weltbildes," in *Wege zur physikalischen Erkenntnis*, Leipzig, 1933, p. 5: "Die Signatur der ganzen bisherigen Entwicklung der theoretischen Physik ist eine Vereinheitlichung ihres Systems, welche erzielt ist durch eine gewisse Emanzipierung von den anthropomorphen Elementen, speziell den spezifischen Sinnesempfindungen."

[5] Further drastic reinterpretations of Cubism are imminent. Above all, I believe that Picasso's Cubist pictures will dissociate themselves increasingly from those of his colleagues and be better recognized as a phase of Picasso's own continuing thought.

[6] The quotations are from *The Sculpture of Picasso*, Museum of Modern Art, Exhibition Catalogue, text by Roland Penrose, New York, 1967, p. 19; and Douglas Cooper, *The Cubist Epoch*, Exhibition Catalogue, Los Angeles County Museum of Art and the Metropolitan Museum of Art, New York, 1970, p. 25. See also John Golding's definition of "what the Cubists called 'simultaneous' vision—the fusion of various views of a figure or an object into one coherent whole" in *Picasso and Man*, Exhibition Catalogue, Montreal, 1964, p. 12. Cf. Marshall McLuhan, *Understanding Media*, New York, 1964, p. 13: "Cubism, by giving the inside and outside, the top, bottom, back and front and the rest, in two dimensions, drops the illusion of perspective in favor of an instant sensory awareness of the whole." McLuhan seems to confuse the totality of the picture with the supposed wholeness of the object depicted. His description of the alleged effect of Cubist rendering is of course based on his reading, and there hardly exists a more eloquent tribute to the power of the

André Lhote even argued the case in the form of a diagram, showing how the image of a drinking glass is conflated from various aspects to become Cubist. But the date of Lhote's diagram is 1952, whereas authentic Cubist tableware resists all such demonstrations. And no human figures in Cubist pictures ever came near such a program. Had comprehensive all-sidedness been the operational principle of Cubism, we would have to conclude that the true Cubist nude appears only in such late inventions as Picasso's *Grand Nu de femme*. Here indeed is a systematic conflation of a half dozen disparate aspects—its date, however, is not pre-World War I, but—like Lhote's diagram—post-World War II.

It is now apparent that Cubism sought neither a three-dimensional nor a "scientific" grasp of depicted form. Whatever objects or portions of objects remained recognizable during its "Analytical" phase (1909–12) were not faceted to demonstrate real structures, but the better to absorb their dismembered parts in the field. In the maturity of Cubism, human figures and implements, having crystallized into angular planes, began to break up; the facets disengaged, tipped and quivered in the thickening ground. The old hollowspace of narrative painting closed in. Pictorial space became a vibrating shallow of uncertain density, the equal footing of solid and void. The perceptual possessiveness which demands the illusion of solids was mocked. "In Cubist painting," writes Harold Rosenberg, "the object is grasped in tiny spurts of perception . . . a pile of clues submitted to an intuitive sense of order . . . it never reveals a 'tangible reality.' " [7]

Picasso's *Woman with Mandolin* ([Fig. 8], 1910) is like an allegory of Cubist process. A woman is there—well centered within the frame, and seen head-on as in any Renaissance portrait. A few telling clues indicate that she is nude, and the instrument in her hands is no secret. But the space behind, smooth at the upper left, is subtly mystified. Stacked rectangles nest in each other and cascade down the left margin. Those near the top read as stretchers and picture frames—a recessional of other art, somewhat as in the background of Poussin's Louvre *Self-Portrait*, except that Picasso makes his hard Cubist quoins fade in a dappled mist. Multipled downward, they seem to fill out as prismatic solids, their substance visibly interchangeable with that of the nude. Incomplete as they are, and never concretely localized, these prisms are the exchange medium between segments of body and geometric right angles. All pictorial action, all rhythmic movement depends upon transience and convertibility—back and forth between

printed word. In the very act of propounding the superior effectiveness of immediate sense stimuli, he succumbs to a verbal message diametrically contradicted by the sensory reality of the medium.

[7] Harold Rosenberg in *The New Yorker*, May 8, 1971, p. 104.

the modeled rotundities of the nude and the flats of the "background."
In this reciprocation, the depicted objects disintegrate beyond grasp-
ing, the disintegration accelerating in the "Analytical" Cubist works of
the years following. The material elements of the painting become
ever more palpable on the surface, the objects to which they allude
ever more evanescent.

This withdrawal from tangibility is an essential feature of Cubist
rendering. And the tendency is not reversed by such "simultaneities"
as a circlet hovering at the brim of a bottle, or the minute glimpse of a
short sidelong plane. A Cubist glass may erect its rim as a circle rather
than as the ellipse actually seen; and a rocking dice cube may show
more of its triple planes than is allowed in fixed-point perspective. But
such details have no bearing on the "objective reality" status of Cubist
objects, being subject to three conditions:

First: they are episodic, they lurk here and there, without
sustaining the general program. The pictorial space and its fill remain
squarely confronted from one position, like a relief.

Second: the few doubling facets that do occur belong to objects
of the most predictable familiarity. Instead of specific shapes fetched
from around top or corner, we get schematic tokens, so that the
information delivered is invariably such as the viewer already has:
everyone knows that the top of a tumbler is round. Similarly, a profile
nose placed on a frontal mask does not advance objective knowledge if
it suppresses the knowledge of its front aspect in favor of a schematic
hook. . . .

Third: the splaying-out of foreshortened facets, though derived
from Cézanne, comes to serve a new purpose: not to fortify the
masonry of interlocked forms, but on the contrary, to disassemble their
thinkable parts, so that conceptual disjunction parallels the visual
fragmentation of the whole field. In other words, in a Cubist picture
the here and there of divergent aspects is not designed to consolidate
body surfaces, but to impress the theme of discontinuity upon every
level of consciousness. Never is a Cubist object apprehendable from
several sides at once, never is the reverse aspect of it conceivable, and
no object in a work of "Analytical" Cubism by Picasso or Braque
appears as a summation of disparate views.

In the succeeding phase of Synthetic Cubism, the decade after
1913, the surfacing of averted facets becomes more frequent. But
these facets, along with other object reminiscences and material
scraps, are admitted as weightless fragments. A broken outline, a label,
the shape of a shadow, two floated facets and a length of contour
adrift—whatever is nameable can be sprung loose and moved on the
board. Again, the process is not a study or symbolization of structures,
but a pictorial dispersion of random parts. . . .

PICASSO AND THE PRESENT CRISIS OF ARTISTIC CONSCIENCE

Waldemar George

If some patient, humble, studious future historian should draw up a precise balance sheet of the attacks and crimes perpetrated by Pablo Picasso against tradition, I hope he will give the "1919 affair" a little more attention than that accorded it by modern critics. This was the time when Picasso was starting his cycle of large-format female bathers. His works threw the public, that malleable commodity, into consternation. Wielding their magic wands, those buffoons the critics tolled the passing bell of Cubism. Picasso's enemies were elated. Forgetting the *Saltimbanques* [Fig. 4], they bayed their supposedly dying quarry, lit bonfires in rejoicing, and initiated the era of public rejoicing with a full-scale scalp dance. The die was cast. Picasso, beaten down by ruin, had confessed defeat and admitted his faults—or in other words that his experiments were misguided!

While the servile crowd of hireling faultfinders, the small-minded camp followers, the uneducated journalists, the patriotic part-timers, and the unemployed painters were, like so many sheep, pronouncing a funeral oration over Picasso as life-giver to form, the mass of the faithful were leaving the courtyard of the Temple. Cubists-outside-the-pale and post-Cubists veiled their faces and scattered ashes on their heads as a sign of mourning. While some of them cast everything to the winds and burnt what they had once adored, others dug in their heels and continued along their accustomed way. These purists, these fanatics of absolute painting, these bastards of Pablo Picasso refused to follow the traitor. Come what might, they would defend the cause of abstract art!

Between 1920 and 1924, we were treated to a hilarious spectacle,

"Picasso and the Present Crisis of Artistic Conscience." From Waldemar George, "Picasso et la crise actuelle de la conscience artistique," in *Chroniques du Jour*, 2, 3–10, June 1929 (slightly abridged). Reprinted by permission of Madame Waldemar George. Translated by A. D. Simons.

the spectacle at once heroic and bizarre of second-zone Cubists taking up the defense of the Cubism not long previously created by Picasso, and doing so in order to attack Picasso himself. Those who were most zealous were not the least stupid, pedantic, and mediocre. Amid an immense flood of books and bookish arguments, they attempted to re-launch a style they had never adopted except in name. Their slogan was "Cubism or death." While the deserters from Cubism put together series of paintings which looked more like designs or stumbled along in the steps of the academic masters, the Old Guard goose-stepped into the infernal circle of the syntactical formulae established in 1914 at the period when the Kahnweiler Gallery was in its heyday.

Acting as god of war and military commander rolled into one, Picasso, in a single gesture, changed the artistic map of two worlds. All that was needed was for Surrealism to conquer the markets of France and Belgium and for Picasso to display to his subjects and confessors a series of new works treated in a style described variously as hieroglyphic and ideographic, and the devoted flock were back at his feet with restored confidence. How long before the dissident Cubists would return to the fold?

The cycle of large-format bathing women which covered the period from 1919 to 1923 and which gave rise to such bitter controversies was however an event of capital importance in the history of contemporary art [Fig. 10]. The revolutionary act accomplished by Pablo Picasso following the armistice at Rethondes was just as important as his campaigns of the years before the War.

If abstraction were the supreme objective of art (which it isn't always), I would say that never had Picasso been so abstract, so intellectual, so impenetrable, and so hieratic than in these large figures, structures with nothing human about them apart from their appearance.

Pablo Picasso's habitual quivering, nervous handwriting is muted to produce a drawing technique implemented with a tyrannical will to order and an Olympian rhythm. The painter annihilates the scale of proportion. He transgresses every norm. The universe in which the artist moved in his early days and at the time of the struggles he waged under the banner of Cubism was a physical, perceptible world (however hermetically sealed its nature). This was a world within the grasp of any man who wished to embrace it, understand it, and discover its key. The world he created in 1919, in contrast, was a refuge of demigods, giants, cyclops, and mythical heroes who lived in the rarefied, smogless air of the mountains and the celestial spheres.

This void, these deserted spaces, this nudity and plasticity of bodies draped in uniform color and subjected to the effects of a monotonous lighting, are elements worthy of meditation.

Having looped the loop completely, Picasso reverted to the emotions of classical antiquity. His Hellenism, his taste for the mysteries of the diurnal, his capacity for transmitting ideas using monumental forms as a vehicle—forms "larger than life," more expressive, more eloquent, and more uninhibited—placed him from the outset among the creators of a vision as pure, exalted, and "detached from things earthly" as to resemble that other vision of the ancient Greeks, those legendary builders of colossi.

The poetic and ideological apport of *nymphes, Nausicaa*'s blond companions, the *baigneuse, déesses,* and *symboles de fleuves* painted by Picasso resides in their fixed and immobile features, like theatrical masks, plaster casts, or mummies; in their bovine, unrealistic gaze; in their flowing draperies; in their statuesque bodies, those bodies so weighty yet so immaterial, whose volume, density, and spatial location partake of the domain of the spirit but remain entirely inaccessible to the senses. Picasso's women, these entities of the mind, are evocative of Hadaly, Villiers' *Future Eve,* fabricated by Edison after a Poe character with an artificial life superimposed.

The three-dimensional apport of these figures resides in their modeling, their presentation and their context. Before executing the work at full scale, Picasso worked up the details and the general design on the protective fabric of the canvas, taking no account of proportions. We see here an eye, a hand, or a toe detached from any functional relationship to the head, arm, or leg and a function solely of themselves, with their own context, their own intrinsic, specific value. Picasso had discovered objects as an end in themselves, objects segregated from their necessity, their fatality, and their relations and ties to the physical organism as a whole. In a picture by Pablo Picasso the exaggerated size of a finger is not determined, as might be thought, by some need for collective harmony or unity of line but by the desire to throw a volume into relief, to underline a significance, and to enhance projection.

I will not dare venture into the domain of probabilities. If I did dare, and if I had no fear of being the first victim of a hypothesis which is subject to discussion (as are all hypotheses), I would seek the occult meaning of the forms conferred by Pablo Picasso, that wizard with the characteristics of a tragicomic actor, and beyond the comprehension of his tribe. But what is the use of attempting, for reasons extraneous to the fine arts, to justify the birth of a formal repertoire which is its own advocate? Its advent upset all logical calculations. Little known, less understood, equated in style with the academic and pronounced unworthy, Pablo Picasso's anthropomorphic cycle seems to me to be among the expressions most exalted and richest in opportunity that his demoniacal or divine genius ever produced. . . .

THE DINARD PERIOD

Carl Einstein

In 1928, Picasso brought back from Dinard a number of small paintings of beach scenes. Then he worked on the cycle of three interiors that included *The Painter and His Model* [Fig. 11]. Here the hallucinatory has a terse, tectonic quality of which it may be said that there is a minimum of static forms and accents resistant to visionary flight. For static forms are barriers that are erected to stem the exuberant flood of spiritual outpouring.

But now the barricades of conservatism have been swept aside, the memories of past compromise abandoned, while in substitution appears an ascetic dedication to a novation which yet seems identical with an age-old way of seeing. The minimum of craftsmen's conventions is used, for the Void is the prerequisite for all creation. Objects had previously stood in the way of unimpeded formal creation, since they produced a dualistic rift and thus a weakening of the psyche.

In these pictures, all that is tautologically conservative is avoided, nor is there any recurrence of objects in their biologically accustomed form. Here we have pictorial creations which are subject-identified and released from the trammels of miscellaneous vision. The images thus created are unmetaphorical and need no legitimation, for the object-conditioned prison has been burst open. And whenever, here and there, traces of the objective do appear, the contrast produced is paradoxical. The imaginative, when not yet adapted to materially oriented conventions, is not susceptible of comparative proof; while reason, slower-moving when it indulges in allegory, will adapt even later.

At this point, Picasso has overrun the conventions of mediate

"The Dinard Period." From the chapter "Pablo Picasso" in Carl Einstein, *Die Kunst des 20. Jahrhunderts*, 2d ed. (Berlin: Propyläen-Verlag, 1931), pp. 95–97. Translated by A. D. Simons. Reprinted by permission of the publisher.

reality, still elsewhere the subject of fetish-worship, like some transcendental substance. The timid, confronted with these pictures, may speak of normality—a normality that to us appears defunct and a mechanical abstraction. This democratic fiction of normality it is which is constantly adduced to defend the mediocre and convert it by dishonest distortion into a criterion in its own right.

These pictures contain much of great human importance. No longer do we find a humble acceptance of what is given. The hallucinatory, the unconscious, no longer functions as a rigid constant (as with Freud) but as the driving force underlying all change. Here the static aspect connotes the intense compression of long yet fast-moving processes which, however, ultimately induce a reaction the more powerfully mobile. For pictures are a crossroads of psychic experience, where choice reinforces the good or evil factors.

The *Ateliers* have an austere and indeed archaic structure which serves as a bulwark against the ramblings of animistic delusion. This notwithstanding, these forms are not regressive in nature, for they make new spatial forms and connotations possible. The geometrical line is clearly definable, the object being rapid attainment of the dénouement. For in the final analysis, scientific verities mean limitation. The force of the Picasso line resides in the wealth and multiple significance of its relationships and the integration of the various axes of vision. Each form can be interpreted in relation to a number of spatial levels, yet all are oriented on a single plane.

In *Atelier I* the figures have clearly circumscribed fields of influence; indeed, auras would perhaps be a better word. In *Atelier II* the formal areas are sharply delimited and the symbols incorporated in the masks are positioned in correspondence with the perpendicular axes of the picture.

These creatures, themselves pure invention, wear masks of a design whose components are located in accordance with the overall composition. The canon followed is that of formality rather than biology, a law of transformation rather than of repetition. The living significance of these pictures consists in the validity of direct reality transcending naturalistic mechanisms. The viewer receives orientation in the true spirit of the composition, as dictated by the telepathy generated by the formal analogies of the invention.

These pictures are far removed from any description of psychic experiences in the manner of the superficial narrations of anecdotal genre-painting motifs. The terse language is matched to the speed of hallucination and to an elemental archaism. What Picasso was here creating was a series of figured images, creatures of a formal mythology far removed from commentaries and derived from formal immanence. The visions in their immediacy seem utterly remote from the commonplace and imitative. For these images derive from psychic

realms as yet untamed and outreach the calculations of reason. The old symbols—the stake, the skull, the house, and the womb—are here rediscovered. These works bear witness that today the isolated formulate the humanly typical, for they do not expend their strength in the fruitless detours of defunct convention. Yet this product of isolation expresses itself in the earliest of languages, that of collective symbols; and it is characteristic of this accursed age that the typical has been distorted to become false and exceptional.

Picasso is a signal of how much freedom this age could possess. He was never content with a merely passive perception. The only hope for Mankind is Man himself and that is why he is constantly compelled to achieve the apparently impossible task of invention. All creation consists in alienation of, and detachment from the self. With Picasso, the battle is between actual human structure and a superficial, atrophied reality. To him, art meant a continuous expansion of consciousness. He does not stop short at grotesque, distorted reproduction; and facetious canting comparison reducing each party to a mere allegory is avoided. Even the shadows of his images do not duplicate their originals but represent some other of the many contradictory emanations of Man. For even shadows are antagonists, and Janus ceases to be a reflection of the ego and becomes a symbol of transformation and antithesis. Picasso realized that the autonomous image postulates the death of reality. Yet reality is thereby reinforced, to the extent that new masses of imagination are projected into it.

These pictures ruthlessly abrogate all reality extraneous to themselves. Yet Picasso provides his hallucinations with a dense formal protection produced by the sharp tectonic segregation of his figures. The passive psychograms of intuition no longer suffice here. The tectonic element serves the picture somewhat as rhyme or division into acts serves a tragedy.

Here we have to do with mantic, psychographic parturition. Picasso substitutes the tectonic for the subjective and thus types his inventions. He confronts the fatality of the unconscious with the will to attain precise configuration, and his pictures thus represent a field of tension between the two poles—as it might be, an endogenous dialectic, or a polyphonic psychic structure.

Picasso shows that reality is for Mankind to discover and that it constantly dies and must be rediscovered. A mantic possession enabled Picasso to attain mythical images and states of being. Man ceases to be a mirror of the future and becomes the agent making that future possible. Figural myths such as these seem to us to convey greater truth than the representational, for their incomparability renders them irrefutable.

Picasso's cyclic existence demonstrates a ruthless expenditure of form and a powerful contempt for fetishes. He projected *blocs* of

invention and myth into spent reality. He did not allow himself to be imposed upon by the limitations of artistic practice. Picasso invented cycles of myths to serve his epoch. He demonstrates that Mankind and the world are daily invented by Man himself.

PICASSO
AND THE ANATOMY OF EROTICISM
Robert Rosenblum

No other great artist of our century has explored so wide a variety of human experience as Pablo Picasso; nor has any other modern artist considered the diversity of human behavior from so many different and even contradictory viewpoints. Within Picasso's vast scope, sexual themes are recurrent, and are subjected, in general, to interpretations consonant with the artist's preoccupations of the moment. Thus, in the early, pre-Cubist years, Picasso's occasional excursions into erotic art reflect, on the one hand, the libertine ambiance of an artist's Bohemia[1] or, on the other, the passive desperation of the ascetic figures who populate the works of the "Blue Period." [2] In the Cubist years, the rare references to sexual themes are, expectedly, intellectualized in the form of witty and risqué verbal puns concealed within a complex formal structure;[3] and in the Neoclassic years of the late teens and early 1920's, sexual motifs are generally interpreted in the guise of classical erotic mythologies.[4]

Robert Rosenblum, "Picasso and the Anatomy of Eroticism." Chapter 5 of Theodore Bowie and Cornelia V. Christenson, eds., *Studies in Erotic Art* (New York: Basic Books, Inc., Publishers, 1970), pp. 337–50. *Studies in Erotic Art* is a volume in the series "Studies in Sex and Society," sponsored by the Institute for Sex Research. © 1970 by Institute for Sex Research, Inc., Basic Books, Inc., Publishers, New York. Reprinted by permission of the editors and the publisher.

[1] As in the bedroom scene of the artist himself and a nude woman in the act of fellation; illustrated in Ove Brusendorff and Poul Henningsen, *Love's Picture Book* (Copenhagen, 1960), II, 112.

[2] For example, the 1904 drawing of a lean and bony couple who copulate in a joyless grip; illustrated in David Douglas Duncan, *Picasso's Picassos* (New York, 1956), p. 204.

[3] As in the clipping that spells out TROU ICI and is pasted under a lingerie advertisement in a Cubist collage of 1912; illustrated in Christain Zervos, *Picasso: oeuvre catalogue* (Paris, 1932 ff.), II (2), 378 (hereafter abbreviated as *Zervos*).

[4] For example, in a series of drawings of a centaur abducting a woman (1920),

Such motifs, however, are relatively peripheral to Picasso's art until the mid-1920's. Then, for nearly a decade, the multiple aspects of sexual experience become a major obsession in his imagery, a phenomenon that may be explained, in part, by both public and private reasons. In public terms, this surge of interest in sexuality is a direct parallel to the official launching of the Surrealist movement in 1924, with its willful efforts to create an art and a literature that could release those suppressed wellsprings of erotic impulse which Freud had found basic to an explanation of human behavior.[5] And in private terms, this new fascination with the erotic may also reflect the particular tensions of Picasso's own life during these years, a period in which a growing hostility toward his wife, Olga Koklova, in the late 1920's was followed, in the early 1930's, by a period of erotic harmony in the person of a new mistress, Marie-Thérèse Walter.[6] Whatever the value of such speculations (and it should be cautioned that an art as complex as Picasso's can seldom be explained satisfactorily by a single one-to-one correlation with the events of his personal life), there is no doubt that during the years that concern us here, from about 1927 to 1933, Picasso devoted much of his energy to the creation of images corresponding to the psychological and physiological realities of sexual experience.

These realities, as interpreted by Picasso, cover an enormous range. At times, sexual impulses, particularly those of women, are seen as menacing, brutal, and destructive; in other cases, these forces are viewed as almost Rabelaisian jokes that turn man into a clumsy, comical creature; and elsewhere, eroticism is celebrated as a lyrical, tender experience saturated with the magic of love and the miracle of procreation. Needless to say, these interpretative possibilities are by no means mutually exclusive, but form, rather, only some of the major leitmotifs which Picasso explores and combines in the rich, multi-leveled visual metaphors of these years.

The image of female sexuality as a monstrous threat dominates the work of the late 1920's, especially in paintings that juxtapose a

probably to be identified as the myth of Nessus and Dejanira. For illustrations, see the exhibition catalogues *Hommage à Picasso* (Paris, Petit Palais, 1966–1967) (dessins, No. 66) and *Picasso: 75th Anniversary Exhibition* (New York, Museum of Modern Art, 1957), p. 51, where three of these drawings are reproduced.

[5] I have elaborated the problematic relationship of Picasso to Surrealism in a short essay, "Picasso as a Surrealist," in the exhibition catalogue *Picasso and Man* (The Art Gallery of Toronto, 1964), pp. 15–17; reprinted in *Artforum*, V (September, 1966), 21–25.

[6] The importance of Picasso's amorous life to the sexual character of his work of these years is stressed in the important study by Jan Runnqvist, *Minotaurus: en studie i föhallandet mellan ikonografi och form; Picassos konst 1900–1937* (Stockholm, 1959); and in John Berger, *The Success and Failure of Picasso* (Harmondsworth, 1965).

male profile of classical beauty with a female head of grotesque ugliness. Characteristically, these works may be read on many levels, both public and private, aesthetic and psychoanalytic. Thus, if they may be seen as demonstrations of Picasso's capacity, after the critical years of Cubism, to work simultaneously within different and contradictory styles (a point made explicit in the artist-and-model series executed in 1927–1928 [7]), they also suggest an image of hostile sexual confrontation between male and female, which may in turn originate in the growing personal frictions between the artist and his wife Olga.[8] In all of these works, the rationally ordered artist's world of rectilinear framing elements and of timeless serenity is shrilly assaulted by female heads of nightmare horror and violence. In one [Fig. 12], the female head almost seems to be an internal, psychological menace, a gaping maw with savage teeth and red barbed tongue that assails the profile from behind and from within its contours. In another, [*Zervos*, VII, 144] this succubus is momentarily caged, squirming, within a frame, although a spearlike tongue form protrudes to assault the male profile's open mouth. And in another, [*Zervos*, VII, 125] an amoeboid head, with a stitched mouth, swells toward the artist and threatens the space between him and the T-shaped form suggestive of picture frames, stretchers, and easels.

In such female heads, humanity is reduced to a subrational, bestial level, almost a pictorial equivalent of Freud's concept of the id. Indeed, in their descent down the ladder of evolution to primitive biological forms and functions, these heads can often take on strong sexual connotations, even to the point where human physiognomy is related, in visual puns, to sexual organs. That such associations were fully as much in the mind of Picasso as in that of the viewer attuned to psychoanalytic speculations may be demonstrated by several drawings of 1929, preparatory to a painting of 1930, the *Crucifixion*.[9] Here, in studies of female figures wracked with grief, [*Zervos*, VII, 279, 280] the head is thrown back, upside-down, in a manner that confounds it with a view of the female pubic region. In the variations upon this theme, the metaphor is expanded in fantastic reshufflings of anatomy that produce startling biological configurations that may be read simultaneously as mouth and vulva, breasts and testicles, nose and penis, head hair and pubic hair.

[7] Especially in the version that represents a grotesquely disfigured model who is translated by the artist into the traditional beauty of a classical profile (*Zervos*, VII, 243).

[8] Indeed, the profile is frequently identified as a self-portrait. See, for example, Roland Penrose, *Picasso: His Life and Work* (2nd ed.; New York, 1962), p. 235.

[9] *Zervos*, VII, 287. The *Crucifixion* and the related drawings are briefly discussed by Penrose, *op. cit.*, p. 235.

Such preoccupations with Freudian sexual metaphors were not unique to Picasso, but were shared by much Surrealist imagery of the 1920's and 1930's, not only in the work of Miró but in that of the more photographic double and triple images invented by masters such as Dali and Magritte. A case in point is Magritte's *Rape* of 1934, in which a female head and torso are combined in a visual pun that recalls as well the erotic double images of popular postcards published in the Surrealist magazine *Minotaure*.[10] Yet Picasso's art, freed from the realist premises of Dali's or Magritte's Surrealism (which permit only a finite number of readings of a multiple image), could create infinitely more evocative puns and metaphors. Thus, in his treatment of the human head alone, the sexual analogies invented are prodigious. In one case, that of a harlequin head, [*Zervos*, VII, 74] the mouth is aligned vertically to produce a vulva shape; in another, a fantastically scaled dream monument [Fig. 13], the vertical slit of the mouth is armed with tiny sharp teeth which evoke that Freudian metaphor of psychosexual castration fear, the *vagina dentata*. At times, the metamorphosis of a head into sexual organs is associated with a sleeping female figure, as if the relaxation of consciousness exposed the sleeper's repressed sexuality. Thus, in two paintings of 1927, [*Zervos*, VII, 71, 72] a nap in an armchair permits the female sitter's mouth to open in sphincteral forms, round and oval, whose inherent savagery is emphasized by the continuous rings of teeth and, in one case, by the upward projection of a pointed red tongue. Or in other paintings of wakeful sitters, [*Zervos*, VII, 361, 357] the soft, padded comfort of an armchair is confounded with limp limbs which take on a potentially erectile quality that underscores the gross sexuality of the mouth's gaping, voracious slit. Such metaphors are paralleled closely in the work of Picasso's compatriot Miró, whose *Woman* of 1934, for example, offers analogies to these translations of the female head and body into primitive organs of almost exclusively sexual function. Similarly, in Picasso's sculpture of the early 1930's, the bronze female heads often appear to be composed of pendulous phallic forms that become synonymous with hair and nose [Fig. 14].[11]

The sexual creatures Picasso invented range from sadistic monsters, armed with fanged teeth, barbed tongues, and cutting carapaces, to unicellular blobs, whose tumescence transforms them into ludicrously clumsy shapes barely capable of performing their urgent functions. Such is the case in a drawing of 1927, [*Zervos*, VII, 99] in

[10] No. 3–4 (1933), p. 89. Magritte's *Rape* was also used to illustrate the cover of André Breton, *Qu'est-ce que le Surréalisme?* (Brussels, 1934). For a reproduction of this cover, see Patrick Waldberg, *René Magritte* (New York, 1965), p. 158.

[11] The sexual metaphors of these sculptures are underlined in Berger, *op. cit.*, pp. 159–160.

which the setting is a seaside resort, a locale that often creates in Picasso's work of these years an ambiance where the human species can cavort, far from civilization, in a maximum of animal abandon. Here, a grotesquely swollen female nude, composed entirely of the same erectile tissue, attempts, with a fingerless hand, to manipulate a key in the lock of a beach cabana.[12] This action, recurrent in Picasso's seaside paintings and drawings of the late 1920's, introduces yet another metaphor whose sexuality would be apparent even without knowledge of Freud.[13]

Even more androgynous and tumescent is the sexual monster in another drawing of 1927, [*Zervos*, VII, 109] whose pneumatic plasm has expanded to a gravity-defiant stiffness that stands with momentary monumental grandeur in a hideous yet comical parody of the distorting protuberances produced by sexual excitement. These bizarre beings continue into the early 1930's, as in the *Bather with a Ball* of 1932 [Fig. 15], in which another humanoid creature is seen in pursuit of her prey, a beach ball.[14] Appropriate to the imagery of the seaside game she plays, the flesh of the woman first evokes the rubbery gray matter of a beach ball itself, and then, in an inspired pun, goes on still further to confound human anatomy with the gummy substance of another object familiar to the seashore, a squid. As the human head is transformed into an inflatable bulb and the wind-blown hair turns into jet-propelled tentacles, the vertical mouth becomes simultaneously a squid's air vent and a vulva, so that, finally, the whole figure is metamorphosed before our eyes into a submarine creature obeying a primal urge.[15]

The protean fertility of Picasso's genius for inventing such complex biological fantasies is nowhere illustrated more succinctly than in the series of erotic anatomical drawings, dated February 22, 1933, which were published in *Minotaure* under the title *Une Anatomie.*[16] Here, not only are male and female organs juggled into totally ambiguous hermaphrodites, but sexual functions are even

[12] Picasso himself has referred to his fascination for keys and to their appearance in these scenes of bathers. See Antonina Vallentin, *Picasso* (Paris, 1957), p. 90.

[13] It may be noted that the sexual connotation of inserting a key in a lock is so basic that the Italian slang word for copulate is *chiavare*.

[14] I have also discussed this picture briefly from a somewhat different viewpoint in "The Unity of Picasso," *Partisan Review*, XXIV (Fall, 1957), 593.

[15] The confounding of a cephalopod with a human being is prefigured, incidentally, in Hokusai's print of an octopus in amorous play with a woman (illustrated in Chapter 3 of *Studies in Erotic Art*). Other sexual associations between human and marine creatures are found often in Surrealist imagery, as in Magritte's *Collective Invention* of 1934, which parodies the newborn Venus on the seashore as half-fish, half-human; illustrated in James Thrall Soby, *René Magritte* (New York, 1965), p. 28.

[16] No. 1 (1933), pp. 33–37.

conflated with man-made mechanical and carpentered parts. Funnels, chairs, cups, paired balls suspended by wires, are all absorbed by these erotic creatures, whose very torsos and heads can become ithyphallic and whose precarious equilibrium between the mechanical and the organic evokes a bawdy circus of sexual acrobatics.[17]

In most works of these years, diverse sexual behavior is conveyed through single figures, almost always female or androgynous, rather than through sexually active couples. Nevertheless, some works of this period do represent sexual couplings, interpreted with a comparably amazing variety that can swiftly change from the tragic to the comic, the sadistic to the gentle, the grotesque to the beautiful. In a pair of kissing heads of 1931, [*Zervos*, VII, 325] one finds a whimsical statement of the discrepancy between sexual passion and modern manners. Man and woman assault each other with a familiar animal savagery of bristling hair, gnashing teeth, and barbed tongue, yet the lady closes her eyes demurely and the pair modestly conceal their bodies under what would appear to be a sheet. The juxtaposition of brute sexual instinct with the constraints of modern civilization recalls the irony of many of Picasso's other works in which the orderly trappings of modern man—beach cabanas, armchairs, middle-class interiors—are startlingly contrasted with the revelation of a monstrously primal sexual force.

In an earlier related work of a kissing couple, [*Zervos*, VII, 313] the situation is far less specific in time and place, so that the couple now seem more unequivocally primitive in their clashing encounter. Sexually differentiated only by the pattern of their hair, this man and woman are about to devour each other with spearlike tongues and locking noses, a grotesque reminder of the physical awkwardness and sadism implicit in an erotic kiss. Members of the same species are seen copulating in other works of these years, such as a painting of 1931 that again uses the seashore as an environment conducive to bestial liberty. [*Zervos*, VII, 328] Once more, the cabana introduces the irony of a modern setting, almost a symbolic shell of decorum into which the figures can retreat after they have disrobed and abandoned themselves to natural biological forces. Balanced in a difficult interlocking of heads, limbs, and torsos, they look at once animal and human, their brute energies countered by the almost tender caress of

[17] These comical forms, both hermaphroditic and mechanistic, are verbally paralleled by the well-known limerick:

> There once was a man from Racine
> Who invented a fucking machine.
> Concave and convex,
> It would fit either sex,
> With a bucket beneath for the cream.

the male's caliper-like left arm, their tough hides softened by the suggestion of pink, sunburnt flesh.

Although the representation of a copulating couple is relatively rare in Picasso's work, in one year, 1933, he did execute a number of astonishingly imaginative variations upon this theme. At times, the motif was seen in classical guise, with one of Picasso's recurrent mythological symbols, the minotaur, as a male assailant who rapes his partner.[18] Half-bull and half-man, the minotaur is particularly appropriate to Picasso's frequent association of sexual desire with the eruption of bestial forces, though it should also be noted that this theme of pagan eroticism was paralleled at the same time by Matisse, whose illustrations for Mallarmé's *L'Après-midi d'un faune*, reproduced in the same number of *Minotaure*[19] as Picasso's *Une Anatomie*, similarly represented a subhuman mythological creature, a satyr, pursuing a nymph. But, characteristically, Picasso explored this theme down to its biological roots in a series of brilliant metamorphoses.[20] In one drawing, the locked limbs and torsos still seem as human as in the minotaur drawing, but the heads of the sexual partners are transformed into images of more basic sexual instinct—that of the male becomes phallic, that of the supine female becomes a multiple organic form that suggests buttocks, vulva, and leaf. The equation of sexual passion with the unleashing of primal animal urges is seen even more fantastically in a drawing of a couple copulating on a beach near a cabana [Fig. 16]. Here, the intricate maneuvering of limbs and torsos is geared solely to the brutal plunge of a gigantic penis into the female, an act whose inexorable force reduces the partners to a pair of brontosaurus-like monsters, whose tiny, reptilian heads look pitifully helpless and exhausted. Even lower on the biological ladder than these love-making fossils is another copulating couple who now pertain far more to a submarine species of crustaceans or mollusks than to the human race. [*Zervos*, VIII, 149] Their male and female hair flowing like antennae in aquatic currents, they lock shells in an armored sexual embrace. Other copulation drawings of 1933 introduce more comical elements. In one, the sexual encounter takes place on what appears to be a bed, a civilized intrusion that makes the couple's animal metamorphoses all the more bizarre. [*Zervos*, VII, 107] Both male and female fingers turn into clumsily outstretched, doglike claws, whereas the heads descend to even lower biological realms. Once again, the

[18] For another version of this minotaur rape, see *Zervos*, VIII, 12.

[19] No. 1 (1933), p. 72. These drawings were preparatory studies for the de luxe Skira edition, *Poésies de Stéphane Mallarmé* (Lausanne, 1932).

[20] These metamorphic copulation drawings, oddly enough, seem to be ignored in the Picasso literature, with the exception of Runnqvist, who briefly mentions them and illustrates one of them (*op. cit.*, p. 122).

female head turns into buttocks, vulva, and leaf, whereas the phallic shaft of the male neck blossoms into a kind of sea anemone, its antennae alertly extended. In another pure line drawing of a copulating couple, sexual activity is confounded not only with organic but with mechanical metaphors. [*Zervos*, VIII, 109] Here, above the serene horizon of the sea, the male, from the waist up, is miraculously airborne, a fantastic Freudian flying machine. His head becomes a steering wheel that permits him to locate and to drop his mechanistic genitals just above their female goal, the rotund womb of a fertility goddess, whose round head and buttocks are merged in generative harmony with the circular plant growth of the earth below. In yet another copulation drawing from this series, Picasso distills an image of such purity and economy that we might not recognize its sexual theme without knowledge of the related drawings of 1933. [*Zervos*, VIII, 106] Here, only a minimum of organic shapes creates the quintessential statement of copulation—above and airborne, the tense thrust of the male genitals and blocky torso; below and earthbound, the swollen belly and buttocks and the extended head of an archetypal supine female form. And the whole is seen in the context of a natural setting that offers an encompassing trinity of earth, water, and sky. Again, it may be worth mentioning that, although the genius of these drawings is uniquely Picasso's, their conception and form are paralleled in the work of other artists, in particular Miró, whose art so often bears analogies to Picasso's. Thus, Miró's *Lovers* of 1934 similarly turns a human couple into a grotesquely encumbered pair of subhuman creatures who desperately manipulate their amoeboid bodies and tiny heads to accommodate the urgent thrust of an enormous red penis.

Indeed, in his exploration of sexual imagery, Miró at times may even have preceded Picasso, especially in his conception of the female figure as a wellspring of procreative forces, a conception which Picasso investigated intensively only in the early 1930's. As early as 1924, Miró's *Maternity* announced this theme: a creature both mammalian (to judge from the breasts viewed frontally and in profile and the young that suckle at them) and submammalian (to judge from the featureless head and antennae) becomes a metaphor for biological fertility, a theme further underlined by the wriggling spermatic form that flows toward the egglike breast.[21] Or in the *nude* of 1926, Miró metamorphoses a female form into a burgeoning tree, a Freudian Daphne from whose maternal trunk leaves and fruit blossom forth. Such veneration of female sexuality as a positive, life-giving force

[21] The same theme is made as explicit in another Miró of 1924, *The Family*, in which the central female figure is dominated by a large vagina that forms the burgeoning, life-giving core of the entire family; illustrated in James Thrall Soby, *Joan Miró* (New York, 1959), p. 38.

contradicted the pessimistic mood of Picasso's female monsters of the late 1920's, whose sexual attributes and functions are usually destructive, like those of a female praying mantis.[22] But soon after, in the early 1930's,[23] Picasso adapted this alternate interpretation at a time when his wife Olga was replaced by a new mistress, Marie-Thérèse Walter, who seems to have inspired a series of works that view the female form as a passive, fecund vessel of biological mystery rather than as an aggressive, menacing trap.[24]

In *Woman with a Flower* of 1932, [*Zervos*, VIII, 381] the Miró-like head and hair become a pun on a sprouting seed, a germinal image which is further elaborated in the vigorous, tendril-like arms that pinwheel outward from the fruitlike breasts, and the curling stem and flower that likewise seem to grow from the fingers themselves. Generative metaphors are even richer in a series of reclining or sleeping nudes of 1931–1932 that may reflect the penchant of the blond, voluptuous, and placid Marie-Thérèse for napping and slumbering. In one of these works of 1931, [*Zervos*, VII, 332] the relaxation of consciousness induced by sleep turns the figure into a human still life. A green leaf sprouts from the extended fingers; two pears in the right foreground are echoed by the two ripening breasts; the lunar and seedlike head, enclosed in a dark, uterine cushion, matures with the solar heat of dawn, whose warm rays are echoed in the fiery, radiant patterns of the wallpaper. Similarly, in another sleeping nude of 1932 [Fig. 17], human and vegetal images are again confounded. Here, a philodendron plant, nurtured by the orange-red heat of the rising sun, virtually grows from the loins of the nude sleeper, just as a white flower blossoms from her fingers, and her blond hair becomes a pun upon a seed that appears to be fertilizing an ovarian breast. It is worth noting that even in still lifes of these years, like one of 1931, [*Zervos*, VII, 317] both the fruit and the inanimate forms of the table legs, pitcher, and bowl are charged with an intense, organic vitality, a tangle of churning, burgeoning shapes whose black spots within swelling spheres evoke the germinal force of fertilized seeds.

These metaphors of procreative magic and energy attain their

[22] The simile of a praying mantis is borne out, in particular, in such insectile heads, complete with vertical mandibles, as found in the *Seated Bather* of 1930 (*Zervos*, VII, 306).

[23] The date of the beginning of Picasso's relationship with Marie-Thérèse is frequently given as 1932, but Berger (*op. cit.*, p. 154) gives it as 1931. That Picasso did, in fact, know her in 1931 is suggested by the appearance in paintings of that year of the blond, lunar head associated with Marie-Thérèse. See, for example, the 1931 Cecil Beaton photograph of Picasso before such a painting; illustrated in Ronald Penrose, *Portrait of Picasso* (New York, 1957), p. 56.

[24] The profound impact of Marie-Thérèse on Picasso's art is particularly emphasized in Runnqvist, *op. cit.*, pp. 108–117, and in Berger, *op. cit.*, pp. 154 ff.

richest form in two paintings of 1932 that introduce a mirror as yet another motif that may generate sexual imagery. In the earlier of the two, *The Mirror*, a sleeping blonde is seen before a mirror whose circular shape is warped into a more spiraling organic form of uterine connotations. [*Zervos*, VII, 378] Indeed, the image reflected in the mirror is not that of the sleeper's head, but that of her buttocks and groin, from which curls forth, along the reflection of the yellow seedlike hair, a green stem, as if from a fertilized seed. Such a conception of woman as a virtually headless bearer of pulsating, biological forces was familiar to these years, witness Arp's so-called Human Concretions[25] of the 1930's or even the photographs by Picasso's friend Brassai, whose studies of female nude torsos, their heads excluded from the camera's range of vision, were reproduced in the first issue of *Minotaure*[26] and offered a photographic equivalent to this equation of the female nude with a primal goddess of fertility.

In Picasso's art, these meditations reached their summit in the great painting of 1932, the *Girl before a Mirror* [Fig. 18], whose imagery, like that of another masterpiece completed in the 1930's, James Joyce's *Finnegans Wake*, is so dense and metamorphic in its constantly fluid evocations of human and biological archetypes that only a few of its multi-leveled metaphors may be suggested here.[27] However, it can at least be said that this work synthesizes many of the sexual themes that preoccupied Picasso at this time. For one, female sexual impulses are conveyed in a series of transformations that evoke these welling biological forces and that contrast virginity and consummation. Thus, the lavender profile view of the girl, enclosed by a white veil-halo, suggests an overt innocence that opposes the more covert frontal view of a rouged cheek and lipsticked mouth upon a glowing, golden face; moreover, the ripening forms of breasts, womb, and buttocks are temporarily constrained by the rectilinear armature of the corseted, skeletal form which holds the figure taut from behind and by the angular frontal silhouette which suppresses the organs of generation that swell toward fulfillment. Furthermore, this tense ambiance of the awakening of sexual desire is underlined by the androgynous puns so common to Picasso's work of these years and soon to receive their most explicit statement in *Une Anatomie* of 1933. Thus, the anatomies

[25] Arp applied this generic title to many of his sculptures of this decade which reduce the human organism to a sub-intellectual, biological state of germinating plasm. The best-known example is that of 1935 in the Museum of Modern Art, New York, illustrated in James Thrall Soby, *Arp* (New York, 1958), p. 65.

[26] No. 1 (1933), p. 43.

[27] The only close study of this painting is that by Carla Gottlieb, "Picasso's *Girl before a Mirror*," *Journal of Aesthetics and Art Criticism*, XXIV (Summer, 1966), 509–518. Some highly suggestive comments about its multiple symbolism are found in Wylie Sypher, *Rococo to Cubism in Art and Literature* (New York, 1960), p. 280.

of both the girl and the mirror image that she embraces and contemplates evoke their male counterparts. In particular, the upraised left arm of the girl becomes, especially in conjunction with the testicular pair of breasts directly below it, an ithyphallic form whose sprouting fingers, in turn, metamorphose it into an image of generation, a kind of Aaron's rod. Later, in *Guernica*, when concerned in a different way with the female as the perpetuator of the human species, Picasso would again seize the visual and poetic analogy of male and female reproductive forms, this time by the close pairing of the testicles of the victorious bull with the breasts of the woman grieving over her dead infant.[28]

Once more, as in the sleeping nudes of 1931–1932, the *Girl before a Mirror* conveys the procreative attributes of sexual desire by a kind of vegetal imagery. The hair that adorns the girl's virginal profile is again seedlike; its mirror reflection is of a green tendril. Indeed, the anatomical zones of sexual function are generally verdant; and the breasts are like ripening fruits that exert organic, burgeoning pressures upon the concentric arcs and circles that surround them. Perhaps most telling is the black, nipple-like spot on the breast reflected at the right of the mirror. As if newly fertilized, this egg shape blossoms forth with a green sprout that in turn is continued above in the green protective layer which surrounds a half-formed head of strange, primitive mystery, both embryo and death mask. Uterus and shroud, the oval enclosure of the mirror image carries within it the wonder and terror of the ultimates of human experience. For Picasso in the *Girl before a Mirror*, these ultimates meant primarily the biological cycle of life, death, and rebirth, a cycle perpetuated by those sexual tensions which, from 1927 to 1933, also created a reigning muse, alternately monstrous and lyrical, for his art.

[28] The possibility of a sexual interpretation of *Guernica* has been suggested briefly by James R. Mellow in "Picasso and the Shy Psychologist," *Lugano Review*, I (Summer, 1966), 99.

PICASSO'S POETRY

Clive Bell

It is customary when a great artist in one medium tries his luck in another not to take him seriously. On this occasion custom must be dishonored. The poems of Picasso will have to be taken seriously, if for no other reason, because they throw light on his painting: also it is only as throwing light on his painting that an "art critic" is entitled to discuss them. To me it seems that even these fragments published in *Cahiers d'Art* will help anyone who needs help—and who does not?—to follow, through Picasso's visual constructions, the workings of Picasso's mind. Often in the poems, which are essentially visual, the connection of ideas, or, better, of ideas of images, is more easily apprehended than in the paintings and drawings. Picasso one realizes, whether one likes it or not, Picasso, the most visual of poets, is a literary painter. He always was: again and again his pictures express an emotion that did not come to him through the eyes alone. Matisse, by comparison, is aesthetic purity itself; and that may account to some extent for the wider influence of Picasso. Notoriously his pictures of the blue period are so charged with a troubling and oppressive pathos that they have been called, not unfairly I think, sentimental. And though the immediate content of all his work, about which I shall have something to say presently, is an association of visual ideas set in train as a rule by a visual fact—the stump of a cigarette or a naked body, behind lie certain emotional preoccupations from which the artist has never freed himself and perhaps has never wished to free himself. Always he is aware, not exactly of human misery, but of the misery of being human. Always he is aware of women. Lust and disgust, women's bodies, women's ways, and what Dryden elegantly calls "the feat of love" are to this artist sometimes visions of delight, sometimes

"Picasso's Poetry" (editor's title). From Clive Bell, "Picasso," in *New Statesman and Nation*, 11, May 30, 1936, pp. 857–858. Reprinted by permission of the publisher.

nightmares, negligible never. To deny the importance, for better or for worse, to the art of Picasso of femininity is, it seems to me, about as sensible as to believe that Shakespeare's sonnets were academic exercises.

It goes without saying that, in his visual art, it is not the ideas, but the connection of ideas that matters. This is equally true of what he writes; just as it is true of what Mallarmé or Eliot write. Picasso is a poet—a modern poet. Peacockians will remember how Mr. Flosky, Peacock's caricature of Coleridge, snubs the pathetic Mr. Listless when he complains that he does not see the connection of his (Mr. Flosky's) ideas: "I should be sorry if you could; I pity the man who can see the connection of his own ideas. Still more do I pity him, the connection of whose ideas any other person can see." Picasso, on the contrary, is not only willing that you should see the connection of his, he seems to suggest that if you do not you will miss the full significance of his art. The task he sets is not simple: happily in *Cahiers d'Art* we find one of those examples, too rarely found in works of aesthetic exegesis, which, themselves easily understood, help us to understand things more difficult. Picasso wrote this line:

le cygne sur le lac fait le scorpion à sa manière

A friend asked him what he had in mind. The artist picked up a pen and scribbled on the back of an envelope a swan floating on sleek water which reflects exactly the bird's long sickle-shaped neck. Anyone who will make the experiment for himself will perceive that he has designed the image of a scorpion in the swan's manner.

Let us apply the method here suggested to a more difficult case: "le tabac enveloppé en son suaire à côte des deux banderilles roses expire ses dessins modernistes sur le cadavre du cheval sur la cendre écrit sa dernière volonté au feu de son oeil." In all humility, with apologies to the author and cautions to those who need them, this I paraphrase thus: "the tobacco swathed in its winding-sheet, a rose banderilla on either side, dies, and dying writes its 'modernistic' drawings on the body of the horse, on the ash writes its last will with the fire of its eye." This is Picasso's sense, expressed verbally, of what was suggested by a cigarette smouldering to its end in, I surmise, one of those Bon Marché ash-trays with the picture of a horse on the bottom—a tray full of ash and stumps, two of which may have been belipsticked. This is what he saw with imagination's eye. Does it not make us see a still-life by Picasso? And, the words read, the connections grasped, do we not half divine by what strange but controlled processes of imagination the master arrives at some of his beautiful, expressive, patently logical yet barely intelligible combinations of forms?

PICASSO AND SURREALISM

James Thrall Soby

Picasso's non-official support in 1927 rescued Surrealism from premature oblivion, since at that time the movement was badly in need of a major artist to extend its fame. In that year, Picasso's sudden preoccupation with psychological meaning, and with emotional elements in painting, came as a sharp contrast to the baroque order of his 1925 and 1926 abstractions. The Surrealists claimed naturally that Picasso had become, despite himself, a Surrealist, and that he had been influenced by the ambitions, if not by the work, of the Surrealist artists. This, however, seems less probable than that, entering middle-age, Picasso went through one of those inexplicable convulsions of spirit which have characterized the brilliant procession of his work. Then it must be remembered that his paintings of the Blue and Rose periods were surcharged with emotion, and that in those paintings there are traces of the psychological contortions which now he uses with a different meaning. Just as the Neo-Classic period is definitely foreshadowed in pictures of the late Rose period, so the subconscious romanticism of his late pictures has antecedents throughout his career.

Even if he was influenced by the Surrealists, he transformed their minor art into a superb monument to the forces underlying Surrealism. As early as 1925, in an enormous painting called *La Danse*, he prefigured much of the Surrealist painting which would be achieved before the arrival of Dali's system of paranoiac symbolism. In 1927, he turned briefly to the *collage*, and used the process with brilliant results. In the *collage* illustrated, [Fig. 19] the strange distortions of the figure take on a super-human meaning and are opposite to the static

"Picasso and Surrealism." From James Thrall Soby, *After Picasso* (Hartford: Edwin Valentine Mitchell; New York: Dodd, Mead & Company, 1935), pp. 96–99. Reprinted by permission of the author.

88

deformations of his previous abstractions. The same year, after making numerous studies and drawings, he painted the *Seated Woman* [Fig. 20], a Surrealist icon which strikes one with a tremendous and uncanny force. The austerity of his abstractions is retained, but the figure has a psychological power which far surpasses anything achieved by the Surrealists themselves. And just as the clawfingers of the *Seated Woman* and the teeth of the *Figure* [Fig. 26] ally him with the paranoiac cruelty of the newer Surrealists, so the monstrous forms of his later works [Fig. 21] seem to proceed from a subconscious and delirious vision.

Throughout the three years from 1927 to 1929, Picasso abandoned the formal order and restraint of his earlier paintings for an actively malignant subject-matter in which strange abstract forms move disturbingly through his canvases. Vicious and powerful heads appeared in his pictures, and were painted with a restless and sharp intensity. For the first time in years, Picasso's paintings struck directly at the emotions rather than at the intellect. Still, he never lost for a minute the deliberate and final dignity of great art which the Surrealists themselves were only too ready to throw overboard. His new devotion to human values connoted, it must be, a final outburst of that romanticism which, disillusioned by the sentimentality of his early periods, he had tried to suppress.

In his paintings since 1929, he has given no indication of turning away from the diabolical violence of his Surrealist pictures. The curious amorphous shapes which appear in his recent portraits, their occasional eroticism, their brilliant and gaudy colors, mark the continuance of that convulsion of spirit he first showed in 1927 [Fig. 21]. He leans more and more towards a hyper-real universe in which both Freudian psychology and the new elements of space have a part. In sculpture, the beak-head of the *Seated Woman* has become a point of focus for studies in portraiture that are infinitely more forceful than anything achieved by Arp, Giacometti or the other official Surrealists.

The limitations of the Surrealist movement are never so apparent as when the name of the movement is applied to Picasso. Long past the need of "a metaphysical assurance," he towers above the Surrealists in every way. Only Dali has gone on to something new in art, while the others have for the most part been pale reflections of Picasso's genius. It is, of course, impossible to foretell what new direction Picasso's work will take. It seems certain, however, that officially Surrealist or not, his paintings will stand with those of Chirico as the greatest art produced by Surrealism. It seems probable that Picasso's fellow-Catalan, Salvador Dali, will stand below them and that, between the work of these three and the work of the other Surrealists, the gap between genius and talent will open wider and wider.

PICASSO IN THE LIGHT OF CHIRICO—MUTATIONS OF THE BULLFIGHT

Robert Melville

In the foreground of one of Picasso's two 1901 oils of the bull-ring, there is a close-up of a white horse lying on its back, with its head raised in agony, and blood pouring from its belly: it operates as a crude moral comment on the spectacle. Picasso is not an aficionado until he turns the bullfight into a love-bout.

The white bull-ring horse makes its re-appearance in a well-known 1923 painting. Neither bull nor bullfighter is present; the horse has backed away to the barrier, and is screaming with fear, under the eyes of a small group of spectators which is dominated by three completely unmoved women. At one time, I thought that the composure of these women precisely conformed with a contention of de Sade's, that women have more cruelty than men because they are more sensitively organized, but I now feel this to be only one aspect of Picasso's testimony. The figures surrounding the three women are dark, but the women are in white dresses and mantillas, and, as an area of white pigment are in obvious correspondence with the white mass of the horse. On account of this formal relationship and because the spectators are in any case rather peculiarly grouped together and on all sides are surrounded by empty seats, so that an air of desertion is an undercurrent of the picture's activity, I tend to remember it as a representation of a horse and a woman, alone in the bull-ring. But this trick of the memory for which I find excuses in the painting itself may all the same be rather more attributable to a desire on my part to evoke a situation not far removed from those in early Chiricos, in which a solitary figure and the shadow of another will charge a public square with eerie eroticism. What is certainly not a result of my

"Picasso in the Light of Chirico—Mutations of the Bullfight" by Robert Melville. From *View*, 1, no. 11 (February–March 1942), 2. Reprinted by permission of the editor, Charles Henri Ford.

intervention is the fact that the women are still the giantesses of the "classical" period, given a Spanish look by their mantillas; they are formal feminine constructions which register no reaction whatsoever to external event, so that the psychological situation ostensibly represented is fortuitous, and although this element of the fortuitous creeps *in*, has no great faith in itself, does not snatch so fierce a victory as in a Chirico, nevertheless it is the source of our presentiment that all is not as it appears to be: the frightened horse brought to a standstill in a posture which leaves it extraordinarily vulnerable to the horns of the bull now reminds us of the Dinard bathers of 1927, dismayed into erotic poses; it has become an image of the provoked activity of Picasso's formal women. So may not the relationship between the white horse and the women in mantillas be not dissimilar to the relationship between the girl bowling a hoop and the yawning pantechnicon in *Mystery and Melancholy of a Street*? Has not the horse been cornered by Picasso as certainly as the pantechnicon has been immobilized by Chirico?

The period of the symbolic bullfights opens quietly in 1933. The variations on classical themes which Picasso conceived in a series of watercolors belonging to the same year, are followed or accompanied, by four etchings (reproduced in the first number of *Minotaure*), each of which depicts a grave and emblematical minotaur, grasping a sacri-ficial knife, and sitting with legs apart to display his beautifully wrought sex. They are graceful and innocent prefigurations of the monster which darkens the *Minotauromachy* etching. At the same time, and in the same mythological vein, the bullfight commences in a large chalk drawing. It depicts a bull standing in a somewhat heraldic pose, with a sword sunk into the back of his neck. He is neither furious nor dying—nor even wounded; the sword in his neck is iconographi-cal, like St. Sebastian's arrows. On his back are a naked woman and a white horse, enfolded together. The woman's arms are in the sleeves of a matador's tunic, and a shred of the breeches still clings to one knee. The horse screams and the woman sleeps. With one hand, the woman supports her sleeping head, the other lightly touches the bull's horn. This is a very Spanish account of Europa and the bull. Europa, the matador, incites and attacks; Europa, the white horse, is timid and unwilling. Between these two co-existent rôles she has received the bull; now she lies squandered on his back, wearing souvenirs of her positive rôle, involved with the image of her negative rôle, and sleeps a triumphant sleep. At the same time, woman and horse are worn as trophies by the bull. It is the heraldry of consummated desire.

The bullfight paintings which follow in 1934 are devoted almost without exception to the depiction of the hysteria of violent contact. Picasso's memories of the bullfight are crossed and fused with mementos of the animal combats on Siberian gold plaques. In every

instance the intimate interlacing of the antagonists fails to disclose the precise nature of the combat, and the effect is not of cruelty and pain but of intense excitement. If, amidst the tangle of forms, we perceive the hanging entrails of the horse, we accept them as a characteristic appendage, of no more and no less significance than the banners which flutter at the confines of the ring, like those banners in early Chiricos which so patently signal a sexual triumph. It may be that these works were the beginning of an attempt to render accessible to painting that situation on which Rilke set his heart (but which in his ineffectual way, he could not contemplate apart from a concept of heaven), a situation in which lovers like acrobats would show their "daring lofty figures of heart-flight, their towers of pleasure" before a great ring of applauding spectators. But these bullfights are more effective together than apart, and in this terrain, Masson, for his woman and bull-piano alone, claims all the honors.

The figures in *Minotauromachy* [Fig. 23] are like the separate cards of a tarot pack, brought together in a permanent configuration. Some of these figures appear to be watching one another, yet no glance reaches a destination; some of them in their gestures appear to be reacting to other presences, but these gestures are simply their fixed attributes. The scene is composite—made out of the heterogeneous fragments of environment which the different figures inhabit.

Picasso does not divide his talents, and his composition is nearly always a result of the compulsive requirements of his forms, but *Minotauromachy* is composed of separable elements which yet have every appearance of inevitability. The early work of Chirico has disclosed to us that the suppression of the representable aspects of a situation often allows the situation to emerge symbolically without the attrition of complexity which is a characteristic of more literal modes of beholding, and his work further demonstrates that a certain poetic incongruity between the objects assembled is a necessary signal to us of the presence of symbolism. But Picasso's symbols, unlike Chirico's, are living creatures; and their disposition is contrived with a dazzling display of seemingly dramatic reactions; in this sense he is near to Ernst, and perhaps the *Minotauromachy* can be called his best contribution to collage: it is a collage of his own images.

The attempt to attenuate the figures of *Minotauromachy* into persons in a dramatic situation or into personifications in an interpretable allegory would bring few rewards. Symbolism has no force outside the erotic domain, for only under the compulsion of Eros can it be unpremeditated, and the symbols of Eros are infinitely mutable. The bull in *Guernica* [Fig. 22] has little validity as symbolism because it presents us with only two possibilities: it can represent the forces of fascist repression or the just rage of the people, and although I think it is *intended* to represent the rage of the people, Herbert Read has

unequivocally expressed the opposite view. When the choice is thus narrowed we do not have presentiments, we are simply confused. But *Guernica* has not the importance which so many people are anxious to assign to it. Sir Kenneth Clark, the director of the National Gallery, London, has even stupidly asserted that it is the real beginning of 20th century painting! An assertion which has an ulterior motive, since he has become the barker for English painters of air-raid damage. The fact is, I think, that *Guernica* is not very much more than a symposium of Picasso "distortions," the chief d'oeuvre of his private academy. Of infinitely greater interest than the symbolism of the *Guernica* bull is its daintily cleft hoof, which has mysteriously identified itself with the heels-together-toes-apart stance of Goya's raffish women.

Some observations on the feminine images in *Minotauromachy* can be made without impairing their potentiality, for they are different aspects of Pasiphaë. As the female bullfighter, she has returned from that love-bout in which she had to be the possessor before she could be possessed. She lies on the back of the white horse, which prances and cowers and exhibits its wound. She is appeased now and withdrawn in sleep, contented with her condition—and perhaps both sadistic and masochistic desires have been gratified, for she still holds her bullfighter's sword, and the wound in the horse from which the entrails flow is an image of rough love-making and of the birth trauma. As the little girl, she takes no responsibility for her actions; she sees by candlelight which gives "a doubtful sense of things," and she holds a disarming bunch of flowers, which will be presented to whoever needs to be placated. Up above, she has taken her seat for the scenes which will be the outcome of her conduct, and with her is a confidant. But this couple sends forth that same cold wind of imperturbable ennui that rises from that early engraving of Juliette and Lady Clairwil pushing the Princess Borghèse into the crater of Vesuvius. The two birds on the window-sill are no doubt the doves of Venus. The naked man climbing a ladder would appear to be the enigma card of the pack, corresponding to the "fool" of the tarot.

The act of juxtaposition has tangled all these figures in a web of ambiguous emotions and potential violence. The figures themselves are visions, seized upon with ardent impartiality and depicted with their psycho-physical loveliness intact.

Someone who respects the living image but holds no work of art as such to be sacrosanct will some day stake his desires and reshuffle the pack.

PICASSO AND THE MYTH
OF THE MINOTAUR

Martin Ries

Picasso's etchings for Skira's *Metamorphoses of Ovid* and *Lysistrata*, a series characterized by classic calm, were followed by the lusty, vigorous Minotaurs. None of the depictions of this man-bull chimera tell a known story; they are more a series of Capriccios, with the Minotaur reveling with a sculptor (who looks like Zeus), and his model; approaching a sleeping nude, Picasso's sleeping women are often in the pose of the Vatican's *Sleeping Ariadne*, reclining in a delirious orgy "the first conclusion of the principle of death"—Alfred de Musset, or watched by a beautiful woman as he sleeps behind a flower-patterned curtain. This is not the terrible monster from Crete but a sympathetic and pampered pet.

On June 12, 1934, Picasso etched a *Tauromachia* with a Europa-like Torera (bare-breasted like the female acrobats of ancient Crete) draped over a bull. This was followed by a series of Oedipal Minotaurs bereft of creative powers and guided by a "Flower Child." To the left is an Onlooker, and in the background is a boat with sailors, recalling Theseus' return to Athens after escaping the labyrinth and abandoning Ariadne. Picasso's Minotaur series takes on more serious meaning with the appearance of his *Minotauromachia* in 1935 [Fig. 23]. This important etching incorporates elements of the earlier work but, in contrast to most of Picasso's graphics at this time, it is heavily textured, indicating many *pentimenti*, viz:

> the rain cloud, upper right, with the line extending down through the Minotaur's left arm (the etching plate evidently was burnished to erase the line and finally scratched over):
>
> Picasso is always explicit about sex organs, yet obfuscates the Minotaur's genitals here;

Excerpted from "Picasso and the Myth of the Minotaur" by Martin Ries. From *Art Journal*, XXXII, no. 2 (Winter 1972–73), 143–45. Reprinted by permission of the College Art Association of America and the author.

there is a difference in scale of the Minotaur's arms and legs, his left leg
is similar in distortion to the knee of the Rushing Woman in *Guernica*;

there is an unexplained drape (muleta?) to the right of the Minotaur;

the lump on the back of the Minotaur's neck could have been a smaller
head scratched over to become a large hirsute neck;

the decoration of the Torera's *traje de luces* changes;

her legs and right arm seemed unattached to her body;

the building either extends out into the water beyond the shore, or
Picasso did not continue the side down to the earth.

These and many other indications suggest that the *Minotauroma-
chia* began as another variation of the frolicking brute. Evidently as
Picasso was caught up in the more profound implications of the myth
he used it as a comment on his times, and that comment reached its
culmination with *Guernica* [Fig. 22], that gray icon of life and anti-life.

Monsters are expressions of time out of joint, they are the
antithesis of the hero whose weapons are positive powers.[1] Thus the
Torera (Europa? Pasiphaë? Ariadne?) in *Minotauromachia* surrenders
her sword to the Minotaur in a suicidal gesture. Does this sword
become the lance that pierces the horse in *Guernica?* Was the warrior,
finally ossified into a fallen and broken statue, originally the vital rider
of the horse, a traditional symbol of the unconquerable force of the
ego? Like the composed, unmoved Onlookers with their doves of
Venus in *Minotauromachia*, the bull in *Guernica* presides over the
catastrophe aloof from human suffering, not as a symbol of "darkness
and depravity" but of the natural forces of the universe, of creativity,
fertility and regeneration existentially unconcerned with moral issues.
The bull ("a bull's form disguised the god") is the principle of
fecundity; the Minotaur ("the deluded bull") devouring youths in his
pentagon-labyrinth is the perversion of god and man.

Like a comment on the beginnings of life and the power of
regenerative force, the Rushing Woman of *Guernica* with the large
knee, genuflects before amoebic vegetation while she looks in
adoration at the bull (the handkerchief on her head has religious
connotations). The horse, too, seems to kneel before this sprig, yet
throws its head back, looking at the bull as though acknowledging a
superior power. The horse, always a white mare in Picasso's *oeuvre*, is
the opposite of the aggressive, powerful bull; the erotic spasms of
death in the afternoon have their sadistic counterpart in the perverted
sexuality of the mad orgasms of war. Life may "choose between
victory and ruin" but Picasso says Make Love Not War as he elevates
symbolism above the level of the personal and places the individual

[1] Arnheim, Rudolf. *Toward a Psychology of Art*, University of California Press,
Berkeley and Los Angeles, 1966, p. 256.

expression of his private emotions within the context of his culture. Carl Jung stated: Picasso did not deposit in *Guernica* what he had thought about the world; rather he endeavors to understand the world through the making of *Guernica*." [2]

We usually reproach those who talk only of themselves, but this is a burden which Picasso, with his extraordinary depth in poetic intuition, carries to us with fertile and generous metamorphoses and countless illuminations. Picasso reproaches our world for its just pleasures lost, its mis-use of life, its worship of darkness and depravity, death and destruction. Does he sense through the making of *Guernica*, that Western civilization is declining and coming to an end "due to the destiny of my line" because "Venus is exacting a tribute of me for all my race"?

[2] Jung, Carl G. *Civilization in Transition*, tr. R. F. C. Hull, Bollingen Series XX, Pantheon Books, N.Y., 1964, p. 78.

THE *GUERNICA* MURAL–
PICASSO AND SOCIAL PROTEST

Vernon Clark

We are the hollow men
We are the stuffed men
Leaning together.

T. S. ELIOT

On April 28, 1937, General Franco's German allies appeared in their Junkers over the Basque town of Guernica and in short order reduced the ancient shrine to a shambles. "Immediately," Mr. Barr of the Museum of Modern Art tells us, "[Picasso] ° prepared an artist's revenge." And, indeed, "artist's revenge" puts the matter well, since I believe we will find that the protest is more esthetic than practical.

The *Guernica* mural allows no simple analysis [Fig. 22]. Had this painting been presented to us as have the cubist creations of the past our problem would have been less involved. We might have applied the rules given us by the abstractionists and their critics, analyzed the weights and tensions, classified the distortions and allusions, and called the matter done. But Picasso has complicated our task. He requires us, by virtue of his captioning, to consider the mural not only as an abstraction but as an excursion into social protest as well.

Since Picasso's orientation toward the social scene is not made clear either by this work or by his past performances (excepting perhaps the vague humanitarianism of the "Blue" and "Harlequin" periods), we are obliged to do more than form an esthetic judgment. It is here that the great difficulties arise.

I do not remember ever standing before another cubist painting

"The *Guernica* Mural—Picasso and Social Protest" by Vernon Clark. From *Science and Society*, 5, no. 1 (Winter 1941), 72–78. Reprinted by permission of *Science and Society*.

° [Clark's brackets—Ed.]

and feeling any particular concern about the relation between the subject matter and the means used to express it. After all, the amount of emotional involvement to be felt before an *Absinthe Drinker* or a *Still Life with Mandolin* is decidedly limited, and one is usually relieved beforehand of the need to react in purely human terms to subjects and situations so remote from our experience. But what are we to say when Picasso chooses for his subject an event as compelling as the destruction of Guernica?

For the first time in the history of cubism it is the spectator and not the picture that speaks first. Our critical approach undergoes a complete change. The very news that the mural has been painted, let alone the experience of seeing the work itself, is enough to flood our minds with the most passionate questionings. Is there to be found here a forceful condemnation of fascist brutality? Does the treatment as a whole reveal confidence in the justice and ultimate victory of the cause the artist has undertaken to support? Or is this merely the self-pitying wail of a bourgeois Brahmin who sees in the ruin of Spain a threat to his own cozily introspective life? These questions which arise so insistently are bound to color our estimation of the work.

We are immediately struck, when we examine the *Guernica*, by the strange lack of relationship between the subject and the method of presenting it. This, of course, represents nothing new in Picasso's career; such a lack of harmony between technique and content appears consistently throughout his painting. The artist has apparently set a limit upon his feelings and upon the intensity of his expression beyond which he has arbitrarily forbidden himself to go. Whenever the emotional content of a subject tends to get beyond these self-imposed limitations it is immediately checked by a muted method that expresses itself in restrained color, static compositions, and less compelling forms. The "Blue" and "Harlequin" periods, of which the major motifs are types of human suffering, show all these characteristics at once; we recall the quietest of quiet compositions and a color range that departs almost hesitantly from the neutrals. Conversely, it is in the Still Life studies (1924–26), where the subject matter is without any appeal in its own right, that the dazzling coloristic and formal virtuosity of the artist finds full play.

By such means as these Picasso has long managed to maintain a paint-and-canvas sovereignty unequaled in its way in the history of art; has built up a controlled range of sensations which can be manipulated as easily as a new-type oil burner. I do not mean to imply that the work of Picasso is inexpressive of many aspects of modern life. We hardly need develop here how such a need for sovereignty, especially of the studio variety, grows naturally out of the insecurity the artist feels in the face of the incongruities he sees and under which he suffers in present-day society.

And what of *Guernica?* Hailed by most critics as independent of all previous periods, this work seems to me the culmination *ad absurdum* of all the trends, artistic and psychological, that the artist has developed in the past. Here the whole principle of muted and controlled emotion is brought out in unusually sharp relief, but with a difference. In this case the subject matter is so extraordinarily powerful in its own right that it will not stay in place; will not respond so easily to the controlling devices that are adequate with less compelling themes. Hence Picasso has needed to resort to the most drastic muting methods, the most remote allusions, the most involved de-emotionalizing mechanics to attain that balance and tranquillity on which he believes the esthetic sovereignty of the artist depends. If we keep this process in mind it will help us understand more easily many of the peculiarities of the *Guernica.*

Many critics have treated the structure and composition, the thrusts and movements of this work as inherently expressive of protest against the horror of war. I can hardly account for such an attitude toward a work which, whatever may be said of its abstract merits, is certainly most perfunctory in solving the problem of the relation of the composition to the essential message of the picture. Let us consider the barest and most essential elements of the composition. The central pyramidal construction emerges at once, flanked on either side by forms which, although diverse within themselves, are, as far as weight is concerned, as near to symmetry as anything in cubist painting. This produces an underlying structural quietness that seems far removed from the realities of the Spanish war. Of course there is no indication here of any lack of penetration on the part of the artist. It is, rather, only one illustration of his resolve to maintain a firm hold over his subject—in this case by the use of a composition that is basically quiet.

An analysis of the curved- and straight-line content of the painting will show that the same principle holds. It is at once apparent that these two elements are almost entirely equal; in no case is there any dramatic emergence of one at the expense of the other. Wherever a strong opposition occurs it is always muted by an adroit flowing together of the main curves or a transitional, fanlike arrangement that blunts the oppositional impact of the straight lines.

Significantly, all this happens within the composition without a great deal of connection with the dramatic emphasis of the subject matter. For example, were we to make a graph of the main lines and movements and then place within it a series of colored spots to indicate the placing of the representational elements, i.e., agonized human beings, animals, etc., we would find that they occur well out of the range of the structural crises. Curiously, it is possible to construct a graph of the structure without showing the representational elements, or to make one of the representational elements without showing the

structure. It is interesting to compare this method with such works as Goya's *Horrors of War* etchings, where representation and structure are inseparably related—so entirely integrated that such an analytical dissection as this is quite unthinkable. But in the *Guernica* whatever specific feelings we get about the horror of war, even in the abstract sense, must be got from the details (pointed tongues, evidences of dismemberment, etc.) and with little help from the main drives of the canvas.

Again, the color, or rather the lack of it, supports this theory of dissociation. At the end of a tradition that has regarded color as the most forceful vehicle of emotional expression, Picasso has chosen to discard this vital element entirely; has confined himself to the most limited range of relationships imaginable. That these harmonies of black, white, and the warm and cool grays are worked out with infinite finesse is beyond question. The astonishing thing is that the spectator must combine such a subtle and delicate esthetic experience with subject matter second to none for strong emotional impact. It is true, of course, that black and white contrasts can be used as forcefully as any conceivable arrangement of color, but what is important here is that the major contrasts once again occur, not in relation to the subject matter, but to the abstract structure. Only in cases where the pictorial elements are well out of the dramatic center of the work do they receive full support from strong black and white contrasts. Again, in the central areas the passages which are psychologically compelling are subdued by such subtle gradation through the grays that in most cases the forms emerge with nothing stronger than line to define them and are incapable of competing with the purely formal aspects of the work. The spectator must become two persons, one who examines and enjoys the abstract-esthetic qualities of the mural, and the other who hunts and picks among the details in search of symbols that refer to the destruction of Guernica.

But there is another important element that demands our attention. The dissociation of the subject matter and the method of expression has vital and curious implications—hints that the protest of this artist may not be so clearly directed against the destruction of Guernica as we are led to believe. At any rate it lacks the direct drive and unity of purpose to be found in a similar subject treated by Goya. Yet the artist must feel strongly, must feel a deep resentment or fear—else the mural never would have been painted.

The underlying motive becomes more clear if we examine carefully the type and implication of the symbols used. At first glance the symbolism seems basically the same as in earlier work; Picasso alludes to the remote and romantic as he always has in the past. But the strangeness in this case springs from the use of such archaic symbols as classical profiles, swords, oil lamps, etc. to express the social

struggle as we know it today. These symbols seem far removed indeed from the problems of our time, and their remoteness is emphasized by the fact that the whole drama of the picture takes place not only in an exceptionally shallow space, but in an interior space as well. It is as though the artist has sought to blunt the impact of an event he fears by removing it from the real world into the easily controlled area of a stage. The two allusions to artificial light seem to confirm this.

Aside from these, we note the use of the symbolism of the bull ring. If we are to trust Ernest Hemingway for the esthetic meaning of the bullfight, the manner in which these symbols are used becomes more than revealing. To the Spaniard the bullfight is a drama in which the animal stupidity and brute force of the bull are overcome by the intelligence and human art of the *toreros*. Now there is nothing surprising in the fact that Picasso has used the bull as a symbol of Franco and fascist brutality.[1] But it is surprising that the bull, villain of the piece, is the only figure in the mural that has any dignity—the only figure whose strength is solidly grounded, both in abstract structure and pictorial detail, and in which these two elements are united toward a single end. The exaggerated testicles, the defiantly erect tail, show clearly that the artist has been at great pains to build up the dominance of this symbol of fascist victory. Although the bull is certainly not put forward to persuade us or to win our admiration, we can sense here more than a hint of resignation before an enemy both successful and strong.

Nevertheless, one is obliged to resist even an overwhelming enemy. But where shall the artist turn for allies? To a cause represented by a bemattressed, disemboweled horse? In the bull ring, we remember, the horse is the comic relief, the symbol of the decrepit, the broken down, the ridiculously outworn. Yet it is with such symbols as this that Picasso identifies the things that died at Guernica—with such symbols as a warrior whose decapitation reveals the hollow body of a mannequin. This theme is borne out by all the scarecrow figures that occur throughout the mural. We see eyes placed awry in the heads of the figures; we see stuffed and clumsy hands, each finger of which has its own direction. These are eyes incapable of seeing

[1] The bull has long been associated with the death-and-resurrection motif in religion, as, for example, in the mysteries of Dionysus of ancient times. It is therefore suggested that Picasso has used this symbol to allude to the resurrection of the Spanish people and not as an emblem of fascist brutality at all. Without going into the problem at any length, I should like to point out that there seems little reason or justification in divorcing the bull from the context in which Picasso has consistently placed it (i.e., the bullfight), not only in the *Guernica*, but in the *Dreams and Lies of Franco, Minotauromachy*, as well as numerous other works. Nor must we overlook the fact that in one of the *Guernica* sketches the bull actually appears with the face and characteristic military cap of General Franco himself.

rationally. These are hands incapable of grasping firmly the weapons of defense. I understand that the delusion of the mutilation or displacement of the essential organs and members of the body is a well-defined characteristic of certain types of mental illness, as Dr. Paul Schilder has pointed out in his book, *The Image and Appearance of the Human Body*. In such cases the sufferer experiences horrible sensations of inadequacy and helplessness and imagines that the simplest functions are beyond his control. It is important to note that these delusions arise from the *inner* instability of the victim and do not refer to any objective reality of oppression or persecution. Yet it is in such terms that Picasso has drawn his picture of the Spanish people. And it seems to me rather obvious that the quality of their three-year struggle against fascist invasion can hardly suggest any such inner instability or lack of unified purpose on the part of the Loyalists, except to those who are without secure faith in the justice and victory of the cause they defended.

The similarity of Picasso's symbols and the symbols used by T. S. Eliot, that prince of disillusionment, begins to emerge more clearly. These are indeed the hollow men, the stuffed men with whom the artist must identify himself and whom he must at the same time strive to reject. Nor does the analogy end here. The network of lines that enmesh the whole mural, the toying with the crossed life lines in the hands of all the figures, becomes the inexorable web of destiny. As Eliot has read his own fate and the fate of his world in the medieval Tarot pack, so Picasso has resorted to the lore of the palmist for a comparable symbol.

Picasso's disillusionment is not mocking and impertinent as is Eliot's. Eliot wrote in this vein during less trying years when cynicism could be cultivated with fair comfort in the university and the café. But the *Guernica* was painted face to face with a struggle that has become an uncomfortable reality of bombs and bullets; barbarian reaction has come to threaten even one's right to be disillusioned. "I do a picture," says Picasso, "—then I destroy it." There is little wonder that he finds cause to protest when this latter office falls into ruder and more practiced hands.

In the *Guernica* it would seem that what Picasso mourns is not so much the ruin of a Basque town as the destruction of his own studio. And by the destruction of his studio I mean the passing of that complex, introspective world where the sovereignty of the artist, at least on canvas, has found during the last half century so convincing a semblance of reality. The mural is the meeting place for all the many ends of Picasso's eclecticism. Cubism, analytical and synthetic, and the nostalgic allusions of the classical period are brought together as though for a last and forceful statement, and in a context plainer than anything we have seen before. Picasso has revealed himself as the

painter laureate of the Wastelanders—of those who see with amazing penetration into the cruelty and contradictions of modern society, yet are unable to ally themselves with any of the forces that are deciding the issues of the day. He has preferred to vacillate at a time when vacillation is both dangerous and expensive.

Although the Guernica mural has shown us that Picasso remains the unchallenged master of abstract art, we see at the same time that cubism cannot be made to bear the weight of social meaning. The Ivory Tower, embattled at last, watches with just apprehension the advance of its dual enemies. Fascism comes down over the mountains —the people march up from the plains. The half-world may well tremble. Once again we turn to Eliot for a terse statement,

> I have seen the moment of my greatness flicker
> I have seen the Eternal Footman hold my coat—and snicker
> And in short, I was afraid.

PICASSO'S GUERNICA

Herbert Read

Art long ago ceased to be monumental. To be monumental, as the art of Michelangelo or Rubens was monumental, the age must have a sense of glory. The artist must have some faith in his fellowmen, and some confidence in the civilization to which he belongs. Such an attitude is not possible in the modern world—at least, not in our Western European world. We have lived through the greatest war in history, but we find it celebrated in thousands of mean, false and essentially unheroic monuments. Ten million men killed, but no breath of inspiration from their dead bodies. Just a scramble for contracts and fees, and an unconcealed desire to make the most utilitarian use of the fruits of heroism.

Monumental art is inspired by creative actions. It may be that sometimes the artist is deceived, but he shares his illusion with his age. He lives in a state of faith, of creative and optimistic faith. But in our age even an illusion is not tenable. When it is given out that a great Christian hero is leading a new crusade for the faith, even his followers are not deceived. A Christian crusade is not fought with the aid of infidel Moors, nor with fascist bombs and tanks. And when a Republic announces that it is fighting to defend liberty and equality, we are compelled to doubt whether these values will survive the autocratic methods adopted to establish them. The artist, at the lowest level of prestige and authority he has ever reached in the history of civilization, is compelled to doubt those who despise him.

The only logical monument would be some sort of negative monument. A monument to disillusion, to despair, to destruction. It was inevitable that the greatest artist of our time should be driven to

"Picasso's *Guernica*" by Herbert Read. From *London Bulletin*, no. 6 (October 1938), p. 6. Reprinted by permission of Mr. Benedict Read, Herbert Read Discretionary Trust, and David Higham Associates, Ltd.

this conclusion. Frustrated in his creative affirmations, limited in scope and scale by the timidities and customs of the age, he can at best make a monument to the vast forces of evil which seek to control our lives: a monument of protestation. When those forces invade his native land, and destroy with calculated brutality a shrine peculiarly invested with the sense of glory, then the impulse to protest takes on a monumental grandeur. Picasso's great fresco is a monument to destruction, a cry of outrage and horror amplified by the spirit of genius [Fig. 22].

It has been said that this painting is obscure—that it cannot appeal to the soldier of the republic, to the man in the street, to the communist in his cell; but actually its elements are clear and openly symbolical. The light of day and night reveals a scene of horror and destruction: the eviscerated horse, the writhing bodies of men and women, betray the passage of the infuriated bull, who turns triumphantly in the background, tense with lust and stupid power; whilst from the window Truth, whose features are the tragic mask in all its classical purity, extends her lamp over the carnage. The great canvas is flooded with pity and terror, but over it all is imposed that nameless grace which arises from their cathartic equilibrium.

Not only Guernica, but Spain; not only Spain, but Europe, is symbolized in this allegory. It is the modern Calvary, the agony in the bomb-shattered ruins of human tenderness and faith. It is a religious picture, painted, not with the same kind, but with the same degree of fervor that inspired Grunewald and the Master of the Avignon Pietà, Van Eyck and Bellini. It is not sufficient to compare the Picasso of this painting with the Goya of the *Desastres*. Goya, too, was a great artist, and a great humanist; but his reactions were individualistic—his instruments irony, satire, ridicule. Picasso is more universal: his symbols are banal, like the symbols of Homer, Dante, Cervantes. For it is only when the widest commonplace is infused with intensest passion that a great work of art, transcending all schools and categories, is born; and being born, lives immortally.

PICASSO IN THE LIGHT
OF A MARXIST SOCIOLOGY OF ART

Max Raphael

Picasso's artistic reaction to the situation to which he fell heir may be divided into two phases: one of sentiment (1901–1906), and one of creation (from 1907 on). These may be further subdivided into various periods and stages of development. The first phase includes his so-called "blue" (1901–1905) and "pink" (1905–1906) periods; the second phase includes his Cubist (1907–1914), his "abstract" and "classical" (1915–1925), and Surrealist (from 1925 on) periods.

During the first phase the content and spiritual conception of the subject predominate; during the second, it is the form-creating elements—the modeling, problems of composition and form, of method and execution. It should be noted that in these connections Picasso has had some outside help, as it were, drawing upon Negro art, classicism and its forerunners, and medieval stained-glass painting, for example.

His almost unvarying theme during the sentimental phase was drawn from the fringes of nature and society: blind men, paralytics, dwarves, morons; poor people, beggars; Harlequins and Pierrots; prostitutes; tightrope dancers, acrobats, fortune tellers, strolling players; clowns and jugglers [Figs. 3–4]. One must not see here anything resembling social criticism, any sort of accusation against the bourgeois order. Very much like Rilke, Picasso looks upon poverty as a heroic thing and raises it to the power of myth—the myth "of great inner splendor." Far from regarding it as a social phenomenon which it is up to those afflicted to abolish, he makes of it a Franciscan virtue heralding the approach of God. Thus virtue becomes sentimentality at his hands, because his purely emotional religiosity stands in opposition

"Picasso in the Light of a Marxist Sociology of Art" by Max Raphael. From *Proudhon, Marx, Picasso* (forthcoming), trans. Robert S. Cohen (New York: Humanities Press). Reprinted by permission of Professor Claude Schaefer and Humanities Press, Inc.

to the severity of the created world; his appeal is to compassion and charity. This passive, mystical, and religious conception of poverty is grounded in the Christian notion of brotherly love and in bourgeois ideology—whose indispensable correlative is brutal cynicism, of the type which may be seen most clearly in papal encyclicals on social issues.

The connection Picasso draws between the subjects he took from the fringes of bourgeois society and that fundamental form of the social life of the bourgeoisie, the family, is altogether characteristic. A painting such as *The Family with the Monkey* [Fig. 4] shows a group unity going back before the particularization of individuals, together with a delicacy of feeling almost attaining to sainthood. What a contrast with the only painting of a middle class family that Picasso did from life rather than from imagination! The *Soler Family* shows us the husband and wife seated at the two far corners, and such grouping as may be discerned has been formed only by the successive addition of persons. However, the contrast is to be accounted for in terms of religious belief rather than in terms of social criticism. It is noteworthy that in Picasso the two forms of sociability are always presented simultaneously: both the disintegration of the group into individuals and the gathering of individuals into a group. He thereby expresses a certain relativism or will to equate the fundamentally opposed principles that govern the formation of social bodies.

His mystical approach to subjects drawn from the fringes of society is clearest in the most successful paintings of this type, from the fact that Picasso uses only one color in each of them. A chiaroscuro movement extends from foreground to background and back again, while the line thus turned in upon itself progressively discovers within itself and releases a relatively independent being, through the oscillatory mystical movement of coming-into-being and passing away. The methodical unfolding of this mystical process in relation to the existence of the physical world, such is the spiritual unity that gives Picasso's multiform development its internal logic.

A comparison between Picasso's *Absinthe Drinker* of 1902 and Degas' painting treating the same subject (in the Louvre) clearly reveals the meaning of Picasso's "mysticism of the internal field." The Impressionist does not present his human figures squarely in the foreground but in the distance. In Degas' painting the space has been hollowed out by a succession of slanting lines (formed by the tables) that circumscribe a void. The latter thus is in contrast with the materiality of the tables, and they in turn seem to be crowding the picture space. Degas leads the viewer's eye along a twisting path around and about the empty space, thus making the two figures appear to occupy the most distant corner of the picture. There they are withdrawn into themselves, an inert mass in the swirling space; they

are like heaps of ash about to crumble, pieces of wreckage cast off from the movement of space, ready to disintegrate; they possess no human resistance. The further the eye probes into these two figures, the more aware it becomes of their erosion, their unresisting insubstantiality, their melancholy despair and cynical indifference. Degas has painted the twilight of mankind that inevitably descends upon modern bourgeois society because its motive forces are essentially inhuman, and because the rhythm of its development excludes all conscious, active, creative human power. This critical attitude of a bourgeois toward the foundations of his own class structure is not shared by Picasso. When threatened, man is shown as fleeing the external world and withdrawing into himself in search of a haven from the disintegrating forces around him, trying to save his own soul amid encroaching disaster.

Picasso's first sentimental phase marks the birth of his mysticism as well as of his tendency to portray the world as static and objective. Soon a principle will emerge, as his mysticism develops, that of the interpenetration of bodies among themselves and of bodies with space. In this way will come about the splitting up of the object's physical unity into various parts differentiated by means of space and color. This is why, from the naturalistic point of view, this mysticism has seemed daring and revolutionary—because of its wealth of new combinations, i.e., of combinations not determined by nature. But the opposition it sets up between physical and psychic laws, its psycho-physical dualism, reveals a romantic wish to escape beyond time, a wish whose reactionary character is not diminished by the fact that its original passivity is combined with creative activity. . . .

Picasso's Cubist period (1907–1914) poses several interesting special problems for a Marxist sociology of art, quite apart from the general problem of an art governed by its own laws. At the beginning, there is the influence of Negro art (Negroid state) [Fig. 6]; at the end, the use of hitherto untried materials on the canvases (stage of new materials) [Fig. 9]. In addition the following question arises at every stage: Why did the abstract laws of Picasso's painting take this particular form of delimitation into geometric figures, of relative discontinuity between (and subsequently the fusion of) planes parallel to the picture surface?

(1) We cannot doubt that there was an evolution from the Impressionists to Picasso. But it primarily involves means of representation, only.

It was by studying nature that the Impressionist artist was able to conquer light with a view to representing it through colors. He analyzed the still undifferentiated unity of one given moment during one season or a single day, decomposing it into atoms, just as the

psychologists had reduced the psychic life to sensations. But whereas the latter linked the various elements mechanically (through associations), artistic unity was restored less through complex use of all compositional means (which were, rather, reduced to a minimum) than by recording a state of mind corresponding to the sensory excitation, i.e., in an aesthetic and often sentimental manner.

Two things must be rigorously distinguished: the individual, monadic character of the general conception of the world, and the sensory domain to which it was reduced for the purpose of artistic representation. This enables us to see that Expressionism maintained the former, modifying only the latter. In other words, the Expressionist artist renounced totality and complexity to the same extent as the Impressionist. The difference between the two lies merely in this, that the Expressionist does not start from the momentary sensory stimulation produced by the outside world in order to discover a psychic equivalent, but rather from the psychic stimulation of the inner world in search of a sensory equivalent. Both remain within a monadic system. Nothing is changed by replacing dots of color with spots of color, nor by regarding as fundamental for artistic creation not the elements, but the totality, of the picture surface. Only the means of representation differ; the essential conception of the world remains unchanged. This difference is analogous to that between a sensationalist and a Gestalt psychology; what is crucial in both cases, is that something individual is at stake. Here too, the difference bears only upon the content on which attention is centered in each case—sensory stimulation and its analysis, or psychic stimulation and its structure.

Picasso has not modified this state of affairs in any essential respect. He effects, so to speak, a synthesis of these two partial conceptions, but without abandoning the assumptions on which they are based. His advance consists solely in this, that he created deeper and more essential means for expressing the conflict between the two dimensions of the surface and the third dimension of depth, i.e., a new method of modeling. In this way he has achieved an organized individualism, a schematization of the monad—an advance which corresponds to the transition from free-enterprise to monopoly capitalism. Just as these two forms of capitalism cling to private property as the fundamental basis of production, so Picasso preserves absolute individualism as the basis of artistic creation. Just as, in monopoly capitalism, there is a widening gap between private property and planned economic organization, so that economic and social crises grow ever more acute, so in Picasso that dualism between his fundamental individualism and his mathematical, generalized means of expression lead to ever more pronounced psychic crises. This accounts for the continual modifications in his "style," the different forms of which all revolve around the same unsolved problems.

The theoretical limits of modern bourgeois art are manifested most clearly in this, that in the last analysis they are rooted in caricature. The economic and social origins of this are beyond question—this is as true of Degas' Impressionism and Matisse's Expressionism, as of Picasso's Cubism. [Figs. 7–9]. Daumier was the first to invent the caricatural style, and down to this day all bourgeois art has revolved around him as a central axis. The essential characteristic of this style is that the whole no longer determines the parts, is not even the result of an accretion of homogeneous parts; the harmony of the whole has ceased to exist. On the contrary, it is the caricatured, exaggerated part, and the discordant relation between its positive and negative elements that determine the whole—emphasizing the impossibility of there being any whole, whether a total situation, a whole man, or the ensemble of their interrelations. Ortega y Gasset was quite wrong when he asserted that modern art has left man out of the picture. At a deeper level it is social life that has eliminated man, by treating him as a commodity. It is for this reason that caricature could in the first place—had to—become an integral part of great art. It alone has made possible the acquisition of a new style; in other words, caricature has become "social nature." It is by this detour that great art has taken man as its subject—not as a human being, but as a contradictory being, in contradiction with himself and with his environment. And since this process of decomposition has gone hand in hand with the development of the machine, the modern artist has been able to go farther than Daumier by replacing all organic elements (both physical and psychic) with mechanical analogies, with a system of general, abstract relationships.

Absolute individualism and the basis of its style in caricature combine inevitably to produce a metaphysical view of the world, which we variously call "abstract" art or Surrealism. And inasmuch as metaphysical worlds are today no longer vital necessities as they were in the Middle Ages, they manifest themselves inversely—not in the creation of architecture, but in resentment against the architecture that is beginning to create a new space based on the needs of modern life. The merest beginnings of such an architecture were enough to provoke liberating laughter at the absurdity of producing one little easel painting after another, enough to reduce all so-called "revolutions" in modern painting to a mere playing around with the means of expression. Confronted with the need and the desire to produce an integral work of art, painting has sunk to the lowest rung on the ladder of the arts, although—or rather, because—modern bourgeois architecture is itself incapable of solving the problem.

(2) Without the introduction of caricature, which has broken up the European tradition, Picasso could never have arrived at his affinity for Negro art. The colonial policy of capitalism provides a background for this; also, a certain degree of decomposition in the unity of the

European mind, determined by this same material expansion (as the idealist Valéry has also noted); and finally, some degree of spiritual influence of the colonial peoples on the great European centers. A comparison between Gauguin and Picasso shows how far this influence has already gone. Although Gauguin actually lived among a primitive people, slept with their women, sympathized with their way of life, contemplated their art on the spot, and constantly struggled against the influence of his "motherland," the women he painted are more like suntanned society ladies of Paris than like Negresses. The European ideal of beauty, French charm, and the reactionary conception of art as primarily decorative shut him off like so many walls from the reality of life in the colonies—at least to the extent that it was still primitive. Picasso, only a generation later, came to know Negro art only from museums and the few pieces he had bought himself from sailors in southern French ports. But he was made aware of two essential facts: that quite apart from the natural laws of the world of bodies and in direct opposition to them there is such a thing as the logical, internally necessary construction of a picture, the forms of which are derived directly from the inner life, from both conscious and unconscious contents, and the development and logic of which are part of this purely intuitive process. The crux of the matter in this artistic necessity is constituted by the modeling. But Picasso's modeling does not follow the European tradition of continuous stereometric bodies (cylinder, etc.), which are the fundamental forms of the members of the human body; on the contrary it is marked by a discontinuous opposition between concave and convex surfaces (as against naturalism) so that concave surfaces come to replace surfaces which are naturally convex (for example, cheeks).

Thus Picasso pays tribute to certain essential elements of life in general, notably the right to a vital impetus that has its source in sex and the subconscious, and that may attain to mysticism—and hence is neither natural nor respectful of the natural laws of bodies. At the same time he also pays tribute to certain essential elements of formal artistic creation. Picasso is not the only artist, and art is not the only ideology, in which this evolution may be seen to have occurred. It is enough to recall Lévy-Bruhl and the discussion that raged among French sociologists over whether the mentality of the primitive peoples is, or is not, essentially different from that of Europeans. But all these considerable efforts cannot make us forget that these artists and scientists have been led to primitive culture by motives directly contrary to those which determined the primitive peoples themselves. For the former were escaping something when they undertook the qualitative leap from the rational into the irrational, whereas the latter were alleviating their worries and fears with each step they took in the logic of their irrational mentality.

From the sociological point of view, we are confronted first of all

with a spiritual adoption of cultural facts become known in the course of the exercise of colonial policy; but, later on, we also have a reactionary flight for the moment from the new European reality. It is interesting to note that as the outside world expanded materially, new, nontraditional, spiritual means became necessary to control this world around 1870. Impressionism had already learned from the Japanese the value of the surface (as against perspective) and of "open composition," and had incorporated them into the European tradition. Thus it was possible to express the vital sense of the new liberal bourgeoisie in the epoch of transition from the Second Empire to the Third Republic. In Picasso, the assimilation involved not only more exotic materials, but also more essential, more far-reaching elements. The integration of Japanese art was the loophole by which traditional artistic rationalism found its way to an artistic sensualism closer to nature. The incorporation of Negroid art, on the other hand, turns against rational and sensory contents in favor of metaphysics and the irrational, and at the same time creates a new, completely non-European rationalization of form.

A consequence of this twofold tendency is to create new positive values out of the existing negative values. Psychically emptied and overrationalized, man discovers in the natives of his colonies a vast traditional domain, and this discovery accelerates his own rapid and continuing flight from Reason. But it also consolidates his humanity in the face of the machine, and activates his hitherto passive mysticism. To gain a better understanding of what this means within the framework of bourgeois philosophy, it is enough to compare a self-portrait by Picasso from the so-called "blue" period with another executed shortly before he embarked upon his Negroid stage, just at the turning point between his sentimental phase and his phase of true creativity: the old-fashioned Bohemian who passively let the world sweep over him has now become a worker who rolls up his sleeves the better to take on the world. The positive result of this active struggle was a raising of the theoretical consciousness thanks on the one hand, to the clear distinction established between the principle of modeling and its aspects, and on the other, to elucidation of the relationships obtaining among physical, psychic, and artistic laws. In this way the Greek and Christian canons of European art were dethroned in an unprecedented manner. This widening of the horizon of artistic practice later reacted upon artistic theory, leading to the establishment of precise distinctions between the theory, the sociology, and the history of art, and more particularly, to a radical change in the perspectives of art history: Henceforward, instead of going from the past to the present, we will go from the present to the past. These are positive results which victorious Marxism will have to develop.

The raising of the theoretical consciousness in the artist himself

led Picasso in the course of his development to treat certain theoretical problems pictorially, and some of his pictures might be described as theoretical essays. For instance, *Three Women on the Beach* (1923) [Fig. 24] shows the significance of the three dimensions for the internal composition of the picture (by no means excluding another, more naturalistic, basis). Hence the theoretical criticisms leveled at Picasso on this occasion. If we recall that throughout the nineteenth century bourgeois philosophy was primarily a theory of knowledge, it will no longer be possible—at least from a bourgeois point of view—to criticize Picasso for having painted a theory of art, but only for having done it so incompletely. One glance at this picture will show that the three dimensions of the figures are not in accord with the three parts into which the background is divided, i.e., that the figures are not connected in space through some over-all plan, and consequently, that the essential element of theory—the *integrating* factor—is absent.

(3) The third problem concerns the stage of Cubism in the use of materials. To grasp this problem in its entirety, it is necessary to discuss the various stages within Picasso's Cubism. During the first, Negroid, stage, Picasso strove to found his over-all composition on a subjective conception, in [the] sense that his bodies are formed independently of their physical laws, and solely according to emotional and pictorial logic [Fig. 6]. The second stage, that of Cubism in the reconstruction of bodies, saw the refinement of this new idiom at the contact of different objects, by the use Picasso made of their articulations, and by combining their different views (profile, frontal view, etc.) according to a spatial dynamism he posited a priori [Fig. 8]. Thus he integrated the Negroid with the European principle of bodies. In the course of the third stage (Cubism of the field) the formal elements were again detached from the various bodies to be linked in space, i.e., with vibrations in depth oscillating around the central plane parallel to the picture surface [Fig. 7]. In this stage, the whole of the painting develops according to a specific conception, by means of repeated differentiations in the new language of spatial movements. The dynamic emotion of the inner sense counterbalances the statics of pictorial construction. It was at this moment that Picasso became aware of limitations in this way of working: the abstract idealism which represented the mystical interpenetration of bodies and space by the relationships obtaining among interacting dimensions and by their opposing directions (top–bottom, front–back, right–left) cannot rediscover concrete, material reality. In the end Picasso solved this problem by a kind of squaring of the circle: alongside the most abstract spatial relations, he makes direct use of nonartistic materials (pasted paper, beads, wood shavings, typographical characters, etc.) [Fig. 9]. Here Picasso was confronted with the most crucial problem of all ideology: idealism and materialism. The paradox of taking idealism

so abstractly, and materialism so literally, is not a solution, but rather confirms his inability to solve the problem. His exaggeration of the two poles of the opposition shows, first, Picasso's torn personality, devoid of any dialectical element, and second, the over-all limitations of his idealism. These two facts are inseparable, and of great importance from the sociological point of view.

Picasso's inner split is manifested as early as the "blue" period, partly in his rigorous setting-off of delimited figures (or groups) against a limitless background; for instance, in his varying of the degree of corporeality with which realization of the mystical process is expressed, and in his drive toward the concrete, objective being. At one moment, corporeality is wholly merged with the picture plane and is lost in it—symbolizing the metaphysical absolute—while at another moment the three dimensions of space and body take over the picture plane—symbolizing earthiness. The principle of division into equivalent contrasts becomes the very motive force of Picasso's development. From 1915 to 1925 he used two seemingly different means of expression simultaneously—the classical and the abstract; this period, taken as a whole, constitutes the clearest separation between static and dynamic tendencies. Its primary result was to give a different formal expression to the various detached functions. Thus the natural unity of the body, which was preserved during the sentimental phase, now was destroyed in favor of the diversity of functions, of which in time no more than a static balance will be kept.

Bathing Woman [Fig. 26] is the most striking illustration of this. The woman seated on the ground before the sea and the sky encloses in both arms the knee of her bent right leg; it rises above the horizon. Here we have at least three functions juxtaposed: the pressure of the body against the ground and the resulting resistance; withdrawal into oneself; and the rising of the torso above the ground. In order to develop simultaneously these three functions with the woman's body, Picasso had to strip away the flesh to the point where all that is left is a translucid jointed doll. This bold idea of expressing the most intense life through contrast with a skeleton is already the sign of an inner split. Previously Picasso had contrasted in a similar way richness and social poverty, tender Lesbian feelings and almost ponderous physical health, without however dissociating the physical unity of the body. By destroying this unity (by stripping the flesh from the body of the bathing woman), he opposes the body, reduced to an inalterable silhouette, to the limitless picture plane, as two contrary principles, shown not only one in front of the other, but also as transparent with respect [to] each other; thus Picasso has created a link between them that underlines their contrast. But what is even more important is that one leg expresses the pressure of the body against the resistant ground, while the other leg is bent in a soft curve (in harmony with the arms);

the back, detached from the torso, expresses the action of getting to one's feet, and the extended neck asserts the idea of stiffening to attention, etc.

The insouciance, the daring, and the consistency with which Picasso dissociates the natural unity of the body into its diverse functions seem to us determined by his Spanish origin. Picasso was attracted by bourgeois relativism less than any other artist; his country, thanks to its medieval spirit not so far in the past, showed him the significance of theoretical principles, and the social struggles of his epoch encouraged him to demonstrate the contrast of irreconcilable principles. Thus he was able to establish the relativity of these principles, by reason precisely of their diversity and their antinomy within their own sphere, not by reason of their insufficiency or abstract character in the face of the plenitude and the multifariousness of concrete reality. If the artist wants to use simultaneously, one alongside the other, principles of equal value but antithetic, he has only one way of achieving unity—static harmony among the different parts of the picture. Picasso realized this principle of balance in all its refinements during the period which was at once "classical" and "abstract" (1915–1925). This split and this manner of overcoming it are to be found in every area of modern life. Another instance is the antagonistic opposition between private property and monopolism, and the manner in which a law-making machine seeks to overcome it by means of dictatorship.

Although for some time Picasso managed to allow all the oppositions that struck him to coexist—successfully, thanks to the static formal harmony he created—he was in the end compelled to choose between idealism and materialism. This latter opposition became so acute that the very foundations of art were shaken. What is noteworthy in the case of Picasso is that, while he confined himself to idealism, he discovered two ways out: (1) in an abstract idealism concretizing itself in color—color conceived not as the surface of the objects represented, but as a symbol of states of mind and as an expression of the functions of things; and (2) in an idealizing realism, which made use of the styles of antiquity and its descendants (Renaissance, Classicism) with a view to developing a powerful three-dimensional corporeality. In this way both materialism and dialectics were excluded. This path taken by bourgeois art was inevitable, for all of Picasso's artistic genius. It would be absolutely erroneous to look upon the phenomenon of the inner split as a phenomenon of personality (and to conclude that Picasso is mad, as some have done). On the contrary, this phenomenon stigmatizes the whole situation of the bourgeoisie: its own abandonment of the free thinking which brought it into being, and its return to a quasimedieval ideology such as it had combated at the epoch of its start. The ghosts

of the unvanquished past haunt the feudalism of monopoly capitalism no less than those of Hellenism and Christianity haunt Picasso. . . .

If we consider Picasso's art as a whole from the sociological point of view, the following results appear: (1) An excessive multiplicity, a disturbing abundance of the most unlike aspects, both simultaneously and successively—inevitable in an artist whose personality is the symbol of the bourgeois ruling class, because he himself and his epoch are experiencing the most contradictory tensions. (2) Even a talent as great as his cannot do without auxiliary means, and ends up as a repertory of the history of art. Today a great bourgeois artist is possible only as an eclectic genius. (3) The artist whose debuts were so radical that he was generally held to be a revolutionary, has proved, after thirty years of work, so far from being capable of solving the unsolved problem of the nineteenth century, i.e., of creating an art based upon materialist dialectics, that he has on the contrary gone to the other extreme: the feudal limits of the bourgeoisie, in the modern form of reaction.

In the light of these three results Picasso appears as the symbol of contemporary bourgeois society, and it is as such that, with a half dozen of his works, he will certainly survive for several decades, perhaps even several centuries. Picasso's social character is also disclosed in his [impact] on the public, which was not slow to show its gratitude to him both materially and spiritually, although no one has put the nerves of his contemporaries to a more severe test. With the exception of Germany, which refused to recognize him for the most futile reasons (the German bourgeoisie thus demonstrating that it lags decades behind world history, not only in politics, but also in ideology), we see that despite the indifference of the "cultivated" masses, dealers and speculators in all the countries of Europe and America pay extraordinarily high prices for his works. Each period of his evolution, and even each caprice of his imagination have aroused boundless enthusiasm; he has been imitated as no painter before him. This desire to imitate, which in the bulk of artists can assume the worst academic character, reveals more than a lack of consistency or instinct for history, more than the mere fact that Picasso time after time discovers forms in which the bourgeois class can assert and understand itself. Since the "free" artist depends on fashion and on the speculations of art dealers, we are witnessing the emergence of new kinds of public relationships between artist and public, which bear no resemblance to those prevalent in the Impressionists' generation.

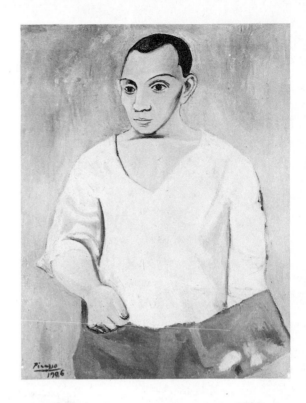

Fig. 2
PICASSO:
*Suite 347, Etching no. 1 with
Self-Portrait* (March 16, 1968)

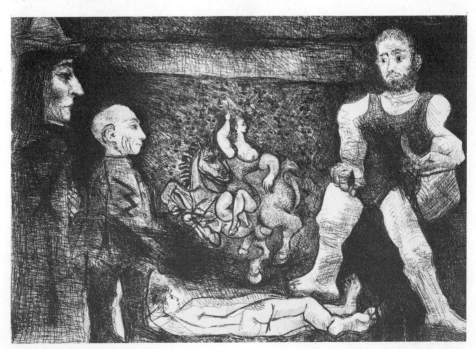

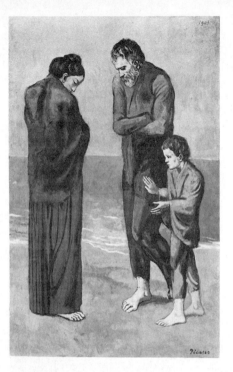

Fig. 3
PICASSO:
The Tragedy (1903)
(National Gallery of Art, Washington,
D.C.: Chester Dale Collection)
© S.P.A.D.E.M., Paris, 1976

Fig. 4
PICASSO:
Family of Acrobat with Monkey
(1905)
(The Gothenburg Art Gallery,
Gothenburg, Sweden)
© S.P.A.D.E.M., Paris, 1976

Fig. 5
PICASSO:
Harlequin (December 12, 1969)
(Photograph, courtesy Galerie
Louise Leiris, Paris)
© S.P.A.D.E.M., Paris, 1976

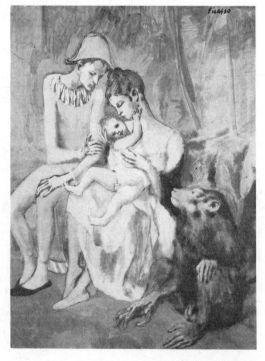

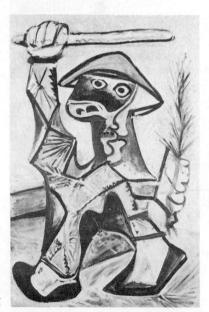

Fig. 6
PICASSO:
Les Demoiselles d'Avignon (spring 1907)
(Collection, The Museum of Modern Art, New York.
Acquired through the Lillie P. Bliss Bequest)
© S.P.A.D.E.M., Paris, 1976

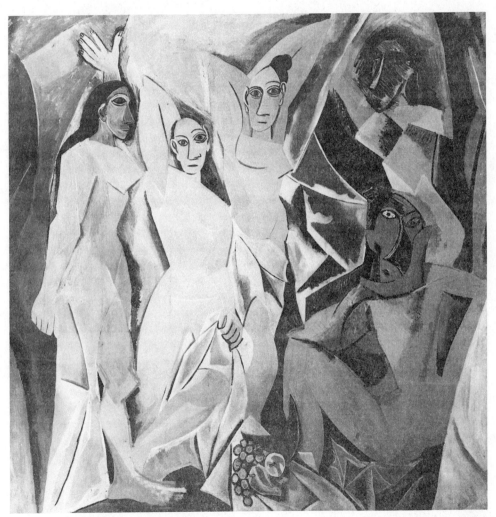

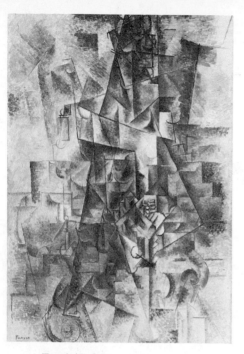

Fig. 7 (Left)
PICASSO:
Accordionist (Ceret, 1911)
(The Solomon R. Guggenheim
Museum, New York)
© S.P.A.D.E.M., Paris, 1976

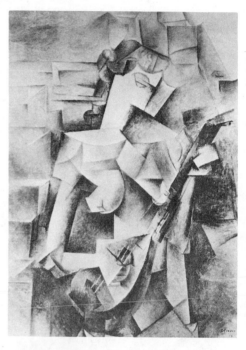

Fig. 8 (Right)
PICASSO:
Girl with a Mandolin
(Paris, early 1910)
(Private Collection, New York)
© S.P.A.D.E.M., Paris, 1976

Fig. 9 (Below)
PICASSO:
Bottle, Glass, Violin (1912–13)
(Nationalmuseum, Stockholm)
© S.P.A.D.E.M., Paris, 1976

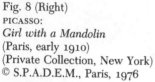

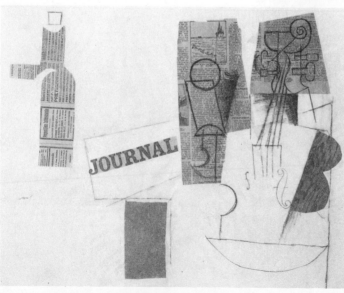

Fig. 10
PICASSO:
Three Women at the Spring
(summer 1921)
(Collection, The Museum of
Modern Art, New York. Gift of
Mr. and Mrs. Allan D. Emil)
© S.P.A.D.E.M., Paris, 1976

Fig. 11
PICASSO:
Painter and Model (1928)
(The Museum of Modern Art,
New York. The Sidney and
Harriet Janis Collection)
© S.P.A.D.E.M., Paris, 1976

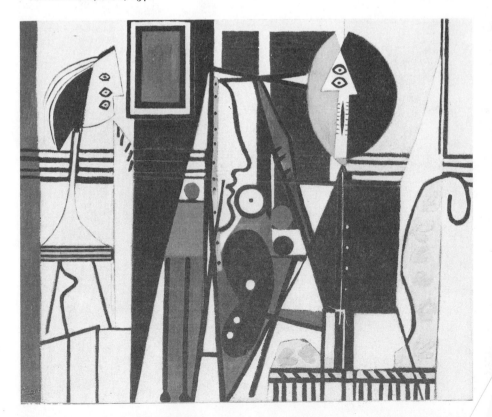

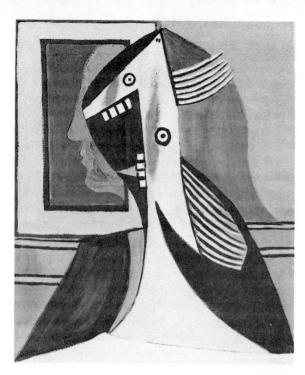

Fig. 12
PICASSO:
Self-Portrait and Monster (1929)
(Private Collection.
Photograph, courtesy of
Sotheby Parke Bernet Inc.)
© S.P.A.D.E.M., Paris, 1976

Fig. 13
PICASSO:
Monument: Woman's Head
(1929)
© S.P.A.D.E.M., Paris, 1976

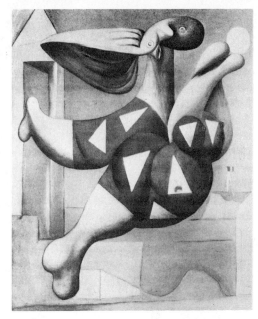

Fig. 14
PICASSO:
Woman's Head (1932), bronze
(Estate of the artist)
© S.P.A.D.E.M., Paris, 1976

Fig. 16
PICASSO:
Two Figures (April 18, 1933) drawing
© S.P.A.D.E.M., Paris, 1976

Fig. 15
PICASSO:
Bather with a Ball (August 30, 1932)
(New York, Collection of Mr. and
Mrs. Victor Ganz)
© S.P.A.D.E.M., Paris, 1976

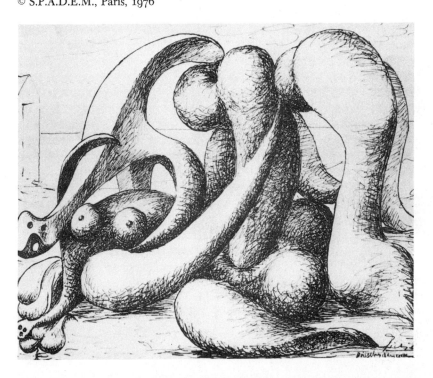

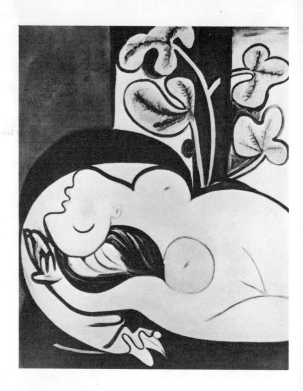

Fig. 17
PICASSO:
Sleeping Nude (March 9, 1932)
© S.P.A.D.E.M., Paris, 1976

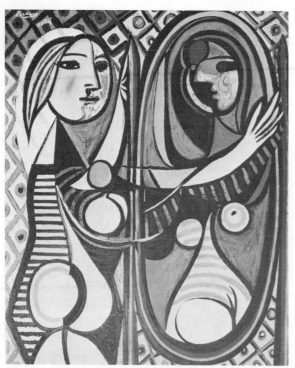

Fig. 18
PICASSO:
Girl before a Mirror (1932)
(Collection, The Museum of
Modern Art, New York. Gift of
Mrs. Simon Guggenheim)
© S.P.A.D.E.M., Paris, 1976

Fig. 19
PICASSO:
Collage (1926)
© S.P.A.D.E.M., Paris, 1976

Fig. 20
PICASSO:
Seated Woman (1927)
(Collection, The Museum of Modern
Art, New York. Gift of James Thrall
Soby)
© S.P.A.D.E.M., Paris, 1976

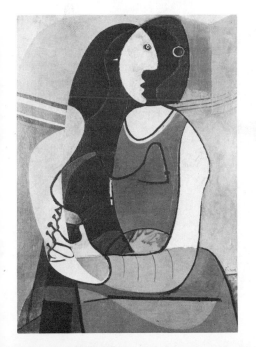

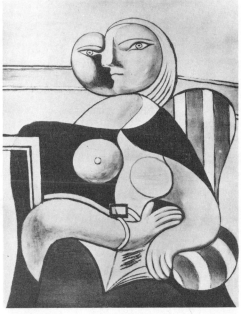

Fig. 21
PICASSO:
Portrait (1932)
© S.P.A.D.E.M., Paris, 1976

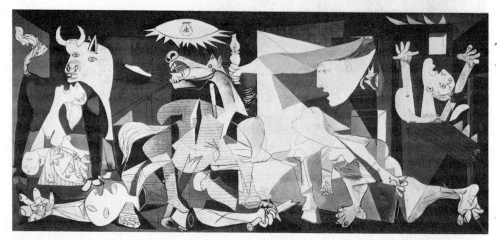

Fig. 22
PICASSO:
Guernica (May–early June 1937)
(Extended loan to the Museum of Modern Art, New York, from the artist)
© S.P.A.D.E.M., Paris, 1976

Fig. 23
PICASSO:
Minotauromachy (1935)
(Collection, The Museum of Modern Art, New York. Purchase)
© S.P.A.D.E.M., Paris, 1976

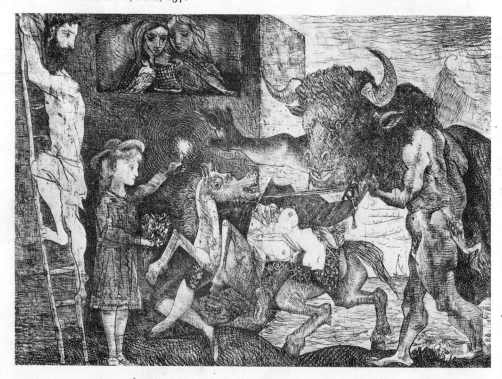

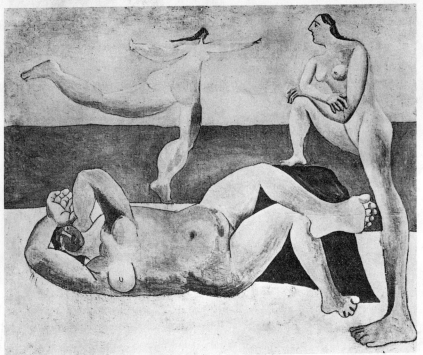

Fig. 24
PICASSO:
Three Women on the Beach (1923)
(Private collection)
© S.P.A.D.E.M., Paris, 1976

Fig. 25
PICASSO:
Woman Dressing Her Hair
(Royan, June 1940)
(New York, Collection of
Mrs. Bertram Smith)
© S.P.A.D.E.M., Paris, 1976

Fig. 26
PICASSO:
Seated Bather (early 1930)
(Collection, The Museum of Modern Art,
New York. Mrs. Simon Guggenheim
Fund)
© S.P.A.D.E.M., Paris, 1976

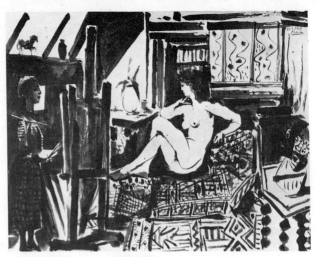

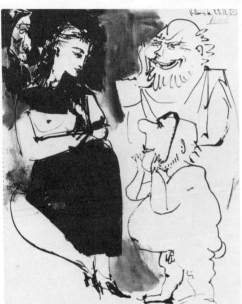

Fig. 27 (Above)
PICASSO:
Woman Painter and Model
(January 21, 1954), drawing
(Photograph, courtesy of Galerie Louise
Leiris, Paris)
© S.P.A.D.E.M., Paris, 1976

Fig. 28 (Left)
PICASSO:
*Two Women and Two Old Men with
Masks* (December 23, 1953), drawing
(Photograph, courtesy of Galerie Louise
Leiris, Paris)
© S.P.A.D.E.M., Paris, 1976

Fig. 29 (Below)
PICASSO:
*Old Painter with a Young and an Old
Model* (January 11, 1954), drawing
(Photograph, courtesy of Galerie Louise
Leiris, Paris)
© S.P.A.D.E.M., Paris, 1976

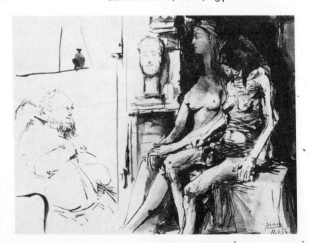

Fig. 30
PICASSO:
Painter and Elderly Model
(January 10, 1954), drawing
(Photography, courtesy of
Galerie Louise Leiris, Paris)
© S.P.A.D.E.M., Paris, 1976

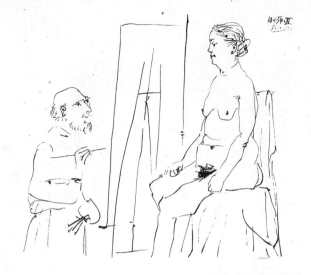

Fig. 31
PICASSO:
Dwarf and Girl with Masks
(January 25, 1954), drawing
(Photograph, courtesy of
Galerie Louise Leiris, Paris)
© S.P.A.D.E.M., Paris, 1976

Fig. 32
PICASSO:
Suite 347, no. 111, *The Infant
Prodigy* (May 15, 1968)

Fig. 33
PICASSO:
Suite 347, no. 114, *Prostitute, Procuress, and Clients* (May 26, 1968)

Fig. 34
PICASSO:
Suite 347, no. 188, *Painter and Model* (June 26, 1968)

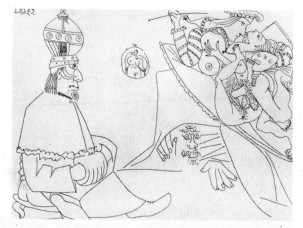

Fig. 35
PICASSO:
Suite 347, no. 237, *Flute-player, Dancer, and Orator* (August 3, 1968)

Fig. 36
PICASSO:
Suite 347, no. 314, *The Pope, Raphael, and La Fornarina* (September 5, 1968)

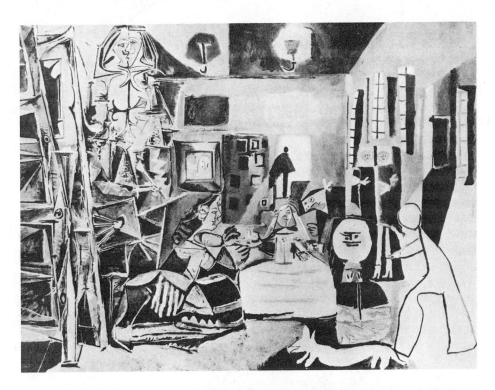

Fig. 37 (Above)
PICASSO:
Las Meninas (August 17, 1957)
(Museo Picasso, Barcelona)
© S.P.A.D.E.M., Paris, 1976

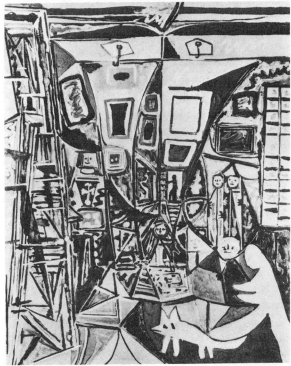

Fig. 38 (Right)
PICASSO:
Las Meninas (October 2, 1957)
(Museo Picasso, Barcelona)
© S.P.A.D.E.M., Paris, 1976

Fig. 39
PICASSO:
Head of a Man (August 3, 1971)
© S.P.A.D.E.M., Paris, 1976

Fig. 40
PICASSO:
The Young Painter
(April 14, 1972)
© S.P.A.D.E.M., Paris, 1976

THE SUCCESS AND FAILURE OF PICASSO
John Berger

The typical modern political movement in Spain was anarchism. As a youth in Barcelona, Picasso was on the fringes of this movement. The anarchism that took root in Spain was Bakunin's variety. Bakunin was the most violent of the anarchist thinkers.

> Let us put our trust in the eternal spirit which destroys and annihilates only because it is the unsearchable and eternally creative source of all life. The urge to destroy is also a creative urge.

It is worth comparing this famous text of Bakunin's with one of Picasso's most famous remarks about his own art. "A painting," he said, "is a sum of destructions." . . .

Barcelona was not fascist but simply lawless. Beginning in the 1890s bombs were being thrown. In 1907 and early 1908 two thousand exploded in the streets. A little after Lerroux's speech twenty-two churches and thirty-five convents were burnt down. There were a hundred or more political assassinations every year.

What made Barcelona lawless was once more the historical rack. Three groups of interests were each fighting for survival. There was Madrid fighting for its absolutist right, as established by the Habsburgs in the seventeenth century, to live off the riches of its manufacturing province. There were the Barcelona factory-owners fighting for independence from Madrid and the establishment of a capitalist state. (Generally speaking their enterprises were small and at a low level of development. When they were on a larger scale—as in the case of the

From John Berger, *The Success and Failure of Picasso* (London: Penguin Books Limited, 1965), pp. 22, 26–36, 129–31. © John Berger, 1965. Reprinted by permission of Hope Leresche & Steele.

banks or railways—they were compromised by being tied to political parties and so run in the interests of bureaucratic graft rather than efficiency and profit.) Lastly there was an inexperienced but violent proletariat, largely made up of recent peasant emigrants from the poverty of the south.

Madrid, for its own interests, encouraged the differences, having no judiciary or state legal machinery with which to control their workers, had to dispense with legality and rule by direct force. The workers had to defend themselves against the representatives of Madrid (the army and the Church) and against the factory-owners. In such a situation, and with little political experience to help them, their aims were inevitably avenging and short-term—hence the continuing appeal of anarchism. Each group—one might almost say each century—fought it out with *pistoleros, agents provocateurs,* bombs, threats, tortures. All that in other modern cities was settled "legally"— even if unjustly—by the machinery of the state, was settled privately in Barcelona in the dungeons of Montjuich Castle or by guerrilla warfare in the streets.

You may feel that what I have said about Spain has very little to do with Picasso's own experience. Yet only in fiction can we share another person's specific experiences. Outside fiction we have to generalize. I do not know and nobody can know all the incidents, all the images in his mind, all the thoughts that formed Picasso. But through some experience or another, or through a million experiences, he must have been profoundly influenced by the nature of the country and society he grew up in. I have tried to hint at a few of the fundamental truths about that society. From these alone we cannot deduce or prophesy the way that Picasso was to develop. After all, every Spaniard is different, and yet every Spaniard is Spanish. The most we can do is to use these truths to explain, in terms of Picasso's subjective experience, some of the later phenomena of his life and work: phenomena which otherwise might strike us as mysterious or arbitrary.

Yet, before we do this, there is another aspect of Picasso's early life which we must consider. The most obvious general fact about Picasso is that he is Spanish. The second most obvious fact is that he was a child prodigy—and has remained prodigious ever since.

Picasso could draw before he could speak. At the age of ten he could draw from plaster casts as well as any provincial art teacher. Picasso's father was a provincial art teacher, and, before his son was fourteen, he gave him his own palette and brushes and swore that he would never paint again because his son had out-mastered him. When he was just fourteen the boy took the entrance examination to the senior department of the Barcelona Art School. Normally one month

was allowed to complete the necessary drawings. Picasso finished them all in a day. When he was sixteen he was admitted with honours to the Royal Academy of Madrid and there were no more academic tests left for him to take. Whilst still a young adolescent he had already taken over the professional mantle of his father and exhausted the pedagogic possibilities of his country.

Child prodigies in the visual arts are much rarer than in music, and, in a certain sense, less true. The boy Mozart probably did play as finely as anybody else alive. Picasso at sixteen was *not* drawing as well as Degas. The difference is perhaps due to the fact that music is more self-contained than painting. The ear can develop independently: the eye can only develop as fast as one's understanding of the objects seen. Nevertheless, by the standards of the visual arts, Picasso was a remarkable child prodigy, was recognized as such, and therefore at a very early age found himself at the center of a mystery.

Nobody has yet explained exactly how a child prodigy acquires or inherits his skill and knowledge. Is it that he is born with ready-made connexions in his mind, or is he simply born with a highly exaggerated susceptibility? In popular imagination the prodigy—whether child or adult—has always been credited with magical or supernatural powers: he is always thought of as an agent of some force outside himself. Paganini was believed to have been taught the violin by the devil.

To the prodigy himself his power also seems mysterious, because initially it comes to him without effort. It is not that he has to arrive somewhere; he is visited. Furthermore, at the beginning he does things without understanding why or the reasoning behind them. He obeys what is the equivalent of an instinctual desire. Perhaps the nearest we can get to imagining the extent of the mystery for him is to remember our own discovery of sex within ourselves. And even when we have become familiar with sex and have learnt all the scientific explanations, we still tend to think of the force of it—whether we think in terms of the *id* or of reproductive instincts—as something outside ourselves, we still tend to project its force on to nature, to which we then gladly submit.

And so it is not surprising that most prodigies believe that they are a vehicle—that they are driven. Keats, the outstanding prodigy of English poetry, makes the point in a letter of 1818. First he distinguishes between two types of poet: the prodigious, and the highly self-conscious, like Wordsworth. Of the character of the prodigy he says:

> It is not itself—it has no self—it is everything and nothing—it has no character—it enjoys light and shade—it lives in gusto . . . a poet is the most unpoetical of anything in existence, because he has no identity; he is continually in for, and filling, some other body.

I myself have heard Yehudi Menuhin say words to very much the same effect. And Picasso, at the age of eighty-two, has just said: "Painting is stronger than I am. It makes me do what it wants."

The fact that Picasso was a child prodigy has influenced his attitude to art throughout his entire life. It is one of the reasons why he is so fascinated by his own creativity and accords it more value than what he creates. It is why he sees art as though it were part of nature.

> Everyone wants to understand art. Why not try to understand the songs of a bird? Why does one love the night, flowers, everything around one, without trying to understand them? But in the case of painting people have to *understand*. If only they could realize above all that an artist works of necessity, that he himself is only a trifling bit of the world, and that no more importance should be attached to him than to plenty of other things which please us in the world, though we can't explain them.

This is partly a reasonable protest against all the pretentious intellectual constructions that have surrounded so much art in our time. But it is also a justification of the nature of his own genius as he sees it. He makes art like a bird sings. Understanding has nothing to do with it—indeed understanding is a hindrance, almost a threat.

> I can hardly understand the importance given to the word research in modern painting. In my opinion to search means nothing in painting, to find is the thing.

This—perhaps the most quoted of all Picasso's remarks—has perplexed people ever since he made it in 1923. It is clearly untrue of modern painting in general. It was undeniably a spirit of research which inspired Cézanne, Seurat, Mondrian, Klee. Did Picasso say it simply to shock? Is it no more than another way of making the commonplace observation that good intentions aren't enough? No. Like everything that Picasso says it is truer for him than seems likely. Picasso does not make paradoxes for their own sake—it is rather that his whole experience is paradoxical. He believes what he says because that is how it happened to him. He himself achieved art without searching. He found his own genius without looking for it. It happened apparently instantaneously, without any preparation on his part.

> The several manners I have used in my art must not be considered as an evolution or as steps towards an unknown ideal of painting. All I have ever made was made for the present, and with the hope that it will always remain in the present. I have never taken into consideration the spirit of research. When I have found something to express, I have done it without thinking of the past or the future. . . . I have never made

trials or experiments. Whenever I had something to say, I have said it in the manner in which I have felt it ought to be said. Different motives inevitably require different methods of expression. This does not imply either evolution or progress, but an adaptation of the idea one wants to express and the means to express that idea.

Here is the secret of the extraordinary intensity of Picasso's vision. He has been able to see and imagine more suffering in a single horse's head than many artists have found in a whole crucifixion.

He gives himself up utterly to the present idea or moment. The past, the future, plans, cause and effect—all are abandoned. He submits himself totally to the experience at hand. *All that he has done or achieved only counts in so far as it affects what he is at that moment of submission.* This is the way in which—ideally at least—Picasso works. And it is very close indeed to the way in which the prodigy submits to the force that plays through him.

Such is the positive result of the mystery at the center of which Picasso found himself as a child. By respecting this mystery he has become the most expressive artist of our time. But there was also a negative result—which may have had as much to do with his childhood success as with the mystery. Picasso denies the power of reason. He denies the causal connexion between searching and finding. He denies that there is such a thing as development in art. He hates all theories and explanations. It would be understandable if he ignored all these intellectual considerations when it came to respecting and responding to the mystery of his own powers. But he goes further than this. He hates reasoning in general and despises the interchange of ideas.

> There ought to be an absolute dictatorship, a dictatorship of painters, a dictatorship of one painter—to suppress all who have betrayed us, to suppress the cheaters, to suppress the tricks, to suppress mannerisms, to suppress charms, to suppress history, to suppress a heap of other things. But common sense always gets away with it. Above all let's have a revolution against that! The true dictator will always be conquered by the dictatorship of common sense—and perhaps not!

This is partly a joke. But nevertheless it reveals an uneasiness. He wants everything to be beyond argument. He wants to be beyond the reach of *evidence.*

> They should put out the eyes of painters [he has said], as they do to goldfinches to make them sing better.

It is as though, in principle, he is frightened of learning. (It is perhaps relevant to note in passing that he is one of the very few modern

painters who has never taught.) He is prepared to learn a new
skill—pottery, lithography, welding—but as soon as he has learnt the
technique, he needs to overthrow and disprove its laws. From this
need comes his marvellous power of improvisation and his wit, which
respects nothing. Yet the need, however exhilarating the results, still
betrays a certain defensiveness. I cannot explain this. I can only
tentatively suggest a possibility. It seems to me odd that the story of
Picasso's father giving his palette and brushes to his son, aged
fourteen, and swearing never to paint again, has never been consid-
ered more seriously. If it is true, it is likely to have been a deeply
formative experience for the young Picasso.

Is it likely that a boy will ever believe in progress step by step
when at the age of puberty he is suddenly told by his father that he
deserves to take his father's place and that his father is going to step
down? Since this is what every boy wants to happen, is he not more
likely to believe in magic? Yet at the same time, and again because he
has wanted it to happen, is he not likely to feel guilty? The most
obvious relief from his guilt is then to tell himself that his father's
patience and slow development and experience do not, by the very
nature of things, count for anything: that the only thing which can
count is the mysterious power he feels within himself. But this relief
can only be partial: he will remain frightened of explanations and of
discussion with and between other people of the way he overthrew his
father.

> We all know that Art is not truth. Art is a lie that makes us realize truth,
> at least the truth that is given us to understand. The artist must know
> the manner whereby to convince others of the truthfulness of his lies. If
> he only shows in his work that he has searched and re-searched for the
> way to put over lies, he would never accomplish anything.

The distinction between object and image is the natural starting point
for all visual art which has emerged from magic and childhood. To
exaggerate this distinction, as Picasso does here, until lie and truth are
reversed, suggests that part of him still believes in magic and has
remained fixed in his childhood. This seems the more convincing to me
because conflicts between father and son are so often fought out in
precisely these terms. The father accuses the boy of lying. The boy
knows he is lying but believes that he is doing so for the sake of a more
important and comprehensive truth that his father will never under-
stand. The truth is the father's defense of his own authority. The lie is
the son's way of escape from that authority. But if the lie is so obvious
that the son can't defend it as the truth, nothing is accomplished and
the father's authority is actually increased.

There may be a possible explanation here. But if you can accept

neither it nor the psychoanalytic premises on which it is based, it is of little importance. The important point for our main argument is that for one reason or another, and as a corollary of his awareness of his prodigious gifts, Picasso has remained sceptical or suspicious of reasons, explanations, learning.

To emphasize this by contrast, I want to quote another painter. Juan Gris was of the same generation as Picasso and was also a Spaniard. He was a great painter—and his contribution to Cubism was as important as Picasso's—but he was in no way a prodigy. This is how he wrote in 1919:

> I would like to continue the tradition of painting with plastic means while bringing to it a new aesthetic based on the intellect. . . . For some time I have been rather pleased with my own work, because I think that at last I am entering on a period of realization. What's more I've been able to test my progress: formerly when I started a picture I was satisfied at the beginning and dissatisfied at the end. Now the beginning is always rotten and I loathe it, but the end, as a rule, is a pleasant surprise.[1]

Compare this with Picasso:

> It would be very interesting to preserve photographically not the stages, but the metamorphoses of a picture. Possibly one might then discover the path followed by the brain in materializing a dream. But there is one very odd thing—to notice that basically a picture doesn't change, that the first vision remains almost intact, in spite of appearances.

Juan Gris has to travel and arrive—and believes in the intellect. Picasso is visited, denies progress—the picture does not go through stages but suffers metamorphoses—and thinks of the brain, not in terms of the intellect, but in terms of dream sequences. Gris's paintings develop from beginning to end. Picasso's paintings, however much they may appear to change, remain essentially what they were at their beginning.

> Everything interesting in art happens right at the start. Once past the beginning you're already at the end.

Picasso is again talking here about a single painting, but what he says could apply to his whole life's work: a life's work made up not of stages, because that implies a desired destination, evolution, logical purpose, but made up of metamorphoses—sudden inexplicable transformations: a life's work which, despite appearances, has left un-

[1] See *Letters of Juan Gris*, edited and printed by Douglas Cooper.

changed and intact its first vision—that is to say the vision of the young Picasso in Spain.

The only period in which Picasso consistently developed as an artist was the period of Cubism between 1907 and 1914. And this period, as we shall see later, is the great exception in Picasso's life. Otherwise he has not developed. In whatever way one applied the coordinates, it would be impossible to make a graph with a steady ascending curve applicable to Picasso's career. Yet this would be possible in the case of almost every other great painter from Michelangelo to Braque. The only exceptions would be those painters who lost their vigor as they grew older. But this is not true of Picasso. So Picasso is unique. In the lifework of no other artist is each group of works so independent of those which have just gone before, or so irrelevant to those which are to follow. . . .

We have already said that Picasso was an invader. This is what he was in relation to Europe. *But within himself he was, at one and the same time, a "noble savage" and a bourgeois "revolutionary." And within himself the latter has idealized the former.*

Why has he idealized himself? Or, to put it more accurately, why has he so carefully preserved the primitive bias of his genius that it can serve as the genius of a "noble savage"? It has not been the result of self-love or vanity. By idealizing his "noble savage," he condemns, like Rousseau, the society around him. This is the source of his sincere conviction that he has been a revolutionary all his life. It is this which has made him *feel* a revolutionary—although in fact few Europeans of his generation have had less real contact with modern politics.

If he had returned to Spain, he would doubtless have developed differently. In Spain he would no longer have been aware of himself as a "savage." This awareness was the result of the difference between himself and his foreign surroundings. For others this difference has made Picasso exotic, and to some degree he has encouraged this, for the more exotic he becomes the more of the "noble savage" he can find within himself, and the more of the "noble savage" he can find within himself the more forcefully he can condemn those who patronize him by considering him exotic. Such is the paradox in Picasso's attitude to fame.

The fact that another part of Picasso is a bourgeois "revolutionary" is equally plausible. He came from a middle class which had not yet achieved its revolution. As a student in Barcelona and Madrid he mixed with other middle-class intellectuals with anarchist ideas. Anarchism was the one political doctrine of the second half of the nineteenth century which continued the eighteenth-century tradition of Rousseau—believing in the essential goodness and simplicity of man before he was corrupted by institutions. After he left Spain, Picasso took no further part in politics for thirty years. At the same time his

life was comparatively unaffected by political events. For many of his contemporaries the First World War was a terrible awakening to the realities of the twentieth century. Picasso was not in the war and appears to have given it no thought. His interest in politics was only re-awakened by what happened distantly *in his own country* during the Spanish Civil War. In so far as he belongs to politics, Picasso belongs to Spanish politics. And in Spain a bourgeois revolutionary is still a possibility.

We can now begin to understand why Picasso claims, like no other twentieth-century artist, that what he *is* is more important than what he does. It is the existence of the "noble savage," not his products, that offers the challenge to society.

We can begin to understand something of the magnetism of his personality, of his power to attract allegiance. This is the result of his own self-confidence. Other twentieth-century artists have been victims of doubt, awaiting the judgement of history. Picasso, like Napoleon or Joan of Arc, believes that he is *possessed* by history—that he is the judgement for which others have been waiting.

We can begin to understand his ceaseless productivity. No other artist has had such an output. Although what he *is* is more important than what he does, it is only by working that his two selves can be maintained. In modern Europe art is the only activity in which the "noble savage" can be himself. Thus the "noble savage" has to paint in order to live. If he did not live, the "revolutionary" would have nothing to live for. He does not go on painting to make his paintings better—indeed he resolutely denies the very idea of such "progress"; he goes on painting in order to prove that he is still what he was before.

On a more objective plane the phenomenon of his success becomes more understandable. His success, as we saw, has little to do with his work. It is the result of the *idea of genius* which he provokes. This is acceptable because it is familiar, because it belongs to the early nineteenth century, to Romanticism, and to the revolutions which, safely over, are now universally admired. The image of his genius is wild, iconoclastic, extreme, insatiable, free. In this respect he is comparable with Berlioz or Garibaldi or Victor Hugo. In the guise of such genius he has already appeared in hundreds of books and stories for a century or more. Even the fact that he or his work is outrageous or shocking, is part of the legend and therefore part of what makes him acceptable. It would be wrong to suggest that each century has its exclusive type of genius. But the *typical* genius of the twentieth century, whether you think of Lenin or Brecht or Bartok, is a very different kind of man. He needs to be almost anonymous: he is quiet, consistent, controlled, and very conscious of the power of the forces *outside* himself. He is almost the exact opposite of Picasso.

Finally, we can begin to understand Picasso's fundamental

difficulty: a difficulty that has been so disguised that scarcely anybody has recognized it. Imagine an artist who is exiled from his own country; who belongs to another century, who idealizes the primitive nature of his own genius in order to condemn the corrupt society in which he finds himself, who becomes therefore self-sufficient, but who has to work ceaselessly in order to prove himself to himself. What is his difficulty likely to be? Humanly he is bound to be very lonely. But what will this loneliness mean in terms of his art? It will mean that he does not know what to paint. It will mean that he will run out of subjects. He will not run out of emotion or feelings or sensations; but he will run out of subjects to contain them. And this has been Picasso's difficulty. To have to ask of himself the question: What shall I paint? And always to have to answer it alone.

PICASSO AND THE MARXISTS

Herbert Read

The importance of the exhibition of Picasso's drawings at the Mayor Gallery (18 Cork Street) was mainly strategical. Naturally, like all drawings, they were the intimate confessions of the painter, aids to the understanding of his paintings; and the selection at the Mayor Gallery had been made so well that it formed a key to the whole of Picasso's development, from the early realistic phase represented by a *Torse de femme* of 1903, to the "super-realistic" designs of last year. But the real strength of the exhibition lay in the actual graphic quality of the drawings. Merely as a linear artist Picasso's genius is so transparent that no one but the intellectually dishonest could fail to recognize it; drawings such as the *Femme à la cruche* meet the academic artist on his own ground, and decisively defeat him. It would be interesting to see some of Picasso's drawings exhibited side by side with representative drawings of the Italian masters; the modern artist would stand the test. Indeed, the final demonstration of the validity of modern art will come when some impresario has the courage to stage, on a grand scale, an exhibition of ancient and modern art in parallel series. It could be done if the owners of masterpieces of ancient art (including the State) would co-operate; and if they refused to co-operate, we should be free to draw our own deductions.

The first exhibition of the British Section of the Artists International, held for a fortnight at 64 Charlotte Street, promised to be of exceptional interest, but even the most sympathetic of critics would have to confess that it was disappointing in quality. One does not need to be a capitalist to describe the exhibition as based on a complete confusion of thought. An introductory note to the catalogue antici-

From "Picasso and the Marxists" by Herbert Read. From *London Mercury*, 31 (November 1934), pp. 95–96. Reprinted by permission of the Herbert Read Discretionary Trust and David Higham Associates, Ltd.

pates adverse criticism from two quarters—"one political, from those who disagree with our political convictions, and the other æsthetic—from those who still adhere in their outlook to the doctrine of 'art for art's sake.' " But my criticism comes from neither of these quarters. It would be unwise to identify myself with political convictions which are not very precisely defined, but I count myself "on the side of the working class against the capitalist class," and I call myself a socialist. Further, in the accepted meaning of the phrase, I do not accept the theory of art for art's sake: art is an expression of the artist's *Weltanschauung*, and this *Weltanschauung* may, and often does, include an attitude towards the moral, philosophical, social and political problems of the artist's period. One might even accept what the catalogue calls the Marxist position—"that the character of all art is the outcome of the character of the mode of material production of its period"—provided that by "character" is meant external features rather than inner form. In any case, we are not excused the process of æsthetic valuation. There are good artists and bad artists in every period. Nothing could be further removed from our own existing "mode of material production" than the mode prevailing in the Old Stone Age; but the drawings of the unknown artist of the Altamira caves have a definite similarity to the drawings of Picasso—the same concentrated vitality expressed by the same mode of linear abstraction.

Marxists often use the word "dialectic," but most of them are dialecticians of an extremely naïve kind. Even if we admit that their only rationale, that of cause and effect, may be of universal application, yet still there is no reason why every manifestation should be strung on the same causal chain. The Marxist can only argue in an horizontal direction; he does not see that history develops on several parallel but distinct planes, and that if, for example, he wishes to arrive at the exact analogue in art for his political locus, he must direct his vision upwards, in a vertical cut across the parallels. The true revolutionary artist to-day is not any artist with a Marxist ideology; it is the good artist with a revolutionary technique. The same is true of poetry and all the other arts, and any understanding between the artistic and political fronts will be impossible so long as there exists this mutual ignorance of the realities of each mode of action. In *A.I. Bulletin*, a publication of the British Section of the Artists International, I find this significant opinion: "Art, in short, has become what it is to-day in its most representative 'modern' form, an art of obscurantism, a petty-bourgeois, sectarian, clique-art completely out of touch with the life of the people. A precious, obscure, unhealthy manifestation, which finds its final absurdity when the individual yields all conscious part in his work as has been advocated recently when a group of artists put forward the claim that they placed arbitrary marks on a canvas and then allowed the picture to evolve of itself."

The group of artists in question is presumably the French "surréalistes," but Picasso has described his own work in similar terms. When the writer of the article in *A.I. Bulletin* has realized that in denying Picasso and his type he is denying the only artists who are breaking down the conventions of petty-bourgeois art, and thus preparing the way for the art of the socialist state, he will perhaps be able to organize something more inspiring than this first exhibition.

PICASSO AND THE UNCONSCIOUS

Frederick Wight

When we examine a painter's work psychoanalytically we attempt to reach an understanding of its significance. What does the painting mean? It is necessary to understand what is happening in a painting before there can be any question of how well it is done. The marks and colors on canvas have a symbolic significance in addition to their obvious meaning. To recognize symbols only where there is nothing else is to have far too small a vocabulary. Picasso is not more or less symbolic than other painters. The objects of a most emphatic realism are also symbols. *The House Across the Railroad Track* of Edward Hopper is the maternal "house where I was born" which the artist will seek in later paintings; the railroad track is the dangerous father-symbol which cuts between the painter and the object of his desire. Because an artist expresses unconscious desires which change slowly, if at all, it is not surprising that once the symbolism has become clear, we find endless variations on a single theme. It is Picasso's distinction not to be more symbolic but to say more things, shifting his position as he follows his subject, so that his work becomes a psychic quest.

The various periods and phases through which Picasso passes, apparently random and disconnected, acquire a logical and inescapable sequence. Picasso progresses: he is engaged in constant exploration, in breaking new ground. He seeks to regain the source of his emotion and thus he moves backward toward his infancy, delving into the relationship of the child to the mother; this regression provides an escape from the feeling of guilt in the presence of the father; first in childhood and then in infancy he finds both the primal emotion and the means to express it without danger. If we admit that guilt limits

"Picasso and the Unconscious" by Frederick Wight. From *Psychoanalytic Quarterly* 13, no. 2 (April 1944), 208–16. Reprinted by permission of the author and the publisher.

expression, that the artist is engaged in seeking emotions guarded by incest taboos, we are given almost parenthetically an explanation of the artist's function. It is his province to do painfully what cannot otherwise be done at all, to obtain firsthand what others desire but cannot have in real life because it is forbidden.

Regression to infancy usually results in isolation. But the genius, projecting his emotion on canvas, lives in and for the adult world, and has his past and present too. The genius and the psychotic are poles apart, with the average man between. Nevertheless the genius and the psychotic both move under compulsion. The genius does not succumb to the pressure of the unconscious because he is able to externalize it. Undoubtedly the amount of canvas Picasso has covered is the purchase price of his psychic stability.

In one of Picasso's earliest paintings a young woman and a bearded young man, both nude, are embracing; on the right is an older woman with an infant in her arms. The man looks over the young woman's head at the mother who glares back at him. Between these two groups smaller figures appear on two levels, which are the two sides of a cube. Cubism is already foreshadowed. A man and a woman are coiled globularly together in a position obviously prenatal; below them a lone male figure repeats the man's attitude. The painting presents an extensive drama; later compositions are scenes from it, treating the subject in detail.

Canvases now follow in which the central subject is a boy flanked by his parents [Fig. 3]. The figures do nothing; they face in opposite directions and always the mother looks away. They present the emaciation of famine, as if they lacked some essential nourishment. These paintings have been interpreted as an expression of social protest; but the protest lies deeper, and the hunger is not for any tangible bread. It would perhaps be reasonable to seek a historical explanation in Spanish asceticism. But Picasso's famine and asceticism have the same cause: fear of the sources of sustenance. There are brighter pictures of partial serenity, paintings of adolescent companions. Even here the feeling is of idleness and underlying quandary. Already there are vague blotched areas on the canvas, like a shadow cast by an object outside, perhaps even by the painter himself.

Then harlequin appears never to leave us again [Fig. 5]. He is make-believe, a grown man playing like a child: infancy in maturity. Harlequin has two lives, daily and dramatic, and therefore he wears a checker of two colors, pink and green. From the Renaissance to the masquerade, the parti-colored costume provides relief and escape. I am several people, not the lone person you took me for; I am myself and someone else, my parent. A man with a black leg and a white leg, a black arm and a white arm, is permitted to cut capers without being called to account.

Besides his checkered costume, harlequin possesses two other lasting symbols, his mask and his cocked hat. The mask signifies concealment. The harlequin of 1905 wears a mask which subsequently he will remove and hold in his lap, as though Picasso sensed the sexual implications and the need of concealment. The horned hat is destined for prolonged symbolic evolution. In Picasso's childhood the horned hat was worn by the Spanish police. The horn also represents the bull's horn; a Spaniard could hardly escape the parricidal drama of the bullfight. Ultimately we have the horned moon, symbol of ambiguity and dilemma and, in the later double image paintings, a symbol of the pregnant woman.

It should be noted that harlequin presents the reverse of normal experience: his everyday life lies concealed under a disguise; on the surface it is the dream. This is the first of Picasso's inversions, devised to prove that what was underneath can be brought to the top. His next topsy-turvy symbol is the acrobat who turns somersaults and walks on his hands with his feet in the air, a profound inversion symbol which can be understood only through his latest works.

There is no happiness in this carnival. Anxiety has not yielded to buffoonery. The acrobats do nothing very acrobatic, and father and child still look askance. A number of paintings follow, ominous with brooding women seated alone at table, lost in bitterness, abandoned but not resigned, with a strong expression of will. The color is blue, the blue of the Virgin in all Catholic painting, of the sky and the maternal sea, symbol of the unobtainable. But the Picasso blue is not that of the sky but of a backdrop disturbingly near at hand.

Picasso now throws himself into the Cubist movement. Cubism was basically a reconquest of architectural space. It revolted against Impressionism and against a geometry forced upon the artist. Perspective had ceased to be an artist's revelation and the sense of space had grown stale. Impressionism had invaded architecture and destroyed the double experience of adventure in the midst of security to be obtained from a decorated wall. The beholder was now exposed to all outdoors. The Cubist space restored decorated architecture, the semi-privacy which men desire. It expanded the wall without destroying the building [Fig. 7].

Picasso constructed three-dimensional still lifes, in an attempt to solve his problem. But that problem was the revelation of things underneath. Later he was to need space for sculptural effects, but the aspect he now prefers is the broken diagrammed surface. His geometric forms become thin, with the creation of just enough space to show that they are superimposed on something half-concealed. Textures are varied to prove this point. The forms seem no thicker than they are and often resemble a scattered manuscript. At times the different levels are actually pasted over each other in the *collages;*

newspaper serves admirably for the conscious surface of daily life [Fig. 9].

We have the impression that Picasso attempts to find in cubism a synthesis between his two worlds. He sets up a screen of geometry between them much as a photographer sets the focal length midway between two objects; and geometry is a double-aspect symbol with a conceptual life of its own. It describes the empirical world. The screen has an important function; it protects the artist from too complete a revelation and allows him to work closer to his image. The screen is like the grill which Spanish etiquette places between lovers who are left alone. It allows Picasso to paint for years without having to seek directly the safety of infancy.

Geometry affords another kind of protection. It is timeless; and the destruction of time removes danger. Artists who resist the safety of infancy become Platonists and escape from time. They take the Chirico path. The artist anæsthetizes his victim and the image can neither suffer nor seek revenge while the artist continues his anatomy lesson. The half-concealing, half-revealing screen is like the half-mask of harlequin and perhaps like the checkers of his suit.

This screen, this mask does not protect Picasso indefinitely. From the beginning the vital matter beneath has been coming through. The shapes soon take on characteristics of what is below: they become ovular, tubular; they resemble viscera, those internal shapes which are more significant than their familiar envelope. All are set in a geometric matrix which includes the frame, just as our bodies are finally framed in the geometry of houses and cities. The shapes take life symbolically: the horn reappears and a female symbol emerges, the guitar. Picasso has appealed to music as he appealed to pantomime to collaborate with him, because it too is a language without words. The checker of harlequin is present and other symbols taken liberally from what is found on a table: bottles, glasses, fruit, papers, pipes, playing cards. Musical instruments and the furnishings of a room are symbolically used. Picasso says that these possessions are the person in extension, the living shell on our backs.

Harlequin is the unconscious man brought to the surface, while the everyday man takes his turn at concealment. The man with his heels over his head was the acrobat. Now another inversion appears. The recognizable portrait was at first obscured by a mask of geometry; little by little the life went out of the image into the mask. Finally Picasso raises the question as to whether reality does not lie in the attributes. Is there any need for a *Ding an sich*? What is there but symbols? Symbols are concrete. What they represent is merely an abstraction.

Picasso painted *The Three Musicians* in 1921. These persons, if persons they may be called, are composed of flat areas which might be

colored paper. There is no break between musician and background. The three wear carnival costume—or they are carnival costume—grown men at play. One is harlequin, another a clown, another a monk. All wear masks. But is there anything under the mask? It no longer matters. Everything is alive. The monk's legs are not under the table, which is a female symbol. Fingers are confused with the keys of an instrument, the clown's fingers forming a keyboard. (Women's fingers will now often be the pegs of a guitar.) Harlequin's hand is a neat little wooden contrivance for the bow of his violin; harlequin's suit might also be an iron grill over a doorway and his lace a net. The horned hat approaches the moon. The notations of music in the center of the canvas are carried throughout. Eyes are notes, and the impression is one of arbitrary marks on paper that nevertheless have power. The masquerade is singularly sinister, with the gaiety and mummery of an auto-da-fé.

Following the last war Picasso undergoes one of his deceptive changes. A time of serenity is ushered in by a few calm, naturalistic portraits, by drawings of peasants sleeping at noonday. Putting aside his arbitrary symbols and with the mask apparently off, Picasso's classic period begins [Fig. 10]. All at once he is able to approach his material directly. How has this approach become possible? Is something resolved or is the whole classic period itself a protection?

The classic time is a symbol of first beginnings. It is naked without sin. Emaciation and anxiety are things of the past. Parents are now shown lolling and opulent; they do not know the meaning of starvation or guilt. They tower with limbs of giants, reaching down with great arms, their very fingers like arms and legs, their faces as expressionless as figureheads with fixed round eyes, because the child has not mastered the play of expression. They suggest classic sculpture in their drapery, and yet they are not classic sculpture and there is no drapery. They wear night clothes. The women have one breast exposed to nurse the child. Picasso has succeeded in calling up the vision of a child at the breast. To reach back this far into the unconscious is a great triumph. It is Picasso's high period of security, for the child has a stronger claim to the mother's breast than the father, and he is victorious if he can be content. It is extraordinary to compare these parents with the starved parents of the blue period. Then there was no possibility of effort, now there is no need. The child feasts directly on his mother's body and nothing is more unimaginable than want. This alone could have been a culmination for Picasso; the same vision of the massive-limbed, expressionless mother sufficed for the last great period of Renoir, who atoned for the intimacy of his touch with the arthritis that numbed his hands.

But for Picasso the security is short-lived. The child's relation to the mother is still unexplored. We are not all the way back. The

language grows more symbolic again. We have highly abstract figure pieces and a long series of more literal still lifes. Symbolically the still lifes are figure pieces too. It is permissible to represent a table more objectively than a woman because few suspect it of being a woman or guess that the bust on the table is its head, or the mandolin its breast. Boldness and richness in color and design increase. The forms are full, not brittle and sharp; they have the large, wobbling outline of infantile draughtsmanship. There is a growing impression of depth, and while there is no extensive space, there is sufficient for objects to possess a fat roundness. There is enough space to contain the object but no more. We are approaching the double image paintings at the beginning of the nineteen thirties, a time of increased tension and excitement. The double image means that mother and child are one [Fig. 21]. This duality takes many forms. The mirror is so obvious as to be almost a preliminary symbol [Fig. 18]. It reflects a different aspect of the image. More commonly there are two entities in the same envelope. The forms are ovular, the colors are vivid. The psyche is free to represent the outside world as a glaring, violent place, for it has found its own safety. Byzantine art has influenced this phase and, like classic art, symbolizes an early period. Like classic art, it too maintains its innocence, in this case through monasticism. It has a child's eye for emphatic colors, for figures fixed in suspension, protected in medallions, the head secure in the gold circle of a halo. It affords Picasso a symbol of the secure life, fixed and suspended within the mother.

A series of related canvases shows us how Picasso describes this woman of the double image. His first infantile comment is that her sex is ambiguous, that she is both parents [Fig. 14]. Masculine characteristics in one painting become feminine in the next; often both are present. The infant male has no reason to suspect that his mother differs from himself. The second comment is more startling; and once made it is repeated indefinitely. Picasso insists on the infantile confusion of the genitals with the features of the head. This confusion is inevitable for the nursing child, with its primarily oral relation to the mother. The confusion goes through endless metamorphoses, providing especially the symbol of duality. Heads are double; there are two profiles, or heavy lines down the middle of the face, or divided features on different levels. There are cleft heads, flat surfaced heads with a double loop across them; heads with two mouths and three eyes. But these double heads that share their features and are contained within one oval are buttocks, not to be confused with the ever-present breasts.

Picasso concludes that we are first and foremost a digestive tract, with areas of sensitivity at both ends, suited for survival. In a paleontology of his own he paints sabre tooth forms, shark heads and shark teeth, faces that look like the jaws of a Stillson wrench with a

villainous dot of an eye: eating is their sole occupation. Nevertheless these creatures protect their young, for they have breasts. But their substance is like bone or stone; and thus Picasso includes architecture with a casual gesture. The only background sufficiently ancient is the sea. But then the horizon changes and becomes the back of a chair, and the coiling intestine is a woman's arm and the arm of a chair. The subject is alive [Figs. 15–16, 26].

Picasso dislikes the word *evolution* applied to his work. For him this remote vision is not remote: the unconscious is here and now; at some level this is what we still are.

Summer at Dinard, an abstract picture of a stick with a ball at each end, recalls the young boy acrobat of many years ago, standing on a ball. Now we understand that the ball is also his head. The subject of the acrobat, the man with his heels over his head, or really his head over his head like a playing card, may at the time have seemed a random choice. But it was a choice of the deepest significance, and explains why harlequin has an instinct for concealing his features with a modesty which allows him greater sensual freedom, and why he can take off his mask if it is then used to conceal his lap.

Latterly there are the three-eyed pictures and the full faces that are also profiles [Fig. 21]. Picasso himself believes these to be a double aspect of the same person. In reality they are the single aspect of two people all over again.

What has been accomplished? Should painting stay on this deep unconscious level? The answer is that discovery goes before commerce. Picasso has had to explore for the sake of exploring; his are the advantages and the disadvantages of priority. Gradually this territory will become less strange and a new range of symbols will grow more familiar. They will be used for things which concern the painter at the moment, not for the excitement of their novelty, as the Elizabethans used words when the English language came into its own. The subject matter of all painting lies in the unconscious; its language is precise and definite, whether it repeats the commonplace, or like Picasso's, says something startling and profound.

WHO KNOWS THE MEANING
OF UGLINESS?

Leo Steinberg

Throughout the early 1940's, Picasso soldered female images out of disparate aspects but, in his characteristic way, never ceased to draw "normally"—that is to say, from the vantage of his own physique, confined to one point of sight. Perhaps for this reason his attacks on the problem of simultaneity often look like fresh starts, as if undertaken again and again from the old position—the position of a sensuality which enjoys its embodiment and rejoices in what it sees. And the attacks were aimed over and over at the same enticement, the same naked evidence.

Now, in the human female, that which perpetually stimulates consciousness of its otherness is the quality which ancient authors call "smooth and shining." "A woman's body," I read in Macrobius, "is full of moisture, as appears from the smoothness and sheen of her skin."

Picasso may have missed reading Macrobius, but he kept informed on the subject. And he must have seen that his harsh female constructs of the early 1940's brought on continuing devenustation:[1] that success in compounding one body from interpenetrant aspects was gained at the cost of delight. But this price, and Picasso's eagerness to be paying it, indicates perhaps how profoundly his interest in women extends beyond beauty and sexual appeal.

From the late twenties and through the thirties, the monstrous and the comical had been part of Picasso's expressive purpose;

[1] A fateful word derived from Venus, whence the Latin *venustas*, beauty, whence *venustare*, to make beautiful, whence its obsolete English opposite, "to devenustate."

invented or hybrid anatomies were the constituent metaphors of his idiom, and dislocations of sensitive organs induced no painful sense of cruelty to human flesh [Fig. 21]. But in the late thirties, and continuing through the early war years, Picasso's image of woman was both rehumanized and embittered—sufficiently like a woman to register as a negation of femininity. The most repellent of Picasso's females date from these years, the violence of their distortion again largely due to the forcing of antithetical aspects. Figures such as the *Nude Dressing Her Hair* [Fig. 25] or the gouache of a woman asleep seem unbearably ugly.

But who knows the meaning of ugliness; or why a painter will choose to reward the expectation of beauty with horror; or why Picasso would scar and mangle his nudes in the process of mating their disjointed sides. These questions may not seem relevant to current high-art considerations, but most of the answers exist ready-made as prejudices; they should be flushed out:

Perhaps these images of the early 1940's have no psychological function at all. Their clamorous ugliness may be the indifferent side-effect of the artist's simultaneity explorations to which questions of sex appeal are irrelevant.

Are these distortions something which Picasso's work does to women, or which he, like a witch doctor, would do if he could? A sadistic streak has indeed been laid to his charge.[2]

Are they an exercise of power over the female, continually re-experienced in manipulating her image?

Or a boast of the potency of his art in making that which the vulgar think ugly acceptable?

Do they express a self-irony—as if to say, look, this is what keeps turning my head.

Or do these distortions expose a seamy side in the subject—symbolic statements designed as revelations of hidden truths about women?

But, at the risk of sounding sophistical, could they not be the opposite? Suppose that the image of women nude is what Picasso admires above all things on earth; then to accuse the atrocity of a warring world he holds up to it the brutalization of what was made to be loved. The degradation of a cherished perfection becomes an index of the general sink. We recall the answer Picasso is said to have given the German officer who asked, pointing to a reproduction of *Guernica*

[2] Françoise Gilot and Carlton Lake, *Life with Picasso* (New York/Toronto/London: McGraw-Hill Book Company: 1964), passim. Compare James R. Mellow in the *New York Times*, October 24, 1971, Section II: "My reading of Picasso's treatment of women over the years . . . is that it has been characterized by a rich vein of hostility . . ."

in Picasso's studio—"Did you do that?" "No, you did that." [3] His quip placed responsibility for the image on the destroyer. And so perhaps in his wartime nudes. The measure of the world's evil is the disfigurement of its flower—whom Picasso in a happier moment would call *la femme fleur*. Some such interpretation has at least the advantage of referring the stateliest and the most abject of Picasso's women to a common emotional ground.[4] For it seems hard to deny that his brutalized women of 1940–42 were meant to repel. They are uncompanionable.

But this last observation points to a significant difference between the monsters of Picasso's Surrealist-metamorphic period and the non-seducers of the early forties. The former appear nearly always in action, usually in a predatory sexual encounter; the latter represent woman alone. She is sleeping, waiting, or dressing, often seated with her legs crossed—the classical posture that seals off the body against the outside. The solitude of these figures, and the palpable evidence of all their sides, lead to another intuition about their state of being. They seem explored in their self-existence, in a condition of involuntary pre-consciousness, unappealing only because not yet the cynosure of men's eyes, the woman alone with her body, unobserved, before beauty is born.

And then again, Picasso may not think they are ugly at all—not if he can make them real. I suspect that Picasso does not "distort," but seeks only to realize. In the last analysis, realization is what they are about.

[3] Roland Penrose, *Picasso: His Life and Work* (New York: Schocken Books: 1958), p. 298, quoting Antonina Valentin.

[4] Cf. the interpretation of the *Nude Dressing Her Hair* as a picture of war given by Picasso's friends Paul Eluard and Pierre Daix (Pierre Daix, *Picasso*, New York, 1965, p. 180).

PICASSO AND THE *HUMAN COMEDY* OR THE AVATARS OF FAT-FOOT

Michel Leiris

> Living as he did on the edge of life, on the outskirts of art, Justin Prérogue was a painter.
>
> <div align="right">APOLLINAIRE, <i>L'HÉRÉSIARQUE.</i></div>

During its summer season the Rome Opera gives performances in the Baths of Caracalla, converted for the nonce into an enormous open-air theater, and there one night in 1949 I saw an excellent performance of that world-famous opera Leoncavallo's *I Pagliacci*. It opens with a prologue, of which I propose to give a brief résumé, based on the programme I have kept among my souvenirs of that Roman summer. Following the custom of the Commedia dell' Arte, one of the characters comes in front of the curtain before it rises. His function is to give the audience an outline of the play they are about to see, and especially to make them realize that under the tinsel and the grease-paint are real human beings with the passions all of us are heir to: hate that burns like fire, love that sings of its romantic dreams. So he asks the spectators not to be misled by the theatrical costumes and the make-up, but to glimpse behind these artifices the vital core and the intensely human reality of the play they are going to see. The actor who thus invites the audience to make as it were a plunge across the footlights which show him the performers in a false light and by the same token dazzle the actors and blur their vision of the public—the man who steps forward to address us after having flung aside for a brief, revealing moment his harlequin cloak and shown us a man in ordinary attire—this actor is none other than the baritone who plays the part of the invalid Tonio, the man who in the play reveals to

"Picasso and the *Human Comedy* or The Avatars of Fat-Foot" by Michel Leiris. Translated by Stuart Gilbert in *A Suite of 180 Drawings by Picasso, November 28, 1953–February 3, 1954* (New York: Random House, Vintage Books, 1954), pp. 1–18. Reprinted by permission of *Verve* and the author.

Canio that his wife is unfaithful and thus starts up tragedy. W
comes before the curtain his face seems devoid of make-up ar
from head to foot in a loosely fitting "domino," he gives the imp
of someone who on a sudden impulse has stepped forth from the
mysterious hinterland behind the curtain.

Reality or make-believe? That is the essential problem set us by
the theater, and indeed by every form of art. How far is what the artist
shows us artifice pure and simple, a more or less sophisticated form of
entertainment but one that merely ranks among the pastimes of the
after-dinner hour? And how far does it touch on something that is truly
vital to us all, an issue of capital importance like the dilemma
confronting Hamlet when he faced up to that event in whose tragic
aftermath both King Claudius and himself were to be so fatally
involved: the crime of which the former was the all-too-willing
perpetrator and of which he, Hamlet, was a reluctant, dutiful avenger?
Reality or make-believe? There is no authentic art—and the art of our
great Pablo Picasso is authentic in the fullest sense—in which beneath
the surface artifice there is not an underlying reality as sincerely felt as
Hamlet's predicament when he had to play a part as terrifying to the
royal murderer (who saw in it a revelation of his guilt) as salutary to
himself, since it freed him temporarily from an obsession. Canio
experiences a similar release when deliberately he reshapes the stage
play into the pattern of a criminal enquiry, followed by punishment
for the guilty with real blood flowing on the boards and his own heart
bleeding under the motley. It is on this plane—accessible only to the
very greatest artists—that naturalism *à outrance* and flights of purest
fancy are integrated into an organic whole, as in this sequence of
drawings and lithographs made by Picasso in the winter of 1953–1954.
Mostly in black-and-white but some in colored pencil, they served him
as a sort of day-to-day journal, graphic not verbal, of an odius "Season
in Hell," a crisis in his private life which led him towards a new
orientation, a stocktaking of life in general. For whenever a man comes
up against an emotionally shattering experience he is bound, if he be in
the least degree sensitive, to call everything in question, to review his
outlook on the world at large. And when this man—as is the case with
the painter of the "blue period," and circus folk, the inventor of
Cubism and now, after so many other "periods," of the famous
dove—when such a man happens to be a genius, the story-telling
element (melodramatic or comic as the case may be) is transcended,
anecdote sublimated into myth.

A Pagliaccio who has lost his simple faith and natural high spirits
and no longer tries to make us laugh, a Don Juan whose power to
charm has left him—such is Charlie Chaplin as we see him in that
self-revealing picture *Limelight*. Almost one might think that with its
twofold theme, the plight of the aging clown and the débâcle of the

successful ladies' man, a tissue of commonplaces worn threadbare (though somehow by a miracle of artistry Chaplin has revitalized it), we had touched the lowest depths of sentimentality. For is it not quite literally the end of everything when such a man has to say goodby to the art which was his joy and to love as well; when the passing years have robbed him of his power to charm and dulled the luster of his personality? But there is something even worse. Though the creative artist may be invulnerable in the domain of art and, like the bull-fighter in the ring, welcomes each charge of his adversary as another chance for exhibiting his prowess, nevertheless even the greatest artist, vast as may be his resources, is but a man, subject like all of us to old age and death. Despite his store of magic, which the years have enriched with precious experience rather than expended, he is no better off than the humblest strolling player when death knocks at his door. Indeed, combining Proust's *temps perdu* with Mallarmé's *coup de dés*, one might say that no stroke of genius can annul time past, and call in question their belief that the supreme work of art enables its maker to withstand the "last enemy" and the torrential lapse of all-devouring Time. Near the end of *A la recherche du temps perdu* Proust invites his reader to a sort of Last Judgment, an evening party at which the narrator meets a crowd of old acquaintances, people he has lost sight of for years. Time has done its work, but each seems to have made himself up to play a part, that of himself when young, and for a moment the story-teller fancies he is attending a masked ball. Thus in the masked ball to which Picasso invites us here, old themes and personages reappear, ironically treated; all have aged terribly and, despite the masks, we see the stark reality, paltry or pitiable as the case may be. But for Picasso, who is no idealist, there is no question of creating an illusion of eternity on the lines of a Proustian *temps retrouvé*. Far from serving to halt the flux of time and that unescapable decline which is the lot of all flesh, this recapitulation of themes and figures of earlier days has an opposite effect; we are conscious that all alike are swept on ruthlessly by a torrent which there is no resisting, and Picasso seems to make a point of stressing its violence.

"The young ladies of Avignon have already thirty-five long, remunerative years behind them." Thus the leading character in *Desire caught by the Tail*, the play Picasso wrote in 1943. Another remark made by this character, whose personality is as grotesque as his name "Gros-Pied" (Fat-Foot), may throw some light on his creator. Welcoming his girlfriend "La Tarte," who has come to pay him a morning visit, he exclaims: "Well, this *is* a stroke of luck to have you here so early, while I'm chewing my morning toast and fresh, sour-sweet figs! One more day gone by, and black fame's mine!" Though *Les Demoiselles d'Avignon* [Fig. 6], a picture that the artist

originally named *Bawdyhouse in Avignon* (that being in fact its subject), has lost nothing of its eternal youth and freshness of inspiration, and though its painter, once a target of the most virulent abuse, now is lauded to the skies and his fame has spread to the ends of the earth even amongst the masses, we must not be misled by appearances. In the eyes of this man whom no force in the world can deflect, so long as he lives, from his chosen path and whose keen sense of humor enables him to advance along it nimbly, burdened though he is by a celebrity that well might overwhelm a lesser man, in the eyes of this man all the worldwide glory that has come to him can never seem more than a "black sun." "My chilblains! Oh, my chilblains!" groan the feet of the protagonists in *Desire* when their owners have just put them outside the doors of their respective bedrooms in "Sordid's Hotel."

If we look for an equivalent of Picasso's art where can we find it better than in the bull-fight and all that goes with it? For the bull-fight covers an immense range of visual experience, from the most squalid—gaping entrails, blood and dung, men spitting out the water with which they have rinsed their mouths—to the most gracefully elegant: the frail form of the man brushing daintily against or weaving around the vast bulk of his adversary, the flash like splintered ice or a sudden flame of the death-blow, flutterings of capes patterned with flowers, blood-red cloths deployed on the *muletas*. Midway between these extremes we have the paraphernalia of a tawdry luxury: wisps of colored paper wrapping the banderillas; sword sheaths of gaudily embossed leather; huge, decrepit trunks; an ancient Hispano-Suiza into which the maestro and his *cuadrilla* have piled as best they can. All this has a remarkable likeness to the drawings made in the winter of 1953–1954. In them too we find that juxtaposition of incongruous elements, so typically Spanish, which characterizes both Picasso's art and the bull-fight. Both alike oscillate between the crudest naturalism and flashes of soaring splendor, dazzling virtuosity.

A *faena* based on "naturals," and real "naturals," those which are done with the *muleta* held in the left hand, at once the simplest and the riskiest pass, since it means exposing one's whole body and leaving it unguarded—such, to borrow the terminology of the bull-ring, is the technique of this set of scenes depicted by Picasso. Their theme is twofold: art envisaged as a whole with many facets (painting, literature, choreography, the circus and so forth) and all the vicissitudes of human love. Each scene gives the impression of having welled up, unsummoned, in the very act of drawing; in a moment of entire surrender to a gust of inspiration. There was no thought of solving any plastic problem; all the artist wanted was to release on paper what weighed on his heart or was passing through his head, without any aesthetic inhibition or any fear of using hackneyed motifs: "When you

are old and grey and full of years," "the snows of yesteryear," and, ringing the changes, "Laugh on, Pagliaccio!"

Almost all the themes used by Picasso in his successive periods have linked up intimately with his personal life: details of personal experience, people for whom he had developed a sensual or sentimental attachment, pathetic or picturesque figures that had caught his youthful eye. Then came big compositions on the epic scale, beginning with *Guernica* [Fig. 22], and characters stemming from the myths of classical antiquity or a folklore of his own invention. All these motifs, not only those relating to things actually seen but also those which conjure up some more or less imaginary world, have a precise connection with the artist's physical or emotional condition at the time; in fact Picasso's art is autobiographical through and through. Indeed so close is the association between the subjects of his paintings and the man himself that their evolution seems to run parallel with his own. Moreover, far from being milestones as it were in his career as an artist, which once attained are left behind for good and all, all these various themes and *trouvailles* are incorporated in his artistic baggage, intermingle and give rise to new creations.

Thus the Pegasus with a winged ballerina on its back which figured on the curtain of the ballet *Parade* developed, years later, into its horrid counterpart, the picador's horse in the last scene of the fourth act of the play *Les Quatre Petites Filles*, where we see it with its entrails gushing forth and on its head the owl whose prototype was a tame bird. (This owl has constantly reappeared in Picasso's paintings, sculpture and, above all, in his ceramics.) The stage direction runs: "Enter a big white winged horse, dragging its guts after it and surrounded by wings, an owl perched on its head. After stopping for a moment in front of the little girl it trots across the stage and vanishes." Later, in *War and Peace*, this same Pegasus (which to start with was a circus horse) is seen yoked to a plough and driven by a child. Flying or sitting, alone or in association with women's faces, the Dove of Peace too had its prototypes. These were the live pigeons Picasso used to keep in his studio in the Rue des Grands-Augustins, Paris; also perhaps, to look still further back, the pigeons which so often figured in the paintings of Ruiz Blasco, Picasso's father. When Picasso was old enough to assist in the work which was the family's means of livelihood his father left to him the painting of the pigeons' legs. In a recent drawing the dove is perched on the hand of a naked woman who is proffering it to a standing clown holding an olive branch (or foliage of some kind). There is a family likeness between Picasso's minotaurs and his bearded athletes, the mossy growth on whose faces so curiously assimilates them to members of the animal or vegetable kingdom and to such subhuman, or if you will superhuman, creatures as the man-bull, man-horse or the man-goat. We are shown minotaurs—ani-

malized men or humanized animals—galloping, banqueting, fornicat-
ing and sometimes being done to death in an arena or stricken with
blindness leaning on sticks, their vacant eyes turned to the stars, with a
child Antigone to guide them. In the [*Minotauromachy*, Fig. 23] one is
plunging forward, an arm stretched out as if to thrust aside an obstacle
or, perhaps, to tear the veil from some ineffable mystery. Others taking
part in this strange scene bathed half in shadow half in light, are a
little girl wearing a short dress and a big beret, who holds a lighted
candle and a bunch of flowers; a woman dressed as a torero, her breast
bare, and carrying the bull-fighter's short sword; an almost naked man
climbing a ladder and looking round to see what is happening; two
women watching from a window on whose sill two pigeons have
alighted. In a 1937 picture named *The End of a Monster* a naked
woman armed with a lance is tendering a mirror to a minotaur pierced
by an arrow. Finally, in a picture sequence made some months ago,
the minotaur has dwindled to a bearded athlete holding to his face or
on his chest a bull's head of the kind used by Spanish children in their
bull-fight games.

It would seem that of all the figures of classical mythology those
embodying a permanent metamorphosis interest Picasso most, for
there is no question of his predilection for creatures such as centaurs,
fauns, the Minotaur. He, too, seems always in a state of metamorpho-
sis; never has he "settled down" to any fixed style and even when the
subject of the picture is not a metamorphosis in the strict sense, he has
a way of transforming all that meets his eye. And is there, in fact, any
essential difference between an ape whose skull, jaws and face are
built up with two little toy automobiles placed wheel to wheel and a
minotaur, a bull-headed man? When an artist sets out to make
"something else" of a picture painted by Manet, El Greco, Cranach,
Courbet or Poussin is he not undertaking something that, in the last
analysis, is an attempt to invent new signs for an old *datum?* And when
he deals thus with a work by an earlier artist is he not treating it as an
object that has been integrated into the real world, something that
must not be allowed to fossilize but must be helped, so to speak, to
fulfill its natural evolution by being given a new lease of life? Nothing,
it would seem, can stay inert once it has come under Picasso's notice
or into his hands. Whether he effects an abrupt metamorphosis or
serializes as it were the vagaries and adventures lived through by his
models, we always find the same unwillingness to allow any object, any
living being, to be what it is once for all, or any field of visual
experience to lie fallow.

In the drawings and lithographs in which Picasso seems to play
the part of his own historiographer—for they are an expression of his
life and time flows for them as it flows for him—we cannot fail to be
struck by the great number of *masked* figures. Here we have that

leitmotif of metamorphosis treated in a derisive form. For a disguise that necessarily fails to take us in is no more than a travesty of a miracle, a botched attempt at transformation. Far from cutting a tragic figure, the man detected *flagrante delicto* in imposture can be regarded only as a fraud or a buffoon, that is to say a comic figure. As early as *Parade* Picasso had indulged in effects of this order. After the Pegasus on the curtain we were shown a grotesque horse prancing on the stage, a sort of parody of the celestial steed, its legs being obviously "manned" by members of the ballet company. Similarly in a quite recent series of engravings representing scenes of chivalry some of the caparisoned "horses" ridden by the knights are pages dressed up for the part.

Picasso, one feels, was aware from earliest youth that every myth is fated to become sooner or later an old wives' tale; that almost every ceremony has not a little of the carnival; that genuine magic often goes hand in hand with quackery. Metamorphosis, like magic, may be "black" or "white" and both species are illustrated by the circus acrobat who in his feats of virtuosity and glittering attire hints at the supernatural, yet is *au fond* a thing of shreds and patches.

During the nineteenth century— a period which began, *pace* the strict chronologist, in France, in 1789, and ended with the October Revolution—alongside the myth of the artist as demiurge (a myth built on the ruins of religious faith and dealt a first blow by Rimbaud when, having sensed the vanity of the poet's dream, he withdrew into silence) there flourished the myth of the artist despised and rejected of all men. Thus we have Baudelaire's *Le Vieux Saltimbanque,* Nerval's *"illustre Brisacier"* (the actor is hissed), Mallarmé's sonnet *Le Pitre Châtié* and, later, Raymond Roussel's nouvel *La Doublure,* written when the artist in a moment of exaltation fancied himself a demiurge. Thus, too, in Chaplin's last film we are shown the "funny man" no longer able to raise a laugh and playing to an empty house. From the romantic viewpoint the creative artist is radically different from the average man and his vocation swings between two extremes. Whether a triumphant or a martyred god, whether an inspired prophet or a madman jeered at by the crowd—"his giant wings hinder him from walking"—he stands alone, and in his lifelong struggle with a hostile world experiences the ups and downs of Balzac's courtesans, their *splendeurs et misères.* In his early days Picasso painted beggars, cripples, prostitutes and on occasion friends (such as Jaime Sabartès) choosing the moments when they most keenly felt their isolation from the world at large. Common to all was their condition of outcasts, denizens of that fringe of society on which the artist lives, most typical being the strolling players, at once purveyors of glamour and vagabonds never sure where the next meal is coming from. Talking of Picasso as he was at the beginning of his Blue Period (the hue,

notoriously, is that of melancholy), Sabartès wrote in his *Picasso, Portraits and Reminiscences*: "He regards art as a product of sadness and pain—and on this we agree. He believes that sadness teaches us to meditate; that suffering lies at the root of life."

Disgusted by the conventions of organized society and challenging the whole structure of the world around him, the romantic artist alternates between savage irony and rapturous effusion. When he ceases to idealize, the Romantic takes to "debunking," showing up the flaws of the established order. The man who uses irony whether as a mask or a weapon of offense knows all too well that behind laughter there may be tears; and if the actor's "truth" is often but a stage effect, another, truer truth may underlie the mummery. Hence the progeny of those curiously ambivalent punchinellos who made their appearance as far back as in the work of the younger Tiepolo; *L'homme qui rit* and the tragic clown (e.g., Triboulet whom Shakespeare prefigured with Yorick's skull and of whom Verdi made his *Rigoletto*) combine with the ill-starred *fille de joie*—Fantine and La Dame aux Camélias who in Italy became the "woman gone astray" or *Traviata*—to prove how misleading it may be to trust appearances. And perhaps in *Pagliacci*, where the theme of the man who weeps behind a laughing mask and remains his own sad self under the motley is carried to its logical conclusion, we have the "type genus," as a naturalist would say, of melodrama.

It is often rewarding to look behind the scenes and to observe what is happening in the wings. Beneath the semblance of play is something serious, and behind seriousness something laughable; hence the touch of clowning in the man who stands on his dignity, the sadness of the professional laugh-maker. There is food for entertainment as well as instruction when we take the familiar puppets to pieces. In his latest drawings Picasso shows both sides of the picture: the great artist as a figure of fun and the mountebank as a man of sorrow, and he does this so effectively, that we suspect there is an element of each in his own make-up, despite the clear transcendence of his genius. For the romantic-minded artist everything hinges on this give-and-take between appearance and reality; thus many have succumbed to [the] lure of finding in it a justification for insisting on appearances. Picasso, however, is too clear-sighted in his quest of truth to become a more or less involuntary dupe. Not for him any escape into a dream-world any more than a rejection of the all-too-human. In his art behind the perpetually challenged, dissected and transfigured data of appearances always we find a hard core of reality ("There am I, and there I always am," as Rimbaud said).

Picasso has explored the field of art so thoroughly that he well knows its limits. All his life long, from the "infant prodigy" stage and that of the fifteen-year-old who had all the Old Masters' secrets at his

finger-tips, up to the present day he has never tired of inventing new procedures—perhaps because for a virtuoso like himself this was the only way of continuing on his path without being bored. The doctrine of "art for art's sake" has no more determined opponent than Picasso; not that he denies art's absolute validity but that he seeks to transcend it. Yet it is equally true to say that no artist has ever dedicated his life to art more passionately than he, for what appeals to him in art—a product of the imagination—is its eminently human quality. His conception of the role to be assigned to art, that of a lifelong mistress to whom the artist gives himself up unreservedly without vainglory or exaggerated ideas about a "vocation," is illustrated, it would seem, by the frequency with which he has employed and still employs the theme of the painter and his model.

In the illustrations of Balzac's *Unknown Masterpiece* this theme —painter and model—is treated from what we might call the professional angle: that tussle between the craftsman and his sitter which is at once the central idea of the story and a résumé of a basic human situation. Painter and model, man and woman—in the field of art as in that of love, there is always a duel going on between the subject and the object, adversaries forever facing each other and separated by a gap that no one, however great his genius, can hope to bridge. As a symbol of the conflict that takes place within a studio, one of the illustrations shows a bull charging a horse, in other words a fight to the death.

Timeless, almost mythological figures in *The Unknown Master-piece*, the artist and his model are treated differently in these later drawings. Both are strongly characterized, sometimes to the point of caricature. As a rule the models have little claim to beauty [Fig. 30]; some indeed are aged harridans and some wear such objects of everyday use as wrist-watches, shoes, and socks. The painters, too, are of every conceivable type, young and old, short-sighted or lynx-eyed, desperately in earnest or mere triflers. Often we see an old or ugly man facing a young woman who like La Tarte in "Gros-Pied's Artistic Studio" may be described as "gloriously beautiful." The painter-and-model situation is but one of the many occasions when man and woman face up to each other; and these, in turn, are included in that wider predicament of the conscious self confronting the not-self, "somebody else." Thus in many drawings the painter is replaced by quite different figures and we are shown a freak wooing a lovely lady, a masked Cupid, a Carnival "King," the melancholy clown (a survivor from Picasso's circus-folk period), a monkey (another reminiscence of his youth), an old man who has something of the buffoon and something of a Chinese wrestler and whose cynical smile tells of long experience of the world. Each leading figure is attended by his or her acolytes—a group of observers facing a group of observed, striking

attitudes or parading their venal charms; sometimes, too, by a third party who on close inspection turns out to be the painter himself. It is as though by dint of toying with so many masked figures and performing animals (another species of masquerade) the artist had been caught in his own trap and since his métier was to render others' figures he too had come to exist only in, so to say, the figurative sense, as a supernumerary, an onlooker, a shadowy presence—a Don Juan punished for his insatiable zest for new adventure by being transformed into a lifeless effigy of the Commander.

On one sheet of this amazing sequence we see a bearded man gazing with gloating satisfaction (like a matador after a successful *estocada*) at a picture he has made of a naked woman in the pose of a fallen Bacchante. We have here a mockery of the artist's "triumph," no less burlesque than the studio scenes with visitors voicing fatuous admiration of a picture that obviously mystifies them. All alike, connoisseurs, critics and fellow-artists of both sexes, gaze at it without paying the least attention to the lush beauty of the sleeping model and equally with only the shadowiest idea of what they are extolling. In fact all concerned are mystified in one way or another; except, perhaps, the sleeping woman.

In this richly diverse masquerade, which combines something of the English Christmas pantomime and something of the Commedia dell' Arte with touches of a *danse macabre*, the very magnificence of the draftsmanship seems to strike an added note of irony. Never has such stupendous virtuosity been so light-heartedly employed for making fun of art. Never, too, has it been proved so conclusively that the man of genius who can bring off everything he wishes with his brain and his ten fingers comes up like all of us against the basic facts of life—of life which is at best a losing game, ending in the inevitable checkmate. Behind all the scenes, ever more eye-filling, that an artist worthy of the name lavishes like a film-producer on the world, and despite the fame they bring him, he remains as he was in the beginning, as helpless as the common run of mortals: a clown titivating his eyebrows in front of a small mirror in the presence of his wife, who is feeding a baby at the breast, or a pretty young woman pulling on her stockings. However inspired he be, no man can escape from the human situation; neither art nor love can halt the flux of time which, once the gay adventure of youth is over, plunges him into a game of blind man's buff in which the winners too (the "jackpot-snatchers" as they are called *chez* Gros-Pied) are losers.

Dionysiac Minotaur and Bacchic faun are gradually replaced, as the years go by, by figures of pure comedy or those of a banal nightmare. The masked man—pseudo-man or a mere wraith of man—takes the place of animal-man; Genesis is followed by the harlequinade, the hybrid forms of mythology by fancy dress [Fig. 31].

That golden age in which sensuality has not yet lost its glamour and love is the most-favored theme is succeeded by a tinplate age when, to the man whose knowledge of life has steadily deepened meanwhile, the colloquy of lovers seems like a cross between a dialogue of deaf men and the sophisticated badinage of homosexuals. "Loving intelligent women is a pederast's hobby," as Baudelaire wrote in *Fusées*; and he, too, saw in art a proof of the (to his mind despicable) taste man has for prostitution.

"Who am I? A man without a name," Don Juan says to Doña Isabella in the first act of Tirso de Molina's *Deceiver of Seville*. "The window at the back of the room flies open," runs a stage direction at the end of *Desire caught by the Tail*, "and a golden ball of the size of a man bursts in, lighting up the room and dazzling the people in it. They take handkerchiefs from their pockets, blindfold their eyes and stretching forth their right arms point to each other. All shout together again and again, '*You! You! You!*' while on the big gold ball appear the letters of the word, NOBODY."

The lights go on, we show ourselves, each gazing at his neighbor in the hope that discovering him will help us to find ourselves. But the light blinds him and we, too, are blinded. Between the anonymity of indiscriminate desire and the comedy of the observed-observers— blind men who are (or are not) seen and cause (or do not cause), others to see—lies the wasteland of Time, of Time which inexorably wears us down, and whenever we try to lay hold of Somebody we find— NOBODY!

Nobody, not even ourselves; and so perfect is the void that we cannot even speak of solitude. For nothing survives except, so long as we remain alive, that human tension shared by all the living and binding us to them. And may it not be that those two terms "nobody" and "all" stand for two complementaries, not opposites, the poles between which has evolved, to the rhythm of a *dramma gioccoso* ruling out optimism and despair alike, the amazing art of Pablo Picasso, by common consent the greatest artist of our age? It is perhaps worth noting in conclusion that both he and that great exponent of the comic sense of life, Charlie Chaplin, made their first bow to the public at almost exactly the same time; that both alike came on the stage with a minimum of make-up and by the same token a minimum of deference to the conventions of the day—and that both have lived to witness a social revolution worldwide in scope.

THE VERVE OF PICASSO

Louis Aragon

The *Suite* is subtitled *November 28 1953 to February 3 1954.* If Picasso had really been gripped only by a single idea for more than two months, as has been claimed, the result, knowing him, would not have been a mere 180 drawings but one or two thousand. Besides, it is quite unlike him to be obsessed at all. A glance at the pottery works produced during the same period will suffice to show that they are completely different in concept (I myself have at home a large black dish showing a moonlit house and dated December 1953). Moreover, even within the period referred to, the time Picasso devoted to the theme of the painter and his model varied considerably. The first two drawings are dated November 27 and 28. But he did not return to the subject until 19 days later. It occupied him for a mere ten days in December (from 16 to 26) and he never produced more than eight drawings in one day. His most productive week was from January 3 to 10, when he reached an output of eighteen drawings a day. Following this, the work became increasingly intermittent and by January 26 the rhythm was roughly back to that of December (nine drawings at most). Some ten colored crayon drawings were spaced out between January 27 and February 3 and on the latter date a final black-and-white drawing concludes the cycle.

The idea of the painter confronting his model, which occurred to him as a subject by chance at the end of November, only actually became a theme proper following the drawings of December 16 and 18, which are really no more than exploratory. It was on December 23, that Picasso really came to grips with the subject, initially showing a bearded, bespectacled painter before a fully-clothed girl. But suddenly

"The Verve of Picasso" by Louis Aragon. Excerpted from "La Verve de Picasso," a series of articles in *Les Lettres Françaises* (November–December 1954). Translated by A. D. Simons. Reprinted by permission of the author.

he discards this line in favor of a drawing whose Goya-like character is obvious from its style and figures alike—behind the woman, this time dressed in black, is the face of the model's agent who, with Goya as with Picasso, is always *La Celestina*. A painting of the blue period bore that name and the famous Spanish play from which it derives was a source of inspiration not only to Goya but also to Picasso, who is known to have collected various editions of it. In front of the girl and her intermediary are two masked grotesques, one large, fat and of antique style, the other small, nude and deformed [Fig. 28]. The very next day, December 24, Picasso returns to his theme and his immediate decision is to show us the picture his painter is working on.

In most of the drawings we do not see this painting, for the canvas is on the easel, perpendicular to us and facing the painter. But on the first day Picasso attacked his theme proper he was concerned to give us, for once, a glimpse of it so that we should know what he was about. The picture, previously concealed from us, is an abstract scrawled right across the canvas by the painter, working at arm's length with a slightly ridiculous delicacy of brushwork, his nose in the air and quite impromptu; while the nude girl, who has moved behind him, seems to be saying, "Can that really be me?"

Next we see her, her head lowered and held between her arms, posing for a canvas we no longer see. But certainly, behind her, there is a study of her face, "figurative" to the point of caricature. And the bearded painter, a man between forty and fifty, is adding some minor touch to the picture, watched by someone, his patron or a visitor, with an exaggeratedly concerned expression. Neither of them seems in the least interested in the beauty so to speak within their grasp. The next drawing shows the bearded artist in stupid self-satisfaction before his work, hat on head and quite indifferent to his model, a girl wearing only a necklace. As the drawings progress, succeeding artists surpass one another in their delicacy of touch. One of them, still quite young, is seen before the girl, here once more fully clothed and gazing with amazement at what he has done with her. Two drawings later, we have a young student with a fringe of beard relaxing in his armchair while the girl, fingers to lips in astonishment, stands contemplating the work before him. Between these two drawings, Picasso makes his painter shortsighted, as though to make him even more ridiculous. The model looks across him at the visitor, but the latter, of whom we see only a head turned towards the picture, has no interest at all in the beauty of her unclothed body.

On this December 24, we are revealed one of Picasso's sources, conscious or otherwise: this nude girl standing behind the painter and looking at his canvas is something we have already seen in Gustave Courbet's *L'Atelier*, for there can be no doubt that this inclined head, this visitor behind the painter, is a classical representation of

Baudelaire, who is also to be found in *L'Atelier*. This is a parallel which cannot possibly be due to mere chance.

But amid this delirium of joy, this strange jumble, what is important in the drawings of this series—irrespective of the borrowings from others and from himself—are the persons seen here by Picasso for the first time and whom we cannot help recognizing; not because we have seen them here or in other paintings but because we know them from real life. Like the young cub with the fringe of beard from December 24, or his two studio comrades with their open-necked sweaters seen in a drawing of the same type of the next day, or the women painters of January 20, the critics, the art-lovers and the whole so extraordinarily evocative menagerie—all of them are unmistakably our contemporaries, drawn from life and given permanence.

It can be assumed that Picasso did not have them pose for him at Vallauris in order to give a practical lesson aimed against abstraction in painting. I would say that the absence of a model when representing persons as closely as this is a counterpart to the fact that Picasso borrows models from abstract painters who who don't know what to do with them. It is both a counterpart and, with respect to the theme dealt with, a counterpoint, for Picasso had no need to *copy* these living persons in order to represent them; Nature provided them, using the vehicle of his experience, so much more protracted and fruitful than any studio sitting could possibly be. Indeed, Picasso did not use models any more than did Toulouse-Lautrec when he designed that other *Caprice*, his *Cirque*. For it is a well-known fact that the *Cirque*, based as it was on observations accumulated in the past, was not drawn from nature but during a period of recovery from intoxication, when Lautrec was alone in the hospital. But in spite of this, Lautrec's *Cirque* produces likenesses, and it is precisely these extraordinary likenesses that give it its value. The likenesses to painters, critics, and models in Picasso's 180 drawings are of similar quality.

But one point of surprise is the beauty of Picasso's nude women at this period. They are not unlike certain female forms produced by Matisse in old age. We have this rather naive idea that only young men are capable of appreciating female beauty; or alternatively that if a man who is no longer thirty dares to depict it, he does so simply as an expression of regret. And that is the origin of the interpretations commonly accorded these drawings. People simply forget that when Ingres painted *Le Bain turc* in 1859 he was six years older than Picasso at this period and that if *Le Bain turc* is the work of an octogenarian it is time to abandon finally the practice of trying to explain pictures by way of the painter's private life.

But let us return to Picasso and to what he was doing between the end of December 1953 and the early days of February 1954.

Patiently following the artist's drawings from the end of December to early February, we find that he abandons his painters in favor of writers reading their manuscripts to various personages, some of them sophisticates, others not—types resembling Léautaud or André Gide and yawning women—and finally loses interest in all but the antics of the nude model, the painter forgotten or assimilated into the old gentleman to whom the bawd is offering the girl. In other cases, he lampoons the stupidity of young men confronted with women, such as the painter in his twenties, blind to the living beauty before him, whose way of holding his brush or pencil seems to be the principal characteristic arousing the scorn of his own depictor.

Where have I seen that before? This affected manner of distinction in approaching paper or canvas reminds me irresistably of a painter who today has ceased to be anything more than a portrait—I mean Alcide de La Rivolière, whose paintings I have never seen, probably because the only time this might have happened was in the portrait of him done by his master, Baron Gros, and Gros was prudent enough to place the canvas to which Alcide is about to apply his portcrayon so as to show no more than a side view (as is also the case with the pictures of most of the painters held up to ridicule by Picasso in these drawings). The portrait of La Rivolière by Gros is a quite magnificent picture but it is simply bursting with the stupidity of its model, particularly in those "distinguished" fingers holding the portcrayon or resting on the edge of the easel—a close resemblance to the delicacy of the abstracts in the *Suite de 180 dessins*.

Admittedly, Picasso does get tired of them in the end. He leaves them in favor of a digression to the nude woman and her winged cupids (January 5) then, suddenly, he interests himself in a little clown-like man already glimpsed in the drawings of December 18 and who is seen on January 6 mounting a horse—goodness knows why, but it brings us back to the circus in the wake of Picasso's whim. Here the clown, a perfectly normal man but just as engrossed as a painter in his work, demonstrates his ability to *detach himself* from his background of scenery.

On January 6 we are back with the painter in his studio. Now mythological themes begin to encompass him, and on the next day, following a somewhat affected drawing in which Picasso returned to this theme, his ideas once more break out towards the faun-inhabited world of mythology, from which no performance of circus agility can divert him. Hercules may belong to the fairground, but he remains Hercules for all that. And here we have a satyr and naiads and a goddess at the feet of Zeus—and at once the thoughts fly to Ingres, to his *Jupiter and Thetis* in the museum at Aix, for here again is Bacchus spilling wine over a maenad, a faun pouncing on a sleeping nymph, and so on.

At this point, Picasso stopped for two days and on the third (January 10) the characters of Greek mythology are gesticulating in a studio where the model, a mature lady very much in the German style, leans on her elbows waiting for it all to blow over while the painter smokes his pipe and a young girl looks on in some astonishment. Two more circus scenes to change the subject and then we return to the basic theme, but this time, a contrivance to keep his model in countenance, the painter has had the idea of giving her a little pot to hold. The next one shows the girl on her knees, holding flowers instead of the pot. Then we have a series of painters whose mistresses are no longer in their first youth but have to make do as models. One of them is not so terribly ugly or old but she is stupid and skinny and does not know what to do with her hands. Another, already well past it, has managed to retain considerable dignity and *she* is certainly not the subject of Picasso's mockery, for look at the painter and the air of subtlety and self-satisfaction with which he regards this rather sad vision—he is quite impossible. Now we have the monkey as painter and his model, very much a product of the Folies Bergère, is wearing her hat. Picasso is hardest on his colleagues when they are young: look at this one, confronting a big, strangely-built girl—an idiot with a little bow tie and scrubby hair taking great pains with some minor touch or other on the canvas; all in all, the monkey is probably the better painter. Then there is the *fin-de-siècle* painter who has posed his brunette on a sofa, but his smile relates to the tiny brushstroke he is making.

On January 11, we have what is perhaps the most unusual drawing of them all. [Fig. 29]. The painter is in a strong light below the window, where a little vase stands on the sill and one curtain is drawn. He is a little fat man with a short nose and receding hair, swaddled in a dressing gown and reclining in an armchair before a canvas out of our view. Between him and his models stands a lowboy upon which has been placed an antique head. The right-hand side is drawn in a quite different style, with a black background against which two women, engulfed in shadow, sit in a nude pose on a bench. One is old, the other young, once again a theme from Goya. The elder is further forward and sits with her head hung as though in shame or perhaps misery. The younger, very Greek, seems more suitable as a model for sculpture rather than painting. No other drawing was produced on that day.

From now on, Picasso adheres to his theme until he has clarified it completely. The drawings of January 14 and 17 take it up again with new variations, more elaborate than in the past. Whether the models are young or old, there is always that delicate touch indicating the subtle thinking of a self-satisfied painter. That young man in the striped sweater and a studio furnished with Charles X furniture takes

us to the heart of the matter. On a piece of drawing paper next to him there is again one of those delicate abstract doodles, but the painter is standing before an empty sheet. This is classical Picasso. So is the old man facing his old wife. And here we have a critic arguing with the painter, a powerful, hairy fellow, while the model reads a book before a hinted-at black curtain, since nobody is interested in her nudity. The next artist has dressed his mature model in Greek costume and has given her an amphora and plaits of hair crossed across her head. The date is January 19.

This is the day on which Picasso returns to his point of departure and again begins to show us the actual canvases for which all these different nude women have been posing for so long. The way he insists on showing us nothing but abstract pictures on his victims' easels make it quite clear that this is the general tenor of what he has been telling us.

To start with, there is a painter with a pig's nose confronted by a critic who is drawing a comparison between the girl crouched with folded arms before him and the abstract canvas just completed. Then a woman and two men closely examining a canvas—a no. 50 at least—one of them bending down the better to admire some minor touch. In the meantime, the model, obviously built for love, sleeps on the sofa. Behind the three visitors on the next canvas, the painter is a woman whose belly and buttocks make her skirt shorter in front than behind and who is holding a palette and sucking a brush. The visitors are examining the big canvas from top to bottom, but the model on the sofa has not yet woken up. In the next subject, the woman painter has become very tiny and the expert in unimportant details, i.e., the visitor looking at the bottom of the canvas, is now right down on his knees the better to scrutinize "the informal," as his eminent colleague, M. Fautrier, would have it. At the next attempt we see the model sleeping, the vacuity of the woman painter, the dusty visitors adopting an air of inspiration—the kneeling man scrutinizing the unimportant details this time resembling M. Georges Duhamel, of the Académie Française.

This is undoubtedly a chance resemblance, as in a novel introducing real people without bothering to give them fictitious names. Did Picasso ever see Georges Duhamel with his own eyes? He would have had no need to do so to be able to imagine him, or perhaps I should say to invent a bald and chubby expert in unimportant details.

At last the model has turned over in her sleep, and while admittedly the woman painter has not grown any bigger there are now suddenly five visitors, a young pipe-smoking man and André Gide having joined the three previous ones.

This scene, the most important in the book, is completed the following day (January 20) when Picasso shows us the woman painter

at work in her studio where it has all happened. There are five drawings of this monster faced by beauty.

A man completes the series, to avoid being systematic. On this day, Picasso's women are more beautiful than ever. Let us impress this date, January 20, 1954, on our memories. On January 21 come the drawings which I mentioned as being in the style of Cranach [Fig. 27]. There is no need to take this too literally. Here the woman is surrounded by the rhombs, dots, and commas of abstraction representing carpets and window curtains. But while she sleeps these young and apparently elegant gentlemen engaged in argument are no more than shadows against the light.

Need we go on? This heralds the end. Picasso has his little nude personalities dancing like actors in an interlude. He has brought in circus characters and a kind of doddering Oedipus. Then the masquing starts again. These nude people, as they confront one another, have no consciousness of their bodies. They amuse themselves by hiding their faces behind cardboard masks as though this is where their modesty is concentrated. And certainly, on January 25, the clown faced with an exceedingly beautiful woman is unwilling to show himself except behind an antique mask representing Jupiter. Then there are the drawings in color pencil which I have not mentioned. They were completed when Picasso, the resources of black and white exhausted, began to detach himself from his subject. They seem like some not terribly necessary paraphrase on the principal theme, with the painter sometimes becoming a playing-card king. These are the kinds of drawings that are the least serious among Picasso's work, the sort of thing he did in autograph books for his friends, rather like writers dedicating their books. The work itself is complete and this is just an addition to give a little pleasure, but it is perfectly clear that what there was to say has already been said. The whole of the last part of this book is rather like a piece of music where the themes are recapitulated to recall them to mind before building up to the big final climax. Yes indeed, this *Suite* does contain more than just satire on the abstract. But in the final analysis, after full consideration and running the magic lantern through again backwards, what Picasso was trying to say and what he did say and what remains in the mind is assuredly that which is contained in the great scene of January 20 with the experts in insignificant detail.

FAUSTUS / VELÁZQUEZ / PICASSO

John Anderson

"The capacity for disgust . . . [that is] [1] the expression of a collective feeling for the historical exhaustion and vitiation of the means and appliances of art, the boredom with them and the search for new ways . . . The vital need of art for revolutionary progress and the coming of the new addresses itself in whatever vehicle has the strongest subjective sense of the staleness, fatuity, and emptiness of the means still current. It avails itself of the apparently unvital, of that personal satiety and intellectual boredom, that disgust at seeing how it works; that accursed itch to look at things in the light of their own parody, that sense of the ridiculous—I tell you that the will to life and to living, growing art puts on the mark of these fainthearted personal qualities to manifest itself therein, to objectivate, to fulfill itself."— Thomas Mann, *Doctor Faustus*, translated by H. T. Lowe-Porter (New York: Knopf, 1948).

Picasso's use of painting cycles since the Second World War is an extension of cubism physically and mentally. The Velázquez cycle of 1957, comprising 44 pictures, owes its multiplicity and its changing point of view to identical principles more concisely described in a single canvas like the *Ma Jolie* of 1912 in the Museum of Modern Art, New York. Strictly speaking analytical cubism had said all it had to say by 1912 and by that date had analyzed and codified a highly sophisticated modern sensibility in mathematically classical terms. What followed immediately and subsequently was the dissolution of the precise cubist equation in favor of a far looser exploitation of cubist forms. That the forms in one guise or another have been

"Faustus/Velázquez/Picasso" by John Anderson. From *Artscanada*, no. 106 (March 1967), pp. 17–21. Reprinted by permission of the publisher.

[1] [Anderson's brackets.—Ed.]

retained is not the result of mere stylistic continuity but because cubism, quite apart from painting, is a way of thought and experience peculiar to this century.

The formal implications of successive related images, each referring to some aspect of a single objective reality, in this case to a specific work by Velázquez [Figs. 37–38], reiterate cubism's conception of reality as the relationship—ironic, passionate or indifferent—between individual members of an object and their co-operative gesture in forming a whole. Near the beginning of the novel *Dr. Faustus* by Thomas Mann, its hero, Adrian Leverkühn, concludes, "Relationship is everything. And if you want to give it a more precise name, it is ambiguity."

Thomas Mann, in this novel devoted to examining the idiosyncrasies of artistic creation, introduces the role of parody as a sideshow to the diabolic theme. Though opening with the mild irony of the quotation above, so redolent of analytical cubism's detached inquiry, parody is not permitted to remain mere arbiter but is made, through the exercise of ridicule, the subject of its own passionate defense. A similar process occurs in Picasso's Velázquez cycle, a work that confounds purely formal explanation.

Picasso uses Velázquez's *Las Meninas* as the butt and victim of his own profound disenchantment with the conventional evidence and appliance of historical reality. The cycle expresses his extreme revulsion for the modelled complacency of form, the closed and bigoted range of human awareness, and for the whole tedious contraption of Renaissance perspective. The violence of Picasso's gesture, the thoroughness of its execution, is partly indebted to the collaboration and sympathy of Velázquez himself, for the original *Las Meninas* in its own historical context borders on subversion.

The liberties in the Velázquez are considerable but are disguised. What is ostensibly intended as a royal portrait celebrating dynastic solidarity (King, Queen and Infanta) has by accident turned into a minor debacle exposing in unrehearsed form degrees of personal variance, social license, individual waywardness, and all the consequent uncertainty, insecurity and freedom from the old hieratic form implicit in such dangerous departures. In resorting to tricks whereby dogs, dwarfs, children and kneeling adults are unkindly confused, where royalty is reduced to eyes in a distant mirror, and perspective made to ridicule its own inevitable laws, Velázquez mocks all preconception; and by making himself a detached and omniscient presence affirms a profound and total cynicism—what Thomas Mann calls "the proud expedient of a great gift threatened with sterility by a combination of skepticism, intellectual reserve and a sense of the deadly extension of the kingdom of the banal."

This painful relationship between Velázquez and Picasso, between the uneasy historic establishment of one and the disenchanted anarchy of the other, between the celebration of form and the demonstration of feeling is conscientiously expressed in *Doctor Faustus*: "The historical movement . . . has turned against the self-contained work. It shrinks in time, it scorns extension in time—and lets it stand empty."

Similarly in Picasso's cycle sheer multiplicity serves the ends of profound skepticism. No one canvas stands complete in itself, each is made to ridicule its precursor and be ridiculed in turn. The cycle is hardly more than the record of the artist's passage—the tremendous speed by which he keeps ahead of his own disillusionment. *Doctor Faustus* continues:

"Not out of impotence, not out of incapacity to give form. Rather from a ruthless demand for compression, which taboos the superfluous, negates the phrase, shatters the ornament, stands opposed to any extension of time which is the life-form of the work. Work, time and pretense, they are one, and together they fall victim to critique [parody] ! [2] It no longer tolerates pretense and play, the fiction, the self-glorification of form which censors the passions and human suffering, divides out the parts, translates into pictures. Only the non-fictional is still permissible, the unplayed, the undisguised and transfigured expression of suffering in its actual moment. Its impotence and extremity are so ingrained that no seeming play with them is any longer allowed."

"The untransfigured expression of suffering" in the Picasso cycle, as opposed to the mannered play acting of the Velázquez, accounts for the rudimentary quality of the painting—the child-like crayon technique, the simplicity, the ingenuousness, the primary colors (bilious or saccharine), the primitive forms, the cartoon expressiveness—all instances of Picasso's inordinate aversion toward the ways and means of art.

Once again Thomas Mann's explanation is crucial in understanding the cycle. He speaks (always of course with music in mind) of "banalities" that occur against a background of the most extreme tensions: "not in a sentimental sense nor in that of a buoyant complaisancy, but banalities rather in the sense of a technical primitivism, specimens of naïveté or sham naïveté . . . not . . . the first-degree naïvetées . . . but as something the other side of the new and cheap: as audacities dressed in the garment of the primitive."

"Audacities dressed in the garment of the primitive" is surely a

[2] [Anderson's brackets.—Ed.]

proud and desperate attempt to halt an erosion of disbelief—at best to outmaneuver it by admitting at once the fallibility and complete inapplicability of all known forms, conventions and pretences of art including, perforce, the notion of "untransfigured expression of suffering." What is left are empty, inanimate, uninformed conventions; mere crockery. Nothing remains that the conscience could object to, yet in this scrap-heap of devices, feints and formulas the scrupulous mind can play at constructions after its own heart—where toys may imitate the human but be toys still.

Picasso's Velázquez cycle is such a construction. This last word in self-deception baffles sarcasm by translating the old world, Velázquez's reality, into the artificial mock reality of the doll's house. This doll's house is an image of perfect freedom. In it Picasso, unbound by laws of gravity or representation, can mime the human condition and the complex of relationships and paradoxically at the same time emulate the intense dramatic unity of the Velázquez, still satisfying his intellect with the knowledge that it is all a masque, pure conceit.

Under the auspices of the doll's house there are no extremes beyond the painter's reach and, as Thomas Mann wrote, the passion for extremes is the compulsive, imperative end to the process of parody, and its only solace. The doll's house, this single room of Velázquez, even in its constricted identity, indeed by virtue of the same, is capable of unlimited imaginative reconstruction. In it, combinations of events, situations, distortions, disfigurements, violations of all laws moral or aesthetic, denial of all prerogative, are uncensored and legitimate. Once again "the untransfigured expression of suffering," impossible itself as a concept, is achieved here not through abandonment of disguise and pretense, but by means of that very falseness.

Far more than the Delacroix or Manet cycles, the Velázquez relies upon its source being recognized as promoter and surety for the cycle, whose anarchy loses all significance and becomes mere raving once divorced from this context. The presence of *Las Meninas* must be assumed before the cycle's counterplot can take effect. It is for this reason that individual canvases, subtracted from the organic succession of the cycle, make as little sense as would the dismembered pieces of a strictly cubist work. But where analytical cubism dismantled and reassembled the object, so to speak *in situ*, the cycle as Picasso employs it, describes not reality but the process of reaction to it; and in order to accommodate a time element that is sequential rather than local, as in analytical cubism, Picasso has evolved a form that amounts to a "lateral" cubism.

The entire fabrication of the Velázquez cycle is a gesture of despair. The progress of the cycle itself, the comparative cogency of

the first half, that most heavily subsidized by Velázquez, compared with the gradual disintegration and rising frenetic tone of the last works, suggest the crowning irony that parody has entered into this synthetic world too.

PICASSO'S *SUITE 347,*
OR PAINTING AS AN ACT OF LOVE

Gert Schiff

Picasso's *Suite 347* [1] represents, in my opinion, the most comprehensive statement ever made by the artist about his philosophy of painting, and of life. He reverts to his childhood and sees himself as the infant prodigy, attended by his future sources of inspiration [Fig. 32]. Throughout his career, Picasso attempted to revive and redefine the great humanistic tradition of painting. This source of his art is represented here by the figures of Rembrandt and Velázquez. Woman, the other source of his inspiration, is present as a majestic nude prostitute with a mantilla. She is accompanied by an old procuress, an archetypal figure both in Picasso's *oeuvre* and in Spanish literature. In 1903, Picasso painted *La Celestina*, the heroine of the fifteenth-century play by Fernando de Rojas; he portrayed her, true to the letter of the play, as a greedy, malicious witch. Now he has transformed her into a much older, almost Fate-like character, and her silent and humble presence in so many scenes of courtship and love makes it evident that he conceives of her as a life-preserving and ultimately benevolent force.

But Picasso portrays himself also as the old man who in front of "warm, fleshy, genial life" is forced into the role of a mere observer. In etching *Number 8* we see him sad and dwarfed by a dressed-up

"Picasso's *Suite 347*, or Painting as an Act of Love" by Gert Schiff. Slightly revised from *Woman as Sex Object*, Art News Annual 1972, eds. Thomas B. Hess and Linda Nochlin, pp. 239–53. Reprinted by permission of the publisher.

[1] This series of 347 etchings was executed by Picasso in Mougins, March 16 to October 5, 1968. They are fully reproduced in the following publications: (A) Picasso, *347 Gravures 13/3/68–5/10/68* (catalogue 23, Série A), Galerie Louise Leiris, Paris, Dec. 1968. (b) *Picasso 347* (2 vols.), Random House/Maecenas Press, New York, 1970. (c) Georges Bloch, *Pablo Picasso, Catalogue of the Printed Graphic Work, II, 1966/1969*, Berne, 1971.

cavalier who rubs his hands in happy anticipation at the sight of a
throng of healthy female animals. And Picasso puts himself a second
time into the picture, this time as an "old child," a *putto* with a
wrinkled face who squats in a Buddha-like attitude in front of the
woman. It is not only a symbolic self-portrait, but also a typical Picasso
paradox. The meaning of the figure is precisely the reverse of its
appearance: it stands for youthful appetites, or for a child's delight in
everything sensual, within an old body.

Picasso redefines the art of the past mostly in terms of parody. In
the aquatint *Number 123* he transforms the spirit of Velázquez' *Las
Meninas* into its opposite. The derivation becomes obvious if one takes
into account that in the original design on the copperplate the painter
and his easel were on the left, as they are in the Velázquez. But
Picasso transforms the courtly scene into a vision of ribald, promiscu-
ous, primeval humanity. The reappearance of the central figure of *Les
Demoiselles d'Avignon* might even designate the locale as a brothel.
Throughout *Suite 347*, Picasso takes an obvious delight in substituting
for the sphere of Spanish courtly etiquette—which signifies civiliza-
tion—this vision of mankind "in the raw." Also, he quite often
intermingles these two spheres of high life and low life.

Etchings like *Number 248* parody a well-known inconographic
model from Dutch art, *The Suitor's Visit*. Such scenes, in which a
well-mannered suitor enters the boudoir of his beloved, have been
painted repeatedly by Gerard ter Borch. In the Dutch prototypes as
well as in Picasso's etchings the suitor lifts his hat and bows in front of
the lady; but with Picasso she becomes a woman of pleasure (again
attended by the old procuress). She exposes herself unabashedly and
his ceremonious bow allows the caller to focus his attention on the
center of pleasure. This might be the right place for a brief remark
about the voyeurist element in *Suite 347*, which has so shocked some
critics. Its presence and even its prevalence are obvious. But then,
Picasso himself would be the first to admit this. He gave a charming
proof of his superiority in regard to his own condition in a remark to
Brassaï: "Whenever I see you, my first impulse is to reach in my
pocket and to offer you a cigarette, even though I know very well that
neither of us smokes any longer. Age has forced us to give it up, but
the desire remains. It's the same thing with making love. We don't do
it any more, but the desire for it is still with us." [2] Furthermore, since
Picasso's painting deals with man's (and woman's) most basic impulses
and passions, sexual symbolism has always been one of the principal
elements of its imagery. Encyclopedic in nature, his art omits nothing
and suppresses nothing. "Pablo never liked to overlook any anatomical

[2] Brassaï, "The Master at 90—Picasso's Great Age Seems Only to Stir Up the Demons
Within," *The New York Times Magazine*, Oct. 24, 1971.

detail, especially a sexual one," Françoise Gilot remembers.[3] And the many scenes of exposure and inspection in *Suite 347* certainly corroborate this. Yet Picasso's scenes of voyeurism imply not the usual mixture of hatred and castration-fear. On the contrary, they represent a fervent homage to life. In order to realize this, one has only to compare Picasso's aquatint of a nobleman paying homage to a prostitute [Fig. 33] with a colored etching on a similar theme by Thomas Rowlandson, *The Inspection*. In the latter, a group of hideous old men gaze, obsessed, at a disdainfully compliant model. Phallic shapes in a bronze container hint at their virtually castrated condition and, hence, at the admixture of infantile horror which Freud detected, 100 years later, in the voyeurist syndrome. In the Picasso, however, the voyeur is a worshiper. The nobility of his conduct could convince us that he had stepped out of El Greco's *Burial of Count Orgaz*. With almost religious fervor he pays homage to the girl's radiant beauty. From a psychoanalytic point of view, we may understand both the caller's bow and the nobleman's genuflection as aim-inhibited gestures, meant to conceal a sexually aggressive drive. But even so, such gestures remind us of the aesthetic—and humane—value of civilized manners, or of the saying: "False modesty is better than no modesty at all." [4]

At his present age, Picasso's world of sexual fantasy is, like the child's, polymorphous perverse. In some of these plates, even small children appear as prostitutes. They expose themselves, and enjoy it, as children do. In that magnificent composition where a delegation of noblemen greets a group of strolling gypsies, we find again sheer, animalistic pleasure extolled, and civilization paying homage to low life.

Picasso's serene detachment from his own condition as one whom "age has forced to give it up" permits him to comment ironically on male frustration in front of the female. Etching *Number 216* depicts a jester, an antique philosopher, a very old satyr, and an equally old dwarf in front of an inviting nude. Like the many painters, clowns, dwarfs, Silenuses, and monkeys in the *Human Comedy* series, this is the split representation of the artist's own self-image. The bearded philosopher seems to ponder the question of whether it is philosophically justifiable to follow one's desires. The hairy, withered satyr is openly embarrassed by his awareness of his faded powers. Only the bragging jester is free from self-doubt: not only does he exhibit his swelling strength, he "underlines" it by mockingly putting his hand on the head of the humble, Socrates-like dwarf. But, unlike the Greek sage, the dwarf betrays by his wistful expression that the desire is still with him also.

In another example the situation is different [Fig. 35]. A young

[3] Françoise Gilot and Carlton Lake, *Life with Picasso*, New York, Toronto, London, 1964, p. 318.

[4] Cf. also *Number 138*.

woman dances to the pipes of Pan which are rather inappropriately played by an unattractive old pedant. In front of them stands a scolding moralist with raised forefinger. However, like so many of his kind he seems to exemplify the proverb that the right hand should not know what the left hand does. Yet, his semen generates men—an old mythological motif, best known in the myth of Uranus. Could it be that the pipe-player, like Amphion, caused the stones to move of their own accord and to form a new city? In that case the strange composition would imply that the unfulfilled desire of old age can be converted into creativity.

In those compositions which deal with his philosophy of painting, Picasso reverts several times to Balzac's *Chef-d'oeuvre inconnu,* which he once illustrated for Vollard. In this story, the young Poussin is introduced by Frans Pourbus to an imaginary artist called Frenhofer. This man, the greatest painter of his age, is working on his ultimate masterpiece, a life-size female nude. He wants to incorporate all his art and wisdom in the painting. Frenhofer keeps it hidden from every-body: the nude is his "creature," "his beloved": to expose her to profane eyes would be blasphemy. Yet, when Pourbus and Poussin are finally admitted to his studio, they find the painter, who has become mad, in front of a canvas covered with senseless lines and blots of color. *Number 344* and *Number 39* are evidently inspired by Balzac's story. In the aquatint *Number 344* we find the mature master (Pourbus *or* Frenhofer) together with the young Poussin, who gazes, fascinated, at the emerging likeness of the model. In *Number 39* we see Frenhofer musing in front of his senseless web of lines, surrounded by one real companion and two shadowy creatures of his imagination.

There are, I believe, two reasons for Picasso's lasting preoccupa-tion with *Le chef-d'oeuvre inconnu.* First, the process by which Frenhofer transforms his originally naturalistic nude into a labyrinth of "senseless" lines corresponds in a certain way to Picasso's own definition of a picture as a "sum of destructions." And because of this "destructive" character of his art he has been thought by many people to be as mad as Frenhofer. Second, there is the motif of the infatuation of the artist with his work, this particular obsession which induced Frenhofer to call the woman in his painting both his "beloved" and his "creature." We may well assume that this is as much a part of Picasso's unconscious fantasies as it is of every great artist's, witness the ancient myth of Pygmalion. Let us mention, if only in passing, that the act of making his own creation the object of his love contains also a good deal of narcissistic projection, and even female (mothering) identifica-tion. In works like the engravings *Number 166* and *188* Picasso finds a disarmingly simple visual formula for the Promethean, man-making activity of the painter.

In both cases he omits the canvas and shows the painter working

directly on his model. In *Number 166*, he adds a touch to the coloring of her bosom, in *Number 188*, his brush glides lovingly around her neck and shoulder. [Fig. 34]. Here Picasso illustrates one of the greatest lines in Leonardo's *Treatise*: "*Si 'l pittore vol vedere bellezze che lo innamorino, egli n'è signore di generarle.*"[5]

His 24 variations on Ingres' *Raphael and La Fornarina* bring the argument to its conclusion. Ingres shows Raphael with the beautiful girl on his knees; both are contemplating her nearly finished portrait. Picasso continues the story and follows the couple through the various *praeludia amoris* to the final consummation of their love. At each stage they are observed by a voyeur—the Pope. First we see him peeping through a curtain, then he is allowed into the room [Fig. 36]. His significance as a father-figure is obvious. As has been shown by Beryl Barr-Sharrar, the image of Picasso's real father Don José Ruiz Blasco, haunts a considerable part of the imagery in the *Suite 347*.[6] The presence of the "Papa" makes the variations on *Raphael and La Fornarina* a primal scene: the male child possessing the mother, with the father looking on. Thus, one of the most deeply-rooted unconscious wishes finds here, at the end of Picasso's life, its imaginary fulfillment. In the example illustrated here [Fig. 36], the additional figure of a jealous husband is included, hiding underneath the bed. Picasso's friend Rafael Alberti, who wrote a cycle of sonnets on this portion of the *Suite*, identified this figure as Michelangelo. Yet this is perhaps too much poetic license. Another point seems more important. In almost every print in this series, even in the supreme ecstasy of his union with the model, the painter retains palette and brushes in his hands. He goes on painting, if only in the air. Thus painting, love-making, and "generation" become literally one, or, in Picasso's own case, the desire, still so very much with him, now finds its gratification in painting. Painting allows him to act out his immense love of life. His is an old age without bitterness. This is why he—ivy-crowned satyr, led by the genius of youth—still has his rightful place among young revelers and majas. This is why he can foresee his own immortality. In one of the last plates of *Suite 347* he designs a monument for himself, a herm with the head of a sacred buffoon. It is crowned with laurel by a delegation from the time of Velázquez—the representatives of civilization. But at its foot lounge earthy nude women, remembering him with a smile: the beautiful creatures of low life.

[5] Leonardo da Vinci, *Trattato*, 13. Translation by A. Philip McMahon: "If the painter wishes to see beauties which will make him fall in love with them, he is a lord capable of creating them." (*Leonardo da Vinci, Treatise on Painting*, I, Princeton, 1956, p. 24.)

[6] Beryl Barr-Scharrar, "Some Aspects of Early Autobiographical Imagery in Picasso's Suite 347," *Art Bulletin*, Volume LIV, Number 4, December 1972.

PICASSO UNDER THE ETESIAN WINDS
René Char

To ensure one's own aftermath in art demands the violation of all that is held sacred, openly or otherwise. If the victim resists, so much the better, for this simply enhances the definition of the process or its equivalents. We need therefore have no fear of glibness in stating that the twentieth century died twenty-seven years before its appointed time in the form of a man aged ninety-two. Could it be that this century regarded its destiny as fulfilled from the moment that its enigmatic creator has produced, with a leap of immense resilience, his last excursion to the fore? Of course, this is a highly simplistic deduction. A painter who best expressed, almost literally, this subdivision of Time, the most marked there has ever been since the start of history; who translated onto canvas or paper with his pencil or with a brush and a few colors its undercurrents and insecurity—this painter well knew that the long and toilsome journey through the trackless universe of art must be made on foot, using visual memory alone, with self-control, accompanied by inner terror and with sarcasm and mercy side by side. Picasso never reached middle age; he never abandoned youth, though he endowed it with the fruits of maturity. His father, a worthy artist, when confronted with his adolescent drawings, threw up his hands and took leave of his work—an honorable termination to his career.

Though haunted by his equals of the past, solitary questers and interpreters of the apparently inextinguishable mass of humanity, Picasso was at no time a duplicate of any of them. In common with the great actors of Shakespearian drama he shared a capacity to discern alien secrets and to clothe them in a multitude of forms. These are

"Picasso under the Etesian Winds" by René Char. Preface to the exhibition catalogue *Picasso 1970–1972, 201 peintures, du 23 mai au 23 septembre 1973*. The exhibition was held at the Palais des Papes, Avignon. Reprinted by permission of the author. Translated by A. D. Simons.

secrets such as dwell in the spaces we set aside for them behind our faces, where they compound with truth. A search of the conscience, a struggle with imagination, dislodges them. This is an *oeuvre* of a wisdom surpassing all others, yet it is furiously subversive, for it impinged upon a concrete world of daily repetition, a world against which its combers break without cease. At this time, we may look back on that unwrinkled child painter, wearing a hat dear to his heart, and with palette and brush in his hands—Pablo Picasso, after being anointed king by his far-sighted father [Fig. 40]. The night of need which begins is starlit. Bending to his sway, a force and a knowing are unleashed, to be recaptured by art. With the wind and flames at our backs, our passage is swift, divinely wicked, and diabolically good as it behooves.

Picasso sometimes felt himself to be a prisoner—but a prisoner with no gaoler—of that perfect understanding of which sadness and melancholy are born; but never nostalgia. Painter and engraver of Lascaux, of Altamira and of all places where bulls are worshipped, he could not but be a lover. He cast the red brightness of his laughing, loving freedom even on Velázquez. [Cf. Figs. 37–38.] If it is assumed, as a figurative abbreviation, that painting is immobility and literature is turbulence, there exist a select few apt to distinguish a reality seen and recorded by discordant movement, as though already obliterated. With Picasso there is not the slightest concession to the meanness of caricature. Boldness and fear pulsate about his brow. How many have been able to ascertain it!

Professional innovator that he was, Picasso delighted in threatening tradition, while at the same time never neglecting to base himself upon it. Revolutionaries are reluctant to accept the wide range of dramas to which they lend the characteristics of an ice-cold gambler, whose winnings stretch away out of reach into a promised, ideal future under the threat of malignant ills. Other paths are possible if doctrine is accepted. But Picasso, with his discoveries and inspirations, Picasso inspiring Picasso, was a revolutionary by nature—a revolutionary, but not a terrorist. Even in his depictions of seemly love, even when recording the image of a person as that person might hope to discover it, usually with a beauty of a dazzling suddenness never revealed by the mirror. Who is not the dupe of his own desires? The ordinary man is confident of his own perfection. But not Picasso. If it is really necessary to wait for the eclipse of a great man to measure the distance from his contemporaries at which he really lived, we can now, in the month of May 1973, realize that Picasso was living in the closest proximity to us. Best evidence of this is the bird in his recent canvases. But the dates the painter has inscribed clearly on certain pictures have a flight as prophetic as that of wild birds against the background of the sky, rendering the calendar obsolete.

Miracles are the fruit of sceptical humour. It is at this point that creation commences. Picasso was everything except comic, with his eternal return to lucidity, in the fact that his themes and motifs are good and that his touch has a power enabling it to remain simple: as though, in the face of every temptation, he was improvising without blemish or ornamentation on the basis of long-standing types. He is not in the least disturbed by the need to reclothe them in innumerable forms. He was a sentry, crouched in watchfulness rather than entrenched, a sinker of wells in the interior of the human body from which to draw its uncertainties and its pulsations. From time to time, there is a pertinacious recurrence of some ancient myth. Suddenly, the subject writhes like a harpooned whale: there was a doubt to be dispelled. The objects, constraints and currencies of our affective world, this ingot-mould, are constantly being refurbished by Picasso. Few artists can have suffered, caused suffering, and rejoiced as much as he. Since the counting of centuries began, there have not been many in which so great an adventure took place.

Picasso displaces the centre of gravity of the shameless play interminably taking place on the stage around us—somewhat late, it may be thought. But he does not reorient himself in the light of this discovery. His youthfulness acquired greater stature from the damage so inflicted. He rewrote the entire drama, cutting it back to the simple subject, no better or worse than the generalities of which it is composed. He drips no moral salve of the "Thy will be done" kind upon the wound. His combative irony, his ruthless demands, his telluric inventiveness become for a moment constrained at the moment of trial, only to return to the assault with a courage undaunted in spite of all. The painted settings continue to consume intrigues, situations, personalities, and deceptions alike right up to the conclusion of the work.

In making the transition from Cézanne's apples to Picasso's toreador, I wonder whether a historic change did not take place. Always assuming, of course, that the two do not turn out to be complementary. However this may be, we no longer have to do with delectation in the manner of Poussin (a painter much admired by Picasso), but with precisely the contrary. A being or an object, in the final analysis, ceases to be narcissistic, deriving no authority from the unbroken dialogue between the real being inspiring us and that opposed to us. And man's recent excursion into grey and grandiose space has nothing to add.

"Proof wearies truth," said Braque. How right he was! There have been other observations, the most sensitive including: "What a light thrown upon evil!" "He burned with a sacred flame. Is that not enough?" "It may prove to have been a battle lost in advance." "An intimidating intellectual adventure. A devastating light bearing down

the resistance of lyric resilience." "The affairs of God and the Devil concerned him little, what though he was in the confidence of both." "A glance at the architecture all around is sufficient to disclose that Picasso, like some reincarnation of Vulcan, has influenced it all." "Ingratitude, if it is to exist at all, must be that of a genius." "This snow Picasso has in store for us is so mild that it seems to bring everything to flower and to cause wheatfields to grow. I seem to see the mendicant horde stretching out behind this block of opacity. A liberty indeed upon this mourning morn. I seem to hear his tread." "The death-inflicting toreador has met his death. A sword against two horns. A palette of a sword."

The sorcerer deceives, the magician computes. The factor of Picasso's power—and it had the texture of a dream—was to liberate the most impassioned portion of the immanent unknown which stood waiting to emerge to the surface of the art of his age, and to let it take its chance till the very end, from Delusion to Illusion. He was successful. Everything is possible in the fullness of time. Picasso's interpretation is neither an approval nor a disavowal. One must pass. He passes. A magnificence of calculation may certainly be granted him. His is an art which is rupestral, magical, pagan, undatable, romanesque, art of our eyes. . . .

Look at this picture:[1] the left eye is run-of-the-mill, while the right eye is a black circle with a black filling. Yet this is not blindness, not even impaired sight. It is the juxtaposition of night and day. It is life. It is an unwinking clarity at the center of the face. There is no divisive work among the whole of Picasso's enormous output. There are, certainly, a few offshoots with an excess of life-force. But who will complain of that?

Seven times on that April 8 a worried titmouse tapped on my window-frame with his beak rushing me from morning heed to noon alarm. Did this mean some message? At four o'clock I heard the news. That terrible eye had ceased to be solar and to draw us into its orbit. Life paints us and death draws us in a series of 201 pictures.

[1] [*Man with a big Hat*, November 23, 1970, *Catalogue Avignon 1973*, no. 38.—Ed.]

Biographical Data

1881	Born October 25 at Malaga, Andalusia.
1895	Admitted to La Lonja, Academy of Fine Arts, Barcelona.
1897	Student at the Royal Academy of San Fernando, Madrid.
1900	Makes first trip to Paris.
1904	Begins his Blue Period; holds first exhibition in Paris at Vollard's; settles in Paris; meets Max Jacob.
1905	Begins his Rose Period; meets Guillaume Apollinaire, Leo and Gertrude Stein, and Fernande Olivier.
1906	Meets Henri Matisse.
1907	Begins his Cubist Period; paints *Les Demoiselles d'Avignon*; meets Georges Braque and D.-H. Kahnweiler.
1909	First exhibition in Germany opens at the Gallery Thannhauser, Munich.
1911	First exhibition in the U.S.A. held at the Photo-Secession Gallery, New York.
1912	Holds first exhibition in England at the Stafford Gallery, London; begins friendship with Marcelle Humbert ("Eva").
1913	Begins his period of Synthetic Cubism; summers in Céret, L'Isle-sur-Sorgue with Braque and Juan Gris; father dies in Barcelona.
1914	Spends the summer with Braque and André Derain in Avignon.
1917	Goes to Rome with Jean Cocteau and designs the ballet *Parade*'s sets for Diaghilev's *Ballets Russes*.
1918	Marries Olga Koklova.
1919	Meets Joan Miró.
1920	Designs for Stravinsky's *Pulcinella*; begins his Classical period.
1921	Paints two versions of the *Three Musicians*; birth of his son Paul to wife Olga.
1925	Paints the *Three Dancers*.
1930	Moves to the Château de Boisgeloup, near Gisors.

1931 Etchings for Balzac's *Le Chef-d'oeuvre inconnu* (Vollard) and Ovid's *Métamorphoses* (Skira) published.

1932 Retrospective exhibitions held in Paris at the Galerie Georges Petit and in Zurich at the Kunsthaus; meets Marie-Thérèse Walter.

1935 Produces the *Minotauromachy* suite; birth of daughter Maia to Marie-Thérèse Walter.

1936 Outbreak of the Spanish Civil War; forms friendship with Dora Maar.

1937 Paints the mural *Guernica* for the Spanish Republic's pavilion at the Paris World's Fair.

1939 Outbreak of World War II; large retrospective exhibition held in the Museum of Modern Art, New York; mother dies in Barcelona.

1941 Writes a play, *Desire Caught by the Tail.*

1944 Paris liberated; homage paid to Picasso at the Salon d'automne; joins the Communist Party.

1945 Resumes lithography in Fernand Mourlot's workshop.

1946 Meets Françoise Gilot.

1947 Begins ceramic work at the Madoura factory, Vallauris; birth of his son Claude to Françoise Gilot.

1948 Moves to the villa La Galloise, Vallauris.

1949 His daughter Paloma born to Françoise Gilot.

1951 Paints *Massacre in Korea.*

1951 Executes *War and Peace.*

1954 Begins variations on Delacroix's *Femmes d'Alger*; meets Jacqueline Roque.

1955 First wife Olga dies; moves to the villa La Californie, Cannes.

1957 Produces series of variations on Velázquez' *Las Meninas*; important retrospective exhibition held in New York.

1958 Executes the mural for the UNESCO building, Paris; moves to the Château de Vauvenargues, near Aix-en-Provence.

1961 Paints variations on Manet's *Déjeuner su l'herbe*; marries Jacqueline Roque; moves to the villa, Notre-Dame-de-Vie, Mougins.

1966 Exhibitions held around the world to honor his 85th birthday.

1968 Executes *Suite 347.*

1971 Exhibitions in world capitals mark his 90th birthday.

1973 Dies April 8 in Mougins.

Notes on the Editor and Contributors

Félicien Fagus (pseudonym of Georges Eugène Faillet, Brussels 1872–1933 Paris) was an art critic and symbolist poet. His writings include: *Colloque sentimental entre Émile Zola et Fagus* (1898); *Fagus: Testament de sa Vie* (1898); *Ixion* (1903); *La Danse macabre* (1920).

Julius Meier-Graefe (1867–1935) was the leading German art critic at the turn of the century and, as such, the propagator of French Impressionism and Post-Impressionism in Germany. He founded four art magazines and traveled widely; toward the end of his life, he became an expert in Egyptian art. Of his works, there are available in English: *Modern Art* (1908); *Vincent Van Gogh, a Biographical Study* (1922); *Degas* (1923); *Cézanne* (1927); *The Spanish Journey* (1927); *Dostoievsky: The Man and His Work* (1928); *Pyramid and Temple* (1930); *Vincent: A Life of Van Gogh* (1936).

Gelett Burgess (Boston 1866–1951), a writer and illustrator for magazines both American and English, edited the periodicals *The Wave* (1894–95) and *Lark* (1895–97). His publications include: *Vivette* (1897); *Goops and how to be them* (1900); *Burgess Nonsense Book* (1901); *The Purple Cow* (1924); *Ladies in Boxes* (1942).

Jean Cassou (1897–), a distinguished writer and art critic, was *Conservateur en Chef* of the Museum of Modern Art in Paris from 1946 to 1965, and *Directeur d'études à l'École des hautes études* from 1965 to 1970. His novels include: *Éloge de la folie* (1925); *Dernières pensées d'un amoureux* (1952); etc. Among his writings on art are books on El Greco, Picasso, Ingres, Matisse, and works on modern art in general.

Robert Goldwater (New York 1907–1973) was one of the greatest scholars of both modern and primitive art this country has produced. He was professor at the Institute of Fine Arts, New York University, and Director of the Museum of Primitive Art, New York, since 1957. His principal publications were: *Primitivism in Modern Painting* (1938, rev. ed. 1967); *Gauguin* (1957); *Bambara Sculpture from the Western Sudan* (1960); *Senufo Sculpture from West Africa* (1964); *What is Modern Sculpture?* (1969). At his death, he was working on a book on Symbolism, which will be published posthumously.

Pierre Daix (1922–) is chief editor of *Les Lettres Françaises*. He wrote: *Picasso (Paris, 1964); New York and London, 1965); Nouvelle critique et art moderne* (1968); and seven novels.

Marius De Zayas (1880–), a Mexican caricaturist and art critic, was a member of the circle around Alfred Stieglitz. He introduced Picasso and other modern artists to the New York art world, wrote articles in *Camera Work*, and helped found the magazine *291*. His major publications were: *A Study of the Modern Evolution of Plastic Expression* (1913) and *African Negro Art; its Influence on Modern Art* (1916). In 1923, Picasso gave him one of his rare and important interviews.

Guillaume Apollinaire (pseudonym of Guillaume Apollinaris de Kostro-vitski, 1880–1918), was one of the most influential figures in the Paris art world from 1900 until his death. Among his numerous writings may be mentioned: the critical manifestoes *Les Peintres Cubistes* (1913) and *L'Esprit Nouveau* (1918); the novels *Le Poète assassiné* (1916) and *La Femme assise* (published posthumously, 1920); the play *Les Mamelles de Tirésias* (1917); the collections of poems *Alcools* (1913) and *Calligrammes* (1918).

Wyndham Lewis (1882–1957), an English painter and polemical writer, launched almost single-handedly an abstract movement in art, called "Vorticism," and edited *Blast* (1914–15). As a critic in the '20s he called himself "The Enemy." In his career he produced "nearly fifty books, some hundred paintings and over a thousand drawings." His books include: *Time and Western Man* (1927); *The Human Age* (1954); *The Demon of Progress in the Arts* (1955).

Andrew Dasburg (1887–), an American painter, was a disciple of the Synchromists Morgan Russell and Stanton MacDonald-Wright. In 1916 he participated in the Forum Exhibition at the Anderson Gallery in New York, "the most important exhibit of American Modernism after the 1913 Armory Show." In 1917 he moved to Ranchos de Taos, New Mexico, where he has lived ever since and where he continues to paint in a style similar to his early one.

Maurice Raynal (1884–1954), a friend of Picasso's, was the first critic to attempt a near-scientific evaluation of Cubism. His principal publications were: *Anthologie de la peinture en France de 1906 à nos jours* (Paris, 1927); *Picasso* (first published in German: Munich, 1921); *Picasso, Biographical and Critical Studies* (1953); *The Nineteenth Century; New Sources of Emotion from Goya to Gauguin* (1951); *Cézanne, Biographical and Critical Studies* (1954); and short monographs on Juan Gris, Braque, Archipenko, Lipchitz, Léger, and others.

Leo Steinberg is Benjamin Franklin Professor of the History of Art, University of Pennsylvania. He is the author of *Other Criteria: Confrontations with Twentieth-Century Art* (New York, 1972). His contribution to this volume is excerpted from "The Algerian Women and Picasso At Large," the major essay in his book. Steinberg's other works on Picasso include: "The Philosophical Brothel (Picasso's *Demoiselles d'Avignon)*" and "Picasso

in the Homestretch" (see Selected Bibliography). His extensive writings on Renaissance and Baroque art include studies on Leonardo, Mantegna, Michelangelo, Pontormo, El Greco, Rubens, and Velázquez.

Waldemar George (pseudonym of W. Jarocinski, 1893–1969), a French art critic of Polish origin, edited and directed successively the following periodicals: *L'Amour de l'Art, Formes, Art et Industrie,* and *Prisme des Arts.* His books include: *Le dessin français au XIXe siècle; L'esprit français et la peinture française; Vers un nouvel humanisme; L'esthétique de Hegel; La peinture expressionniste;* and monographs on Matisse, Rouault, Picasso, Chirico, Gris, Chagall, Léger, Larionov, and others. Most of his books have been translated into English, German, Dutch, and Italian.

Carl Einstein (b. 1885 in Berlin, died a suicide during the German invasion of France in World War II). Expressionist poet and art critic, editor of esoteric periodicals during and after World War I. His book *Negro Sculpture* (1915) introduced an entirely new view of the autonomous formal value of "primitive" art. His great volume *Die Kunst des XX. Jahrhunderts* (1931) is one of the first comprehensive historical accounts of modern art and is in many respects still unsurpassed.

Robert Rosenblum is Professor of Fine Arts, New York University. He has written: *Cubism and Twentieth-Century Art* (1960); *Transformations in Late Eighteenth Century Art* (1967); *Ingres* (1967); *Frank Stella* (1971); *Modern Painting and the Northern Romantic Tradition* (1975); and many articles, including studies of Picasso's Cubist and Surrealist phases.

Clive Bell (1881–1964) was from 1906 on, along with T.S. Eliot, Wyndham Lewis, and Roger Fry, a member of the Bloomsbury Group. His books include: *Art* (1913); *Since Cézanne* (1922); *Landmarks in Nineteenth-Century Painting* (1927); *Victor Pasmore* (1945); *The French Impressionists* (1952).

James Thrall Soby (1906–) was Assistant Director, and Director of Painting and Sculpture at the Museum of Modern Art in New York (1943–45); art critic for the *Saturday Review of Literature* (1946–47); and acting editor of *Magazine of Art* (1950–51). He is the author of standard monographs on Chirico and fantastic art. His more recent publications include: *Modern Art and the New Past* (1957); *Juan Gris* (1958); *Joan Miró* (1959); *Ben Shahn: Paintings* (1963); *Magritte* (1965).

Robert Melville is the art critic of the *New Statesman* and *Architectural Review,* London. He has written monographs on Picasso, Graham Sutherland, Samuel Palmer, Henry Moore, and others, as well as a book, *Erotic Art of the West* (1973).

Sir Herbert Read (1893–1968), one of the most important writers on art in the twentieth century, declared himself "literary critic, poet, art critic and anarchist." From 1922 to 1931 he was Assistant Keeper in the Department of Ceramics at the Victoria and Albert Museum in London. In the '30s he established himself as the champion of the modern movement in England and became associated with the sculptors Henry Moore, Barbara Hepworth, and

Naum Gabo, and the painter Ben Nicholson. In 1936 he defended Surrealism at the time of its first major exhibition in London. He published: *Art and Industry* (1934); *Art and Society* (1937); *Poetry and Anarchism* (1938); *The Philosophy of Anarchism* (1941); *The Innocent Eye* (autobiography, 1947); *The Art of Sculpture* (Mellon Lectures, 1956); *Art and Alienation* (1968). He was co-editor and co-founder with Frank Rudder of *Art and Letters* (1917–20); editor of *The Burlington Magazine* (1933–38); Professor of Fine Arts at the Universities of Edinburgh (1931–33) and Liverpool (1935–36).

Martin Ries is a painter who teaches at Long Island University, Brooklyn. His contribution to this volume is from a book he is writing on *The Theme of the Minotaur in Western Art*.

Vernon Clark remains the great unknown in this collection. I have been unable to trace him, and the present editors of *Science and Society*, with whose permission I included his article in this volume, are also not acquainted with him.

Max Raphael was born in Schönlanke (West Prussia) in 1889 and died in New York in 1952. Although many of his works are still unpublished and only a few are accessible in English, he is considered by some to be one of the most important aestheticians of our time, founding his theories on a very broad and unorthodox brand of Marxism. His books include: *Idee und Gestalt* (1921); *Der dorische Tempel* (1930); *Proudhon, Marx, Picasso: trois études sur la sociologie de l'art* (1933); *Zur Erkenntnistheorie der konkreten Dialektik* (1934); *Prehistoric Cave Paintings* (1945); *Prehistoric Pottery and Civilization in Egypt* (1947); *The Demands of Art* (1968).

John Berger was born in London in 1926. He started his working life as a painter and teacher of drawing, then began writing art criticism for *Tribune*, the *New Statesman*, and other newspapers and periodicals. His published works include a book of essays called *Permanent Red* (1960); *The Success and Failure of Picasso* (1965); three novels; and *Art and Revolution; Ernst Neizvestny and the Role of the Artist in the U.S.S.R.* (1969).

Frederick S. Wight (b. New York, 1902) is a painter and art administrator. He taught at the University of California in Los Angeles (1953–70) and has been Director of the Frederick S. Wight Galleries, UCLA, since 1953. His publications include: *Morris Graves* (1956); *Hans Hoffmann* (1957); *Arthur G. Dove* (1958); *Modigliani* (1961); and others.

Michel Leiris (b. Paris, 1901) is a writer, poet, ethnographer, and essayist. He participated in the Surrealist movement from 1924 to 1929. As an ethnologist, he joined the Dakar-Djibouti Mission from 1931 to 1933, and is a Senior Research Fellow at the *Centre national de la recherche scientifique*. Among his poetical writings are: *Simulacre* (1925); *Hautmal* (1934); *L'Afrique fantôme* (1934); *L'Age d'homme* (1939); *Haut Mal* (poems, 1969); *Mots sans mémoire* (poems, 1970). His writings on art include: *The Prints of Joan Miró* (1947) and *African Art* (1968). He also wrote ethnological works on the civilizations of Martinique and Guadalupe, on the Dogon, and on the Ethiopians.

Louis Aragon was born in Paris in 1897. He founded and was the principal contributor to the review *Littérature* (1919) with André Breton and Philippe Soupault, and founder (1935) and secretary of the *Association Internationale des Écrivains pour la Défense de la Culture*. Aragon is a Member of the Central Committee of the Communist Party of France. His major works are the books of poetry *Feu de joie* (1920) and *Le mouvement perpétuel* (1925); and the novels *Le Paysan de Paris* (1926), *Les Beaux Quartiers* (1936), and *La Mise à mort* (1965). An outstanding example of Aragon's Surrealist art criticism is *La peinture au défi*. (Paris, Corti, 1930), with passages on Picasso's collages. In 1953 he caused a minor scandal by putting Picasso to the inappropriate task of drawing a portrait of young Stalin.

John Anderson is a Canadian painter and art critic.

Gert Schiff is Professor of Fine Arts at New York University. He has written studies on Henry Fuseli, William Blake, Gustave Moreau, the Pre-Raphaelites, Max Beckmann, Paul Klee, Hans von Marées, Thomas Rowlandson, and, most recently, an essay "Laughing and Weeping in Art."

René Char (b. Vaucluse, 1917) is one of the greatest of the poets who have grown out of the Surrealist circle. Picasso made drawings for his poetry. His books include: *Le Marteau sans maître* (1934); *Dehors la nuit est gouvernée* (1938); *Le soleil des eaux* (1949); *Trois coups sous les arbres* (1967); *Le Nu perdu, Recherche de la base et du sommet* (1971); and many others.

Selected Bibliography

The standard catalogue of Picasso's work, each piece illustrated, is *Picasso*, 23 vols., ed. Christian Zervos (Paris: Cahiers d'art, 1932–71).

ALBERTI, RAFAEL. *Picasso en Avignon.* Paris, 1971.

ARGAN, GIULIO CARLO. *Scultura di Picasso.* Venice, 1953.

ARNHEIM, RUDOLF. *Picasso's* Guernica, *The Genesis of a Painting.* Los Angeles and London, 1962.

BARR, ALFRED H., JR. *Picasso: Fifty Years of His Art.* New York, 1946; reprinted 1967.

BATAILLE, GEORGES. "Soleil Pourri," *Hommage à Picasso, Documents.* 2, no. 3 (Paris, 1930).

BERGER, JOHN. *The Success and Failure of Picasso.* London, 1965.

BLOCH, GEORGES. *Picasso, Catalogue de l'oeuvre gravé et lithographié, 1904–1967,* Vol. I. Bern, 1968.

———. *Picasso, Catalogue de l'oeuvre gravé et lithographié, 1966–1969,* Vol. II, Bern, 1971.

BLUNT, ANTHONY. "Picasso's Classical Period (1917–1925)," *The Burlington Magazine* (April 1968).

———. *Picasso's* Guernica. Oxford, 1969.

BLUNT, ANTHONY, and PHOEBE POOL. *Picasso, The Formative Years, A Study of his Sources.* London and New York, 1962.

BOECK, W., and J. SABARTÈS. *Pablo Picasso.* New York and London, 1955.

BOGGS, JEAN SUTHERLAND. "Picasso and the Theatre at Toulouse," *The Burlington Magazine* (January 1966).

BOLLIGER, HANS. *Picasso, Vollard Suite.* London, 1956.

———. *Picasso: Fifty Years of his Graphic Art.* Exhibition catalogue, London: Arts Council, 1956.

BRASSAÏ *Conversations avec Picasso.* Paris, 1964.

BRETON, ANDRÉ. "Picasso Poète," *Cahiers d'Art,* no. 10 (1935).

BUCHHEIM, L. G. *Picasso.* London, 1959.

CIRICI-PELLICER, A. *Picasso avant Picasso.* Geneva, 1950.

CIRLOT, JUAN EDUARDO. *Picasso, Birth of a Genius*, Barcelona and London, 1972.

COOPER, DOUGLAS. *Picasso, Les Déjeuners*. New York and London, 1963.

———. *Picasso: Theatre*. London and New York, 1968.

CROMMELYNCK, ALDO and PIERO. *Picasso: 347 Gravures*. Paris, 1968.

DIEHL, GASTON. *Picasso*. Paris, 1960.

D'ORS, EUGENIO. *Picasso*. Paris, 1930.

DUFOUR, PIERRE. *Picasso 1950–1968*. Geneva, 1969.

DUNCAN, DAVID DOUGLAS. *The Private World of Pablo Picasso*. New York, 1957; London, 1958.

———. *Picasso's Picassos*. London, 1961; New York, 1963.

ELGAR, FRANK. *Picasso, époques bleue et rose*. Paris, 1956.

ELGAR, FRANK, and ROBERT MAILLARD. *Picasso*. Paris and London, 1955.

ELUARD, PAUL. *A Pablo Picasso*. Geneva and Paris, 1944.

FELD, CHARLES. *Picasso Dessins 27.3.66–15.3.68*. Paris, 1969. (Preface by René Char.

FERMIGIER, ANDRÉ. *Picasso*. Paris, 1969.

GALLWITZ, KLAUS. *Picasso at 90, The Later Work*. New York and London, 1971.

GEISER, BERNHARD. *Picasso, peintre-graveur, Catalogue illustré de l'oeuvre gravé et lithographié, 1899–1931*. Bern, 1933; reprinted 1955.

———. *Picasso, peintre-graveur, Catalogue illustré de l'oeuvre gravé et des monotypes, 1932–1934*. Bern, 1968.

GEISER, BERNHARD and HANS BOLLIGER. *Picasso: His Graphic Work, 1899–1955*, Vol. I. London, 1966.

GEORGE, WALDEMAR. *Picasso, Dessins*. Paris, 1926.

GILOT, FRANCOISE and CARLTON LAKE. *Life with Picasso*. New York and London, 1964.

GOLDING, JOHN. "The *Demoiselles d'Avignon*," *The Burlington Magazine* (May 1958).

GONZALEZ, JULIO. "Picasso Sculpteur," *Cahiers d'Art*. 2, nos. 6–7 (1936).

GUNTHER, L. *Picasso: A Pictorial Biography*. New York, 1959.

HORODISCH, ABRAHAM. *Picasso as a Book Artist*. New York and London, 1962.

JACOB, MAX. "Souvenirs sur Picasso," *Cahiers d'Art*, no. 2 (1927).

JAFFÉ, HANS L. C. *Picasso*. New York and London, 1964.

JANIS, HARRIET and SYDNEY. *Picasso: The Recent Years, 1939–46*. New York, 1946.

JARDOT, MAURICE. *Picasso, Dessins*. Paris, 1959.

JUNG, C.G. "Picasso," *Neue Zürcher Zeitung*, no. 13.

KAHNWEILER, DANIEL-HENRY. *Picasso: Dessins 1903–1907*. Paris, 1954.

KAUFMANN, RUTH. "Picasso's *Crucifixion of 1930*," *The Burlington Magazine* (September 1969).

LARREA, JUAN. *Guernica*. New York, 1947.

LEONHARD, KURT. *Picasso: His Graphic Work, 1955–1965*, Vol. II. London, 1967.

LEVEL, ANDRÉ. *Picasso*. Paris, 1928.

LEYMARIE, JEAN. *Picasso Drawings*. Geneva, 1967.

———. *Picasso, The Artist of the Century*. Geneva, 1971; London, 1972.

LIEBERMAN, W.S. *Picasso and the Ballet*. New York, 1946.

———. *Picasso: Blue and Rose Periods*. New York, 1952.

MELVILLE, ROBERT. *Picasso: Master of the Phantom*. London, 1939.

MILLIER, A. *The Drawings of Picasso*. Los Angeles, 1961.

MOURLOT, FERNAND. *Picasso lithographe*. 5 vols. Monte Carlo, 1949, 1950, 1956, 1965, 1970.

OLIVIER, FERNANDE. *Picasso et ses Amis*. Paris, 1933.

PARMELIN, HÉLÈNE. *Picasso sur la place*. Paris, 1959.

———. *Les Dames de Mougins*. Paris, 1964.

———. *Le peintre et son modèle*. Paris, 1965.

———. *Notre-Dame-de-Vie*. Paris, 1966.

PENROSE, ROLAND. *Homage to Picasso*. London, 1951.

———. "Picasso," *L'Oeil* (October 1956).

———. *Portrait of Picasso*, London, 1956; New York, 1957; rev. ed., 1972.

———. *Picasso, His Life and Work*. London and New York, 1958.

———. *The Sculpture of Picasso*. New York, 1967.

PENROSE, ROLAND, and JOHN GOLDING, Advisory editors. *Picasso in Retrospect*. New York, 1973.

PENROSE, ROLAND, and EDWARD QUINN. *Picasso at Work*. London and New York, 1965.

POOL, PHOEBE. "Sources and Background of Picasso's Art," *The Burlington Magazine*, 101 (May 1959).

PRÉVERT, JACQUES. *Portraits de Picasso*. Milan, 1959.

READ, HERBERT. "Picasso's *Guernica*," *London Bulletin*, no. 6 (October 1938).

RICHARDSON, JOHN. "Picasso's *Ateliers* and Other Recent Works," *The Burlington Magazine*, XCIX (June 1957).

———. *Picasso, Watercolours and Gouaches*. London, 1964.

ROSENBLUM, ROBERT. "Picasso and the Coronation of Alexander III: A Note on the Dating of some Papiers Collés," *The Burlington Magazine* (October 1971).

RUBIN, WILLIAM. *Picasso in the Collection of the Museum of Modern Art*. New York, 1972.

SABARTÈS, JAIME. *Picasso; portraits et Souvenirs*. Paris, 1946.

———. *Picasso: Documents Iconographiques*. Geneva, 1954.

———. *Picasso, Les Menines*. Paris, 1958.

———. *Picasso, Les Bleus de Barcelone*. Paris, 1963.

SPIES, WERNER. *Picasso Sculpture*. New York and London, 1972.

STEIN, GERTRUDE. *Picasso*. London, 1938; New York, 1939.

SUTTON, DENYS. *Picasso, peintures, époques bleue et rose.* Paris, 1948.

SWEENEY, J.J. "Picasso and Iberian Sculpture," *Art Bulletin,* 23, no. 3 (1941).

TÉRIADE, E., ed. "Picasso at Antibes," *Verve,* 5, no. 19–20 (1948).

————. "Picasso at Vallauris," *Verve,* 7, no. 25–26 (1951).

TZARA, TRISTAN *Picasso et la Poésie.* Rome, 1953.

UHDE, WILHELM. *Picasso and the French Tradition.* Paris and New York, 1929.

VALLENTIN, ANTONINA. *Picasso.* Paris, 1957; New York and London, 1963.

VERDET, ANDRÉ. "Picasso et Ses Environs," *Les Lettres Nouvelles* (July–August 1955).

WERTENBAKER, LAEL. *The World of Picasso.* New York, 1967.

ZERVOS, CHRISTIAN. "Oeuvres et images-inédites de la jeunesse de Picasso," *Cahiers d'Art,* no. 2 (1950).

List of Illustrations

2310
646 5252 522
2416 522
2135.9792
2135

Del
18 22 11212
52508280
0280
747 736 6247